Raphael and His Age

Drawings from the Palais des Beaux-Arts, Lille

Raphael and His Age

Drawings from the Palais des Beaux-Arts, Lille

Paul Joannides

The
Cleveland
Museum
of Art
A world of great
art for everyone

Réunion
des Musées
Nationaux

PALAIS DES
BEAUX–ARTS
LILLE

#51088044

This exhibition is organized under the aegis of

French Regional & American Museums Exchange
www.on-frame.com

FRAME is supported by the Foundation for French Museums, The Florence Gould Foundation,
the Felix & Elizabeth Rohatyn Foundation, by Agnès Lobel, Sophie and Jérôme Seydoux, and Barbara Walters.

The Sara Lee Corporation, Vivendi Universal, and Divento.com are the official sponsors.

Additional support was provided by bioMérieux and Cap Gemini Ernst & Young
Published on the occasion of the exhibition *Raphael and His Age: Drawings from the Palais des Beaux-Arts, Lille.*
www.raphaeldrawings.com

The Cleveland Museum of Art
25 August–27 October 2002

Palais des Beaux-Arts, Lille
Winter 2003

ISBN: 2-7118-4552-4
EK 3800 48

Printed and bound in France.

Contents

Foreword
Museum Statements
Preface
Introduction
Acknowledgments

Foreword

FRAME is a unique organization which stresses cultural exchange and cooperation among its nine French and nine American museums. Nothing could be more indicative of the success of this cooperation than the extraordinary opportunity presented by this exhibition, in which Cleveland and its museum public will enjoy true masterpieces of Renaissance drawing on loan from the Palais des Beaux-Arts in Lille. The idea for the show and the generosity of its loans are due to Arnauld Brejon de Lavergnée and the city of Lille, an idea that germinated at the very first FRAME meeting in Lyon. His proposal was gratefully accepted by Diane De Grazia, then chief curator at the Cleveland Museum of Art, as one of the first important projects of FRAME, and enthusiastically supported by Director Katharine Lee Reid. The exhibition has been a true joint effort between the staffs of the two institutions. Thanks to the involvement of Paul Joannides, University Lecturer, Department of History of Art, University of Cambridge, the project took on an important scholarly focus, and his keen connoisseurship and knowledge of Renaissance art have made this catalogue a significant contribution to the field of Italian drawings. It has been beautifully produced thanks to the able involvement of the Réunion des Musées Nationaux. The exhibition is also supported by an indemnity from the Federal Council on the Arts and the Humanities.

Francine Mariani-Ducray,
Directrice des Musées de France, President of Frame
Françoise Cachin and Elizabeth Rohatyn,
Co-Founders and Chief Executive Officers, FRAME

As two of the greatest museums in their respective countries, the Cleveland Museum of Art and the Palais des Beaux-Arts, Lille are well known to art historians and enthusiasts all over the world and much loved by their own local audiences. They are less well known to museum visitors outside their respective metropolitan areas, and part of FRAME's mission is to increase awareness of the artistic resources in regions with exceptional traditions of collecting. The differences in that kind of collecting are precisely what affords the opportunity for the exchange this project represents. Drawings by Raphael are rare in America but not, thankfully, in Lille, where native son Jean-Baptiste Wicar left his collection in 1834, nearly eighty years before the founding of the Cleveland Museum of Art. Now, thanks to Wicar's interest in Italian drawing and the generosity of the city of Lille and its museum, Cleveland audiences will have an unparalleled opportunity to see Raphael's drawings in a depth not possible with our own collection, or indeed, anywhere in this country. We are grateful, above all, to the city of Lille for sharing these remarkable works with Cleveland and its museum visitors. We would also like to thank FRAME and its co-founders and chief executive officers, Elizabeth Rohatyn and Françoise Cachin, for their efforts to ensure the success of the project, including financial support for this catalogue.

Katharine Lee Reid
Director

The European Renaissance invented new worlds: it redefined geographical contexts and saw the world grow in line with major discoveries; it redefined knowledge with a re-interpretation of the Ancients and the development of new sciences; and it redefined political power, with priority given to the economy and finance.

In all that, are there perhaps some both strange and familiar similarities with our era, as in fact historians have often noted? Just as in the Renaissance, a new form of publishing in our own era has been invented—the Internet—which explores and conquers still unknown, new territories—cyberspace. There is a reformation that, through the globalization of the world, reflects a search—more often than not—for the general interest of the world and for the common good.

This exhibition is exceptional in more than one respect. It offers some of the most wonderful drawings to come out of Florence, Umbria, and Rome under the influence and genius of Raphael. With more than fifty drawings of this calibre, it represents one of the most dazzling collections of drawings in the world, and among the best are the most sensitive and the most brilliant creations in the history of art—not an inconsiderable feat! Furthermore, not only have these works rarely left the museum in Lille, where they are one of the jewels in the museum's crown, but many have never before crossed the Atlantic. Above all, however, this exhibition provides a familiar echo of our times. It reminds us that the artists did not work in isolation, locked away in some high and proud solitary retreat but created a sort of "network" . . . even then.

Over more than a century, whether in red chalk, silverpoint, black chalk, or ink, whether portraits, studies, or preliminary sketches, we can follow the influences, the interdependence of the artists, and some of their aesthetic choices that are reworked, corrected, exchanged, shared, modified, and sometimes magnified. Many different expressions of individuality are at the heart of a network that brought them together and enriched them all.

Vivendi Universal is delighted to support this exhibition co-organized by FRAME, the first Franco-American program bringing together eighteen regional fine arts museums in France and the United States. In fact, there could be no better illustration of our commitment to encouraging, supporting, and promoting cultural diversity than this superb exhibition, which sings the praises both of fertile influences and of the necessary and rich interchange of sensitivities and singularities.

Vivendi Universal

Preface

One of the purposes of this exhibition and its catalogue is to help familiarize North American audiences with a great French collection of Italian drawings that, famous for its remarkable holding of sheets by Raphael, remains otherwise insufficiently known. Although extensively studied and recently the subject of a model collection catalogue by Barbara Brejon de Lavergnée, the collection is less visited than it might be even by scholars of the subject. While there have been several exhibitions devoted to surveys of the collection, they have been confined to Europe and naturally, when such great drawings are available, the Raphaels have generally been given pride of place—with the exception of the splendid exhibition *Le Bellezze di Firenze,* catalogued by Marco Chiarini, devoted to Florentine seventeenth-century drawing, shown both in Lille and Florence in 1991.

The present exhibition cannot match the pioneering brilliance of Chiarini's; many of the drawings shown here are well known, have been well discussed in the past, and there is little that the expert will find surprising. The point is rather to show Raphael in his context and, perhaps more significantly, the context in the light of Raphael. It aims to provide pleasure and excitement for the visitor in encountering some of the most incisive and intelligent drawings produced in a period universally acknowledged to be one of great draftsmanship, but also to demonstrate that even geniuses require soil in which to grow. Thus while works by Raphael form the exhibition's center, they are placed in dynamic relation with those by his predecessors, contemporaries, and successors.

The bibliographies are kept short and are based on—and often abridged from—those in Barbara Brejon de Lavergnée's 1997 catalogue, with a few more recent studies indicated where they seemed significant. The catalogue entries themselves are more speculative than usual, and more heavily freighted with hypotheses, since it is helpful even for the scholar—to say nothing of the compiler—to have accepted ideas questioned or alternatives proposed. A difficulty with well-known works is to recapture the excitement that attended their creation—or one's own first acquaintance with them. It is easy to take great works of art for granted, and a way to jolt one out of inattention is to attempt to recreate the state of their world before they entered it. In the case of drawings, a path to refreshment is to reconsider their functions and purposes, and the compiler has ventured a few new hypotheses here in the hope of providing it. But the functionalist path can also lead to a dry spring: the assumption that the interest of drawing is identical with its function. It is always important to know why and for what a drawing was done—a training exercise, a preparation for a painting or a sculpture, or an independent work—but its function does not exhaust what a drawing has to offer. It is what is surplus to function that is fascinating, in what ways the drawing participates in and exceeds the role that the artist might initially have envisaged for it, in what ways self-set problems animate the artist's own procedures. And since drawings reveal the creator's patterns of thought—sometimes shifting ones—more intimately than the other branches of the visual arts, close study of them allows us all to participate in creative intelligences far superior to our own. It is our hope that this exhibition will recover something of the wonder and excitement, and no doubt envy, that Raphael's immediate contemporaries would have felt when they saw him set a stylus to prepared paper or load his pen with ink.

Paul Joannides

Introduction

Raphael in Lille—we recognize that the association is an unusual and original one; indeed, it is so original that we would like to "explain" or justify it as it were, quite simply by describing three meaningful episodes gleaned from the beginning of the nineteenth century to the start of this new millennium.

To begin, it would be difficult to find a better illustration of an honest man's judgment of the great Renaissance artist Raphael than the one offered by Jean-Baptiste Wicar's contemporary, the man of letters François-René de Chateaubriand (1768–1848), whom Wicar certainly met while in Rome.

Chateaubriand cites the artist from Urbino two different times in his *Mémoires d'outre-tombe* ("Memoirs from Beyond the Grave"). He relates his visit to the Vatican in the following words: "While wandering around the Vatican I stopped to contemplate these stairs . . . These stairs . . . These Rooms [by Raphael] that so many immortal artists decorated, so many illustrious men admired—Petrarch, Tasso, Ariosto, Montaigne, Milton, Montesquieu—and then queens and kings both powerful and fallen, and finally a people of pilgrims coming from the four corners of the world: all of this now immobile and silent."

The author mentions Raphael a second time when he describes the château and the park of Stowe in England: "Beautiful pictures of the Italian school languished in the depths of some uninhabited rooms with closed shutters—poor Raphael, a prisoner in a château of the old British, far from the sky of the Farnesina!" (he develops the same idea a few pages earlier when speaking of a picture by Albani, which is "exiled" in the chapel of the family château, Combourg). This completely romantic meditation on the destiny of the work of art—a declaration imbued with philosophical notions about the slippage suffered by art when removed from its context—is the idea still pertinent today?

"Raphael in Lille" is certainly a "hiatus" that would have shocked the writer Chateaubriand. But "displacements" such as this one are no longer regretted so dramatically, especially in light of the important role played by museums in transmitting knowledge and appreciation.

Three generations after Chateaubriand, the highly cultivated artist Edgar Degas (1834–1917) expressed his desire to visit the museum of Lille in order to see its Raphael drawings. Degas's action throws a favorable light on his methods, illustrating his professionalism in his work, his cultivation, and his will to find the necessary means to aid him in his pursuit of perfection. At the same time, the museum was fulfilling its role in the formation of the artist, just as the Louvre had done for several generations. Through his wish to know the drawings in the "musée Wicar" Degas brought new relevancy to the art of Raphael.

Now, at the beginning of the twenty-first century, it is not a question of acquisition (Wicar), nor of creation (Degas), but a question of erudition—namely, the contribution of Paul Joannides, one of the greatest contemporary connoisseurs of Italian Renaissance drawings, as author of the present catalogue. Joannides's work of impeccable erudition, combined with the indispensable method of the *connoisseurship* or "informed connoisseur" (a method of training the eye that is not given to everyone), has resulted in a comprehensive catalogue giving new honor to the science of connoisseurship.

While there is no longer someone like Wicar enriching the institution with such a magnificent collection, nor a literary figure like Chateaubriand lamenting the object torn from its context, nor a Degas feeling the need to cross the threshold of the drawings department, there remains a museum that understands and is willing to share the fruits of its outstanding collection of art—and isn't this the essential?

<div align="right">

Arnauld Brejon de Lavergnée
Conservateur général du Patrimoine
Directeur du Musée des Beaux-Arts

</div>

Impartially considered, Raphael was much the more universal genius, as contemporaries such as Aretino were quick to point out, and for most artists much the more appropriate model. Raphael was an innovative designer and painter of small-scale works such as Madonnas and Holy Families, a pictorial staple; he was an expert and highly inventive portraitist; he was among the most accomplished fresco painters of his time; and he extended the range of fresco technique to approach the richness of oil painting. Astonishingly—one might say compulsively—creative in his own right, he was untiringly alert to the skills and discoveries of other artists and, as an organizer of genius, quick to make use of them. He was an architect as able to design small private buildings as large public ones. And he was an accomplished courtier, of the rich and powerful, of women, and of his fellow artists. Vasari says, with some surprise, that under Raphael's sway, painters worked together amicably and Raphael's school was one of the most productive and varied in the history of Western art. In choosing Michelangelo (a proponent of what would, in the eighteenth century, be called the "sublime") as his hero, Vasari selected an artist of a different kind: one who was proud, moody, and difficult to deal with, who had no significant pupils, and produced no school; an artist who executed great projects and generally ignored minor ones; a man who, despite his immense qualities, was open to the charge of inefficiency in the direction of some of the schemes with which he was entrusted. Indeed, in various ways Vasari created problems artistic and political for both himself and later historians in lauding Michelangelo so comprehensively. Raphael would have been a more productive and assimilable model. Artists, on the whole, voted with their brushes. In the later seventeenth and eighteenth centuries in Italy, when Michelangelo's work held little interest for most painters, Raphael's continued to exercise a strong effect.

This universality is one of the reasons why Raphael is so rewarding to study. Like Rubens in the early seventeenth century, similarly omnivorous in his interests, Raphael provides a ready opening to his own time and that of his forerunners and successors. Vasari says he derived help from Raphael's writings on art, and although Vasari was no doubt referring mainly to the letter to Pope Leo X concerning the features of antique architecture, it is also fair to conclude that Raphael had an extensive and relatively unprejudiced acquaintance with art history and an attitude to art of the distant and recent past that was open and lacking in *parti-pris*. His approach to contemporary art was comparable. In a single altarpiece, the *Entombment* (Galleria Borghese, Rome), one can find threads of the antique, Leonardo, Michelangelo, Perugino, Ghirlandaio, and Northern European painting woven into a vital and dramatic composition. Raphael could well have said with Molière: "Je prends mon bien où je le trouve."

II

Raphael is one of the earliest Italian artists by whom a large quantity of drawings survives that can be connected with surviving works in painting. Only from Fra Bartolommeo and his shop are more drawings known. Even though the 450 or so sheets that have come down to us can represent only a small proportion of Raphael's graphic production, we can nevertheless reconstruct in detail his thought processes, working methods, and the development of some of his compositions. In the case of the degli Oddi *Coronation of the Virgin* (see fig. 20a) we can uncover two major phases and propose with reasonable security that a change of plan occurred late in the design process. In the Borghese *Entombment* we can also find two major design phases: first a static Pietà, then a mobile and highly dramatic Entombment, and within each of them a considerable number of intermediary stages. For

three of the four wall frescoes in the Stanza della Segnatura at the Vatican reasonable numbers of drawings are known, and for the fourth, the *Disputa,* an extensive run of sheets. At the end of Raphael's career, a considerable number of drawings—shared between Raphael and his most important assistants, Giulio Romano and Gian Francesco Penni—are known either in originals or copies for the *Transfiguration* (Pinacoteca, Vatican City), which underwent three major changes in design. Even for some smaller, less complicated works groups of drawings are known. For the *Madonna del Prato,* probably of 1505, in Vienna (Kunsthistorisches Museum), five pages of drawings survive and for the *Madonna di Loreto* at Chantilly (see fig. 40b), four. Although none even of the longest series is in any way complete—and we must be careful not to assume that what survives is representative—they mean we can reconstruct Raphael's thoughts about his compositions in more detail and with more intimacy than those of any earlier artist.

Furthermore, the insight these drawings provide extends beyond compositional design. It is clear that Raphael, who seems to have employed all the graphic media that were available in his time with a sovereign competence in all of them, often selected the technique of this or that drawing with a precise aim in view. This is not to reduce his graphic oeuvre simply to functionalism, for it contains many surprises and Raphael often employs media in ways that one would not anticipate. But, by and large, in the development of a particular project, Raphael's drawings were end-directed, and the medium was chosen with an eye either to the final result or to the particular emphasis that he sought at the particular stage. Raphael thought as an engineer, carefully selecting his tools with the task in view; but it is clear also that he reveled in his capacity to exploit whatever medium he was employing to the utmost. Thus while there survive relatively few drawings by Raphael not directly, or conjecturally, connected with projects—unlike say Parmigianino, who left very large numbers of drawings that had no specific purpose and who clearly drew just because he liked to—his variety and virtuosity have something of the same effect. Fra Bartolommeo prepared his paintings with at least equal care, but, after his earliest period, seems to have used his drawings rather as a means of attaining an end already foreseen than as a process of investigation. The surplus of graphic effort and graphic experiment beyond what another artist would have regarded as necessary was one of Raphael's ways of keeping himself up to the mark. Unlike Parmigianino, who dissipated his extraordinary creative talent, Raphael made his count. And unlike Fra Bartolommeo, whose meticulous and exhaustive preparation can sometimes lead to dullness, Raphael continually set himself new problems to solve, even at the risk of disrupting schemes already far advanced. By shifting from one medium to another and sometimes back again in the course of preparing a single work, Raphael ensured that the qualities proper to one graphic medium would engage in productive dialogue with those proper to another.

The very fact that so many of Raphael's working drawings survive presents us with a problem. Does it mean that he simply made more drawings than most of his contemporaries and predecessors, or is this merely accident of survival? It is obvious that great swathes of earlier drawings are lost. To take a single example: Vasari tells us that Donatello was a fluent and very active draftsman, and his prodigious output of sculptures in the round and marble and bronze reliefs, some of which are exceptionally complicated in composition and contain large numbers of figures, gives him credence. Yet no single drawing can today be given to Donatello with confidence. This is not to say that quattrocento drawings are not known in fairly large numbers, although survival rates are certainly much lower than for the cinquecento. But when sizeable groups do survive, the type of information

Acknowledgments

The success of this exhibition and catalogue and the mounting of the show at the Cleveland Museum of Art are due to the hard work of many, and it is a pleasure to express sincerest thanks to them all. Without the support of FRAME and of Arnauld Brejon de Lavergnée the exhibition would never have come about. Françoise Cachin, Elizabeth Rohatyn, and Richard Brettell of FRAME encouraged the project from the start, ably assisted by Pierrette Lacour. Paul Joannides's enthusiastic interest as guest curator and catalogue author has been the other essential element for success. Barbara Brejon de Lavergnée wrote two of the entries on Fra Bartolommeo. Béatrice Foulon of the Éditions des Réunion des Musées Nationaux and the project's editor, Geneviève Rudolf, oversaw the production of the catalogue and its editing in French. Patrick Shaw Cable of the Cleveland Museum of Art translated Barbara Brejon de Lavergnée's catalogue entries and coordinated photography orders. The staffs of both the Cleveland Museum of Art and the Palais des Beaux-Arts, Lille are here commended for their efficient work. In Lille, we are especially grateful to Barbara Brejon de Lavergnée, curator of drawings, Odile Liesse, restorer in charge of the mounting of the drawings, Patricia Truffin, assistant in charge of the photographic services, and Jean-Marie Dautel, registrar. In Cleveland, we thank Jeffrey Baxter, head of exhibition design and production; Sylvain Bellenger, curator of paintings; Joan Brickley, assistant, department of prints and drawings; Laurence Channing, head of publications; JoAnn Dickey, graphic designer; Heidi Domine, head of exhibitions; Charles Eiben, preparator; Jeff Falsgraff, installation supervisor, and his staff; Beth A. Gresham, associate registrar of exhibitions; Shelley Langdale, assistant curator of prints; Marlene Kiss, exhibitions associate; Jane Panza, exhibitions editor; Jeanette Saunders, assistant registrar; Katie Solender, former exhibitions director; Moyna Stanton, associate conservator, works of art on paper; Jeffrey Strean, director of design and facilities; Mary Suzor, chief registrar; Chris Tyler, lighting designer. Further thanks for guidance and advice are due to Joseph Giuffre and Jeannine O'Grody.

And finally, we would like to express our gratitude for their generous participation to the Annenberg Foundation, the Boeckman Family Foundation, Steven D. Brooks, Mr. and Mrs. Henry Buchbinder, Bruce and Carol Calder, the Fox Family Foundation, the Gingko Group, Emily Summers, Constance Goodyear, Nancy B. Hamon, S. Roger Horchow, Michael J. Horvitz, Mr. and Mrs. David Mesker, Mr. and Mrs. Peter O'Donnell, the Perot Foundation, Mrs Lewis T. Preston, Emily Rauh Pulitzer, Georges A. Schutt, and John R. Young.

Carter E. Foster
Curator of Drawings, The Cleveland Museum of Art

Author's Acknowledgments

In addition to the pleasure provided by the extraordinary quality of the works available for this exhibition, much of the enjoyment of its preparation, and that of its catalogue, came from the warmth and enthusiasm of others involved. At Lille, the source of the drawings, the compiler is deeply grateful to Barbara and Arnauld Brejon de Lavergnée for their kindness in affording him the best possible working conditions and for their constant and constantly available collaboration. Their support was seconded by that of the other members of the museum's staff, notably Annie Scottez de Wambrechies. At Cleveland, the guidance of Diane De Grazia was fundamental in the earlier stages of the project (and her absence keenly felt in the later stages), and she and Carter Foster earned the compiler's gratitude for their direction of the exhibition's scope and purpose, as well as for much practical assistance; en route, the collaboration of Patrick Cable was invaluable.

Naturally, the work involved research in other collections. At the Gabinetto Disegni e Stampe degli Uffizi, the compiler was greeted with their habitual helpfulness by Annamaria Petrioli Tofani, and by Lucia Monaci Moran, and the other members of their staff; a word of thanks is also due to Paolo Mannoni who kindly took photographs at short notice of several drawings. The staff of the print room at the Städelsches Kunstinstitut, Frankfurt was exceptionally helpful as were those of the Department of Western Art of the Ashmolean Museum, the Department of Prints and Drawings of the British Museum, and, of course, the Département des Arts Graphiques at the Louvre, which the compiler has come to regard as a home away from home.

Among others who helped in various ways were Michael Clifford, Gregory Rubinstein, Sheri Shaneyfelt, and Letizia Treves. Francis Ames-Lewis, a scholar whose familiarity with this material is unequalled, kindly read through an earlier version of the catalogue and introductions and saved the compiler from numerous errors.

Drawing in Central Italy

in the Late Fifteenth and Early Sixteenth Centuries

The Palais des Beaux-Arts de Lille possesses a rich and varied collection of drawings made in Italy between the fifteenth and the eighteenth centuries, but it is best known both nationally and internationally for its series of drawings by Raphael, one of the largest to survive. Nearly all these drawings date from the first half of Raphael's twenty-year documented career as an independent artist, which runs from 1500 to his death in 1520. Such a grouping inevitably excludes the drawings of his later Roman period, most of them made in red and black chalks, and many of them of great beauty. But, in compensation, the collection poses few of the problems of attribution that have bedeviled the study of Raphael's late paintings and drawings, particularly the work produced by the artist and his studio in the years following the completion of the Stanza d'Eliodoro at the Vatican in 1514.

Supporting this series are drawings by numerous other artists whose work is, in one way or another, related to that of Raphael. None of them is represented by more than a few sheets, but the examples of their work in the Palais des Beaux-Arts are, for the most part, of high quality and great interest. This exhibition seeks to exploit these resources and relations. Taking the work of Raphael as the central referent, it looks to the world of drawings in central Italy that preceded and led up to Raphael and that which succeeded him. Representation of the succession is inevitably more restricted since the collection of Lille is not rich in drawings by artists who came to maturity at the end of Raphael's career. Nevertheless, it does contain a sufficient number of fine sheets to demonstrate some of the ways in which central Italian draftsmanship would develop after 1520.

I

Although Giorgio Vasari, the first and greatest historian of Italian art, admired Raphael intensely, he did not accord him a major structural role in his *Lives of the Artists*. It is not Raphael but Leonardo who is the founder and initiator of the third period of this history, assuming for Vasari's time the roles Giotto and Masaccio took in the first and second periods, respectively. (Incidentally, Leonardo himself outlined such a schema at least half a century before Vasari set to work on his history.) Nor is Raphael characterized, like Michelangelo, as a demi-god and the culmination of the *Lives*. Vasari's organization is understandable, but it is in part the result of historical accident. Leonardo was two generations older than Raphael and, while not very productive, was a genuine initiator whose advances were taken up and adapted by Raphael and others. But Michelangelo, only eight years older than Raphael, was his great contemporary rather than his forerunner. Michelangelo was, of course, a sculptor as well as a painter and he slowly became an architect, but by 1520 Raphael too had begun to design, if not execute, innovative sculpture and he was much farther advanced than Michelangelo in an architectural career. Raphael was appointed architect of St. Peter's, the most important architectural project in Christendom, in 1514, at the age of thirty-one, whereas Michelangelo was not to obtain that post until 1547, at the age of seventy-two. Michelangelo outlived Raphael by forty-four years. Had Raphael been blessed with comparable longevity, he might well have usurped Michelangelo's place as the commanding figure of sixteenth-century art and the culmination of Vasari's *Lives*.

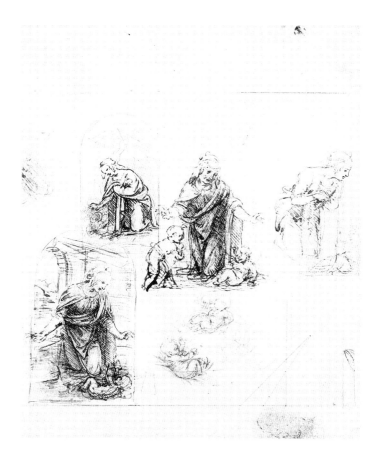

Fig. 1
Leonardo da Vinci. *Studies for a Virgin and Child with Saint John the Baptist,* c. 1480, pen and ink over leadpoint, 195 x 153 mm. The Metropolitan Museum of Art, New York, Rogers Fund, 17.142.1.

they provide differs from what Raphael's drawings provide. Thus a large number of drawings exists by Pisanello and his studio (most of them in the Musée du Louvre, Paris) some of which can be linked with his known paintings, but the survival rates of the latter are so slim that the connections that can be made between them are, inevitably, limited in scope. Pisanello's contemporary Jacopo Bellini left two albums of drawings (Louvre, Paris; British Museum, London), but their status and purpose is problematical—their purpose may be archival more than creative because very few of them can be connected with known or projected paintings.

The most immediate forerunner of Raphael was of course, Leonardo da Vinci, whom Raphael knew and whose significance for him was enormous. Hundreds of pages of scientific writing by Leonardo are known, many illustrated with diagrams and small sketches, sometimes of exquisite delicacy. But drawings by Leonardo demonstrably made for pictorial projects are comparatively few (fig. 1). And while, of course, they vary in technique and medium, it seems doubtful whether Leonardo made as systematic use of graphic preparation in different media for his paintings as did Raphael. Conclusions about Leonardo's draftsmanship can be no more than provisional: it is clear that a very large number of his drawings are lost. But the impression created by those that survive is that, increasingly as he grew older, while the process of design stimulated him profoundly and while the detailed work on the pictorial surface preoccupied him, the intermediate stages were not prepared with the same degree of precision and detail as those of Raphael.

Leonardo, however, was recognized even within his lifetime as something of a dilettante, a man who found it very difficult to finish his work. Leo X famously said of Leonardo that he worried about the varnish before beginning the painting. And Leonardo's ceaseless desire for experiment, to the detriment of craftsmanship, has meant that many of his works have survived, if at all, in poor condition. The *Last Supper* (Santa Maria delle Grazie, Milan), for example, began to crumble from its wall as soon as it was completed. And since Leonardo took some four years to paint an area that a Raphael would have finished in a few weeks, it is evident that he did not approach the younger man's decisiveness.

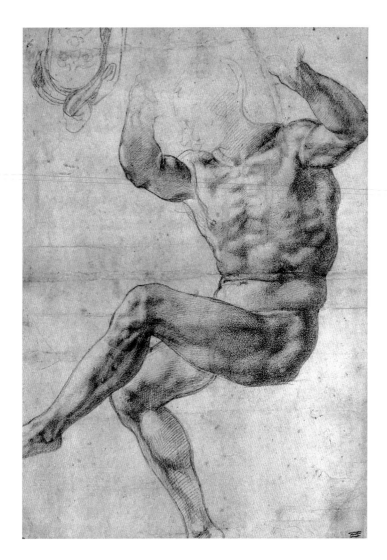

Michelangelo is a different case. Some six hundred sheets of drawings by him survive, but from a career nearly four times as long as Raphael's. And they include many of rudimentary practical type, such as outline drawings for blocks, not found in Raphael's oeuvre. Michelangelo is known to have destroyed piles of his own drawings and he no doubt made many thousands, but in no case that survives can he be shown to have employed media with the same sense of system as Raphael. In his preparatory drawings for the unrealized *Battle of Cascina* fresco in the Palazzo Vecchio in Florence, for example, he used soft chalk for the background figures and chalk handled more sharply and less atmospherically for some of those in the foreground. For pivotal figures in the composition he made drawings in closely hatched pen, sometimes with the addition of white body color. But one never finds in the preparatory studies for any single work the range of media employed by Raphael. Similarly, Michelangelo's preparatory drawings for the Sistine ceiling display a variety of media, but they seem to correspond to his development as he worked his way along the ceiling rather than being directed to the production of a specific image. In the early stages of work, Michelangelo primarily used black chalk for figure studies and brush and wash over penwork for draperies, but he gradually came to realize that the tonal range and the precision of red chalk was more effective for unifying figures and forms, and in the later part of the ceiling he largely switched over to that. He used red chalk in different ways, sharply pointed and applied in fine hatching for figures designed to protrude in relief, more broadly and pictorially for figures planned to lie in the plane of the vault (fig. 2). But on Michelangelo's part this method of working responded to an instinctual drive as much as an intellectual conceit, and to his innate desire to make the single figure

his primary expressive vehicle. While Michelangelo painted great multi-figure compositions later in his career, he never attempted the combination of spatial depth and complexly related actors that Raphael achieved in his mid twenties in the *Disputa* or the *School of Athens* in the Stanza della Segnatura.

Unlike Leonardo, Michelangelo was an impeccable craftsman whose works have survived in good condition, but neither came from families with any artistic tradition or that had displayed any interest in the visual arts. Raphael, in contrast, sprang from such a workshop. The family into which he was born and brought up was both typical and atypical. His father, Giovanni Santi, a late starter as a painter, ran a small business in Urbino that served the local population and its hinterland in routine tasks but one also in contact with, and patronized by, the local court, that of the Montefeltro. Giovanni emphasized craft above the expression of individual genius. A mediocre painter, he was a more than competent executant, and most of his work has survived in good state. Unusually, Giovanni was also to some extent an intellectual—the author of an enormous narrative poem about the house of Montefeltro—and he had a reasonable understanding of both the political and the artistic worlds of his time. Furthermore, although the poem is not particularly good, its thematic scope and development does demonstrate a level of education above that of the average artist, and its length argues both persistence and application. The lessons Giovanni could inculcate were intellectual, political, and literary as well as pictorial. In addition, his painted production, while not distinguished, is not simply repetitive. It displays both ambition and an inquiring and comparatively wide-ranging mind. Giovanni looked closely at Northern art, present in Urbino in the paintings of Justus Van Ghent, and he knew well the work of Piero della Francesca, Uccello, and, of course, Perugino, as well as some of the developments of the brothers Pollaiuolo. Giovanni Santi's late work might indeed be described as a fusion of Perugino and Pollaiuolo.

We have little knowledge of Giovanni's draftsmanship. The only secure drawing by him to survive—and even that is sometimes denied him on the grounds that it is of better quality than his paintings—is a densely worked and highly competent *modello* for his painting the *Muse Clio* (fig. 3). Interestingly, the source of this figure's pose is to be found in work by Piero Pollaiuolo. Although an isolated survival, this drawing is not without significance. It demonstrates at least part of what Giovanni Santi could have taught his son. Raphael would have been introduced very early to the careful preparation and effective production of paintings and would also have gleaned some idea of the range of both pictorial and intellectual ambition that an artist might have. It is clear from Giovanni's chronicle that the artist he most admired was Mantegna, the most erudite painter of the quattrocento, a great expert on antiquity and the ornament of a much-admired court for which Giovanni himself briefly worked. Erudition, particularly about the art and architecture of classical antiquity, was to become one of Raphael's greatest strengths during his later period in Rome.

The craftsmanly side of Raphael's education would have been reinforced by his subsequent education. Vasari's affecting story—that Giovanni Santi, realizing he could teach his son no more, sent him to train with Perugino, the most eminent and successful contemporary Umbrian painter—has often been queried, on the grounds that Giovanni died when Raphael was eleven and that this would have been too early to send the boy away. But apprentices could be put with a master at eight or nine; at eleven, children in the United Kingdom go to secondary school and, often, to boarding school, separated from their parents for long periods. There is nothing inherently improbable in Giovanni's consigning his son to Perugino before his death, especially since everything in Raphael's later career suggests that he was dramatically precocious. Whatever the precise relation between

Raphael and Perugino, never satisfactorily elucidated in detail, he seems to have worked closely with the older man. But it must not be forgotten that Raphael had not only the advantages of a natural genius, but a further advantage over most youngsters—even Michelangelo, who entered Ghirlandaio's shop at no older than twelve—in that he would have learned to handle drawing and painting instruments virtually from birth. Raphael's period with Perugino, which need not have been continuous, was probably more in the nature of finishing schooling than full training. Filippino Lippi's sojourn with Botticelli might be analogous.

Perugino ran an efficient shop, which worked widely within and without his native town, Perugia. The 1490s was one of his most successful periods; he probably worked in Rome, where he had executed some of the most important parts of the fresco cycle in the Sistine chapel in the previous decade, as well as in Venice and Florence and in the communes of Umbria, Tuscany, and the Marches. But despite his great reputation, he increasingly contented himself with a recycling of figures and compositions, and while his style underwent a significant change after 1500, this involved the enlargement of figures, broader paint application, and the reduction of modeling and color-range rather than any fundamental change in principles of design or in his figure types. Innovation was not on Perugino's agenda, whereas it had been something for which, however inadequately, Giovanni Santi strove. Given the relative repetitiveness of Perugino's work and his general eschewal of complex composition, it is evident that elaborate and varied graphic preparation was not high among his priorities nor needed to be. Cartoons were frequently

Fig. 3
Giovanni Santi. *Modello for the Muse Clio*, c. 1485, brush and wash with white body color on green prepared paper, 248 x 179 mm. The Royal Collection Her Majesty Queen Elizabeth II.

re-used and there is a sense in some of his work of templates being employed. There are of course, exceptions. Every now and then an artistic challenge—or larger than usual pecuniary incentive—seems to have fired Perugino's enthusiasm and he would produce careful and sharply focused studies. Thus for the panels of a polyptych executed for the Certosa of Pavia in the later 1490s, when Raphael may well have been in his studio, he made several fine preliminary studies. One, a silverpoint drawing on pink ground of *Tobias and the Angel Raphael* now in the Ashmolean Museum and once owned by Wicar (fig. 4), represents a type that influenced Raphael. After establishing the grouping, working from two models rather than from rote, Perugino added smaller sketches around the edges of the sheet in order to refine specific details. In this respect he behaved exactly as did Raphael when he employed the same medium and color of ground a dozen or so years later in the drawings for the *School of Athens* (fig. 5). The result, in Perugino's work, is one of his most solid and appealing paintings, now in the National Gallery, London. But notwithstanding that there must be great losses, it seems evident that such studies are in the minority in Perugino's later work and that this example represents an unusual exercise of care from an artist who seems gradually to have regressed to the comfortable role of a successful craftsman. One vital negative lesson that Raphael would have learned working with Perugino was the danger of allowing routine production to deaden creative intelligence.

At the age of seventeen, in December 1500, Raphael received his first documented independent commission, for one of the two largest altarpieces he was ever to paint: the *Coronation of Saint Nicholas of Tolentino* for San Agostino in Città di Castello (fragments now in Pinacoteca Tosio Martinengo, Brescia; Louvre, Paris; Museo Nazionale di Capodimonte, Naples) where he may already have executed a double-sided banner for a confraternity. A preparatory drawing in Lille (fig. 6), which unfortunately could not be included in this exhibition, establishes the layout. This commission need not indicate that Raphael had severed all contact with Perugino's studio. Indeed, the *Mond Crucifixion* in London (National Gallery), whose stone frame—still in San Domenico in Città di Castello—is dated 1503, is in some ways more Peruginesque than the surviving fragments of the *Saint Nicholas*. Nevertheless, this

Fig. 4
Pietro Perugino. *Studies for Tobias and the Archangel Raphael,* c. 1496, silverpoint on cream prepared paper, 238 x 183 mm. The Ashmolean Museum, Oxford.

Fig. 5
Raphael. *Studies for the School of Athens,* c. 1509–10, silverpoint on pink prepared paper, 278 x 200 mm. The Ashmolean Museum, Oxford.

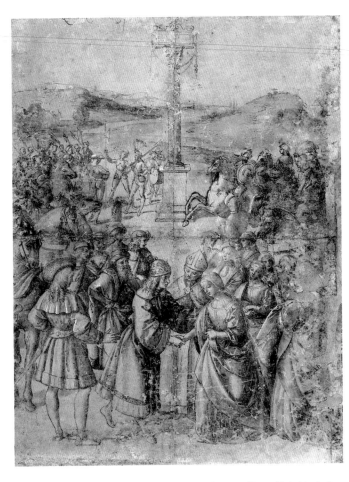

Fig. 6
Raphael. *Study for the Coronation of Saint Nicholas of Tolentino*, 1500, black chalk, 400 x 263 mm. Palais des Beaux-Arts, Lille.

Fig. 7
Raphael. *The Betrothal of Frederick II and Eleanor of Portugal*, c. 1503–4, pen and ink over stylus, brush and wash and white body color, 545 x 405 mm. The Pierpont Morgan Library, New York, 1996.9.

project does suggest that he was now operating in an elastic relation with the studios of his Umbrian elders and establishing an individual reputation. A document of 1505, which seems to refer to an opinion held already in 1503, describes him as the best painter in Perugia; traces of his influence—as opposed to that of Perugino—can be found in Perugian paintings from 1504 onward. Of particular significance is that Vasari records Raphael as having made drawings to assist Pintoricchio with the design of his frescoes of the life of Aeneas Sylvius Piccolomini, Pope Pius II, in the commemorative library built by his family attached to the cathedral of Siena. There seems to be no earlier case of a young artist providing designs for a much older, vastly experienced one, and if Vasari's account and the surviving drawings did not confirm each other, no art historian would have dared propose such a collaboration. It is not clear whether Raphael provided designs for all ten historical scenes in the interior, but modelli survive by his hand for two of them (fig. 7), a copy of a lost modello for a third, and a preparatory sketch for a figural grouping in a fourth, plus other sketches connected with the basic organization of the frescoes. Additionally intriguing is that another modello, conforming with the others in size and medium but preparing a scene that was not finally included, was known to the Sienese painter Sodoma when, between 1505 and 1508, he was executing the cycle of frescoes devoted to the life of Saint Benedict in Monte Oliveto Maggiore, for he employed Raphael's idea in two of them.

By October 1504, when he made his move to Florence, where he was to spend much, but by no means all, of his time for the next four years, the twenty-one-year-old Raphael was a painter whose work was widely sought by patrons in Umbria and a designer to whom other artists went for assistance. Within the conservative atmosphere of Umbrian painting, where the example of Perugino was dominant and all-pervasive, and where even a painter of individuality and strength like Lo Spagna was unable to break free from his patterns, Raphael must have realized that a move was essential.

<p style="text-align:center">III</p>

The two minds from which Raphael learned most during his Florentine period were those of Leonardo and Michelangelo. He was certainly acquainted personally with Leonardo, who was in Florence for considerable periods during the years 1504–8, and Raphael gained at least occasional access to his drawings. It is probable that he was also, for a time, closer to Michelangelo than their subsequent hostility might lead one to think, even though Michelangelo spent only one extended period in Florence during these years, six months in 1506. As well as copying sculpture by Michelangelo both publicly visible and privately owned, it seems that Raphael also knew some of his drawings. But these great models posed problems for a young artist desirous of maximizing his opportunities to produce. Neither Michelangelo nor Leonardo provided guidance in the organization and execution of most of the types of fresco schemes that Raphael might be required to execute, nor would either have much encouraged antiquarian ambitions. Furthermore, both were artistic personalities of such power that any ambitious youngster would have to avoid falling under the spell of either. Only a few years after Raphael arrived in Florence, Andrea del Sarto—three years younger than Raphael—found himself in an analogous position. He also learned from both Leonardo and Michelangelo but took care to follow neither too closely. Revealingly, he was guided in this by the example of Raphael, whose forms and color range he imitated in some of his earliest Madonnas.

In addition to Michelangelo and Leonardo, among his contemporaries Raphael looked to Fra Bartolommeo, with whom he became friends, according to Vasari. That account is plausible because nearly a decade later, when the Frate left a painting unfinished in Rome, Raphael completed it. Vasari says that Raphael learned about perspectival organization from Fra Bartolommeo, and while he would hardly have been a novice in this area, it is likely that his friend's example deepened his awareness. The great *Last Judgment* in San Marco (see fig. 10, cat. 10), which created a simulated apse that seems to open out from the wall, with unerring foreshortening, was an important exemplar for both the San Severo *Trinity* in Perugia (see fig. 31b) and the *Disputa*. Acquaintance with the working procedures that the Frate had employed in this painting in particular would also have reinforced Raphael's practice of extensive preparation. While Fra Bartolommeo was nothing like so versatile an artist as Raphael and while his work developed along fairly constrained lines, by 1500 he had produced a number of magnificent and innovative black chalk drawings whose power is still apparent (cat. 10). Raphael had already employed soft black chalk in his Umbrian work, but the Frate's magnificent drapery studies—in which great sweeps of light and shade, and the vibration of particles of light within the shadows, establish simultaneously grandeur and local sensitivity—would have alerted Raphael to a potential not previously appreciated. He would also have become aware of the capacity of black chalk for evoking the softness of flesh. Like Fra Bartolommeo's, some of Raphael's most charming studies of infants are executed in black

chalk, with filmy rubbing evoking the light on skin, and it is not surprising that a few drawings of this type have been disputed between them.

It should also be observed that in this period of Fra Bartolommeo's career, his graphic preparation was more technically varied than it later became. For the *Last Judgment* he employed metalpoint and white heightening, pen, black chalk by itself or with added white body color, and studies in tempera on linen. It is true that within these media his command was not as great as Raphael's and that to evoke solid form with a few silverpoint lines was beyond him. Similarly his pen drawing tends toward softness, evoking physical form competently but without the dramatic internal contrasts that infuse Raphael's work with such power. Bartolommeo is said by Vasari to have burned his studies of the nude on one of the Savonarolan bonfires of the 1490s, and when he returned to painting after the completion of his novitiate, he largely abandoned life study. Nevertheless, his preparation for the *Last Judgment*—for which some sixty drawings survive—marks a high point of variety and intensity in his graphic production and the fact that it is overshadowed historically only by Raphael's preparation for the *Disputa* is also a testimony to the Frate's achievement since Raphael's creation would hardly have been possible without his example.

In addition to contemporaries, Raphael also looked to the work of the preceding generation. Filippino Lippi had died only six months before Raphael came to Florence, and his last, unfinished, work was in the process of being completed—to universal dissatisfaction if not derision—by Perugino. This response would have taught Raphael another lesson: what Perugino could get away with in Umbria would catch up with him in the tough artistic climate of Florence. But Raphael would have realized that Perugino was not representative, and that there was still much to be learned from the great Florentines of the later quattrocento. Indeed, he had encountered—and responded to— the work of Filippino Lippi and Ghirlandaio while still in Umbria.

The major Florentine artists of the last third of the fifteenth century had, in some areas, made considerable advances on the work of their great predecessors. To simplify, the prime achievement of the early Renaissance in Florence, in the period around 1420, was to realize a species of what in linguistic theory is called a double articulation, of phonemes into words and words into sentences. In part inspired by classical statuary, but also by life-study, Donatello had produced figures of hitherto unseen mobility and life-likeness. He had, that is to say, greatly extended the expressive range of the realistically portrayed human body, both draped and nude. Complementing this was Brunelleschi's invention of perspective, which provided a spatial theater within which the forms pioneered by Donatello could move and have their being. Thus it was possible, by the mid 1420s, to place recognizable human figures playing legible roles in precisely measurable—even illusionistic— space if the artist so desired. Such possibilities were realized by the single most significant painter of that decade in Florence, Masaccio, in his frescoes of the *Lives of Saints Peter and Paul* in the Brancacci chapel in Santa Maria del Carmine and the *Trinity* in Santa Maria Novella. Masaccio's achievement was recognized by Leonardo, who wrote of him as the great restorer of painting, and he was effectively canonized by Vasari. But Masaccio was an exacting model. His emotional grandeur was conveyed by massively draped stately figures with impassive expressions making simple memorable gestures; in this Masaccio owed much to Giotto, for Masaccio too looked to tradition. What was often missing from Masaccio's work was particularization and detail, the precise delineation of expressive heads and expressive hands. Even Masaccio's most closely observed gestures have a

distanced, normative, quality, and even the most realistic heads in the Brancacci cycle—as precisely delineated as contemporary Flemish portraiture, examples of which he no doubt knew—are autonomous and play small expressive role in the compositions they attend. And Masaccio's devotion to three-dimensional form counted against surface patterning. Whereas Masaccio's work was infinitely more significant for the future development of painting than that, say, of Lorenzo Monaco or Gentile da Fabriano, they could explore, respectively, dramatic compositional patterns and refined and decorative detailing that Masaccio could not.

One of the efforts of Florentine artists of the generation following Masaccio was to combine his majestic and austere organization and forms with a greater variety and detail. Filippo Lippi, for example, created more homogeneous tonal organizations—an approach that had a pronounced effect on Leonardo—and also endeavored to soften his figures, to make them more tender and mobile, and to increase the range of textures of their draperies. Castagno, a painter of an austerity comparable with Masaccio's, took another route. He emphasized the intensity of sharp contour and aggressive plasticity, as opposed to the evocation of bulk and mass upon which Masaccio had concentrated. While he did not flatten his compositions in the manner of Lorenzo Monaco, Castagno generally set his figures in relatively shallow space, so that their gestures could tell more emphatically across a surface.

Both trends, that of Filippo and that of Castagno, were combined in the work of one of the most productive, powerful, and inventive painters of the next generation, Sandro Botticelli. A pupil of Filippo Lippi and the master and guardian of his young son Filippino after Filippo's death, Botticelli was equally attentive to the tender expressions and diaphanous textures of Filippo, and the vigorous and rigorous design of Castagno. But in his earlier work Botticelli was more concerned with the precise definition of space than either. In his paintings of the *Adoration of the Magi* in London (National Gallery), Florence (see fig. 1, cat. 1), and Washington (National Gallery of Art), he created meticulously calibrated spatial ensembles, in which figures and animals find convincing place. On these stages, figures interact with a freedom and vigor not previously seen even in the most ambitious reliefs of Donatello or Ghiberti: body movements, hand gestures, angles of heads, and facial expressions combine in vivacious dialogues. The firmness of spatial structure in such paintings, and the comparative geometric relaxation in the organization of their casts—interacting individuals and groups rather than chorus lines—set a model that Leonardo was to pursue on a larger scale in the San Donato a Scopeto *Adoration* and that Raphael was to bring to fruition in, above all, the *School of Athens*. It is emblematic of Botticelli's significance that his study for two of the figures in the Del Lama *Adoration* at Lille (cat. 1) should approximate to the angular handling of figures characteristic of Castagno, while enhancing their comparatively stiff forms—conceived as such because they frame the composition and do not play central roles—by a precise study of the rear figure's hand. The minor pentimento at the upper left side does not much alter the stances of the two figures but brings them closer together by a feature that catches the eye in its complex sculptural form and is closely focused in its psychological expression. It is doubtful whether any earlier artist would have been so conscious of, or so attentive to, the structure of the hand and the semantic possibilities of its fingers.

Botticelli continued to draw and paint some of the most expressive and eloquent hand gestures in the entire history of Western painting. Yet while he never lost his competence at perspectival

construction, it came to play a lesser role in his art, giving way to surface-stressing arrangements in which emotional communication was paramount. Still active while the young Raphael was in Florence, the elderly Botticelli had moved further into areas of distortion that attain, on the one hand, the ethereality of Lorenzo Monaco—whose work he reconsidered—and, on the other, the painful intensity of a Schongauer. Botticelli's decline of interest in perspective was echoed by Michelangelo—who remarked to his pupil Tiberio Calcagni that he had never been much concerned with it—and Botticelli's expressive hands and fingers fed into this major interest of both Michelangelo's painting and his sculpture. Naturally it affected also Raphael's work, and while no copies are known by Raphael after Botticelli, that he made them seems inescapable. It has been plausibly proposed that the background of Raphael's *Knight's Dream* (National Gallery, London) reflects that of Botticelli's *Cestello Annunciation* (Galleria degli Uffizi, Florence), and whether or not that is accepted, the concentrated studies of hands and fingers found among Raphael's Florentine drawings are barely conceivable without Botticelli's example.

Filippino Lippi, the son of Filippo and the pupil of Botticelli, had a double heritage. One of his first commissions was the completion of the frescoes in the Brancacci chapel—its demands may explain why Filippino did not accompany Botticelli to Rome in 1481 to collaborate on the prestigious cycle of frescoes on the walls of the Sistine chapel. Who commissioned the completion of the Brancacci chapel or why is not known, but Filippino might have been chosen because his father, resident in the Carmine when Masaccio was working there, was thought to have participated in its execution. Filippino's completion is remarkably successful: although he did not attempt to pastiche Masaccio's style, let alone that of Masolino, he produced effectively grand and stately groupings. But his subsequent work, even in fresco, departs from this grand manner. Whereas Botticelli, until his last years, aimed to combine expressiveness with grace and elegance, and was particularly concerned that his groupings should read clearly on the surface, Filippino was more daring, aiming at times for compositional disharmony, even awkwardness, in his arrangements (cat. 3). He was, of course, capable of devising grand figures in complicated poses, which did not pass unobserved by either Michelangelo or Raphael, who copied at

Fig. 8
Raphael. *Copy after Jacob by Filippino Lippi in the Strozzi Chapel, Santa Maria Novella,* c. 1507, pen and ink, 140 x 205 mm. Musée du Louvre, Paris, 3848.

least two and probably all four of Filippino's seated *Prophets* on the vault of the Strozzi chapel in Santa Maria Novella (fig. 8). But even here, Filippino exasperated the contours of his figures with broken drapery edges and undermined coherent plasticity by waves of complex folds. This sense of disruption was combined with an extensive focus on the eccentric—rather than the heroic—aspects of classical antiquity, more than was displayed by any Italian contemporary: massive pilings-up of antique architectural forms in unnatural relations; fancifully decorated pseudo-antique armor; figures borrowed from antique sarcophagi but whose proportions are altered and made anti-classical; exaggerated coiffures in parody of antique types. It is as though Filippino felt the urge to subvert Florentine art, even the heroic aspect of the antique, to pursue an art that privileged movement, energy, and entropy. Filippino was followed in some respects by Piero di Cosimo and, to a lesser extent, by Raffaellino del Garbo (cat. 8), after which his influence gradually fades out. However, Filippino was still being copied c. 1540, for a sheet in the Louvre (10487) bears on its recto a detail from the Strozzi chapel and on its verso a copy after a fresco by Beccafumi of c. 1535. Furthermore, certain aspects of Filippino's approach were taken up by Giulio Romano, who would have known Filippino's work in Rome if not in Florence. The way in which Giulio disrupted his master's schemes in the years immediately following Raphael's death resembles Filippino's treatment of the Masaccesque tradition, and Giulio too pursued Filippino's vitalist approach to the art of classical antiquity.

Giulio would no doubt have seen his master's copies; that Raphael's interest in Filippino's work was aroused while he was still working in the orbit of Perugino is clear. A study of a seated figure in the Ashmolean (fig. 9), drawn in a broad pen, with jagged strokes, is hardly conceivable without Filippino's example, and the same sheet carries forms loosely based on a design made by Filippino for his father's memorial in the Duomo of Spoleto, the site of Filippo's last great fresco scheme. A certain elongation found in some of Raphael's figures c. 1504 may also be a response to Filippino, whose work was probably among the attractions that drew Raphael to Florence. If so, it was not to persist, and although a few compositional ideas derived from Filippino occur in Raphael's art, he was not to be a primary model for Raphael. But Filippino's penwork retained an appeal, and the more

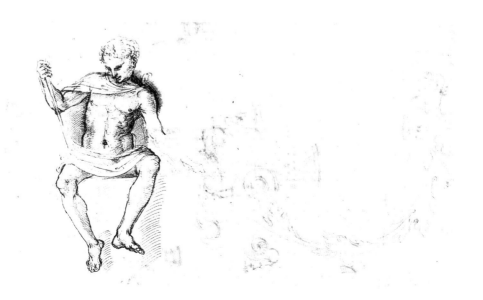

Fig. 9
Raphael. *Figure Study,*
c. 1503, broad pen,
219 x 377 mm.
The Ashmolean Museum,
Oxford.

energetic pen drawings of Raphael's Florentine period, such as his *Battle Scenes* of c. 1507, reflect Filippino's love of action and uncontrolled jerky movement.

Raphael also had strong allegiance to the Masaccesque tradition. Its primary exponent in late quattrocento Florence was Ghirlandaio, who executed a wide range of work both in and outside the city. One of his paintings destined for Umbria, the *Coronation of the Virgin* of 1486 at Narni (Palazzo Comunale), had a widespread reputation and was much copied and adapted there. It was proposed to Raphael as the example—rather than the model—for the *Coronation* he contracted to paint for the nuns of Monteluce in 1505 (Pinacoteca, Vatican), so he was already well aware of aspects of Ghirlandaio's work. But Ghirlandaio's great fresco schemes in Santa Trinita and Santa Maria Novella must have excited Raphael. They were the most profound and recent restatements of Masaccism and Raphael no doubt studied them intensively. Certain elements from Ghirlandaio's work recur in Raphael's fresco schemes until a quite late point in his career: the figures entering the field from beneath in the *Coronation of Charlemagne* of c. 1516 (Stanza dell'Incendio, Vatican), for example, seem to owe a debt to Ghirlandaio's *Confirmation of the Franciscan Rule* of c. 1482 in Santa Trinita. Ghirlandaio, while working in the tradition of Masaccio's stately forms, also enlivened them by more precise concentration on details of heads and hands.

Ghirlandaio and Filippino were useful for Raphael in another way. They demonstrated to him what he might have found—in a small way—in his father's workshop, but not in Perugino's—a genuinely creative approach to studio production. This was particularly the case with Ghirlandaio, an immensely productive fresco painter unafraid even of the largest tasks. He employed many assistants, and even though he kept them under tight control, he seems to have got the best out of them. Although he must have made drawings in great numbers, relatively few survive—the most recent catalogue numbers about forty. Yet even from them it is clear that his graphic preparation was of a systematic but enlivening kind. Drawings survive in all the main media employed at the time: metalpoint, sometimes heightened with white body color, sometimes not; pen and different shades of ink, sometimes on colored grounds, sometimes on white paper; brush and wash, generally combined with pen work, but not invariably; black chalk, again sometimes used in combination, but also separately.

Ghirlandaio was much more than a draftsman of competence. While his graphic work is end-directed, the journey was as important to Ghirlandaio as the arrival, and within his practical aims, real sensitivity, real innovation, are continually apparent. Furthermore, he seems to have been a draftsman who liked to experiment with a range of techniques, setting drawings of different techniques against one another to enliven his creative procedures. Drapery studies might be prepared in closely hatched pen and ink, like that in Lille (cat. 7), or in quite tightly hatched black chalk. Head studies and portrait heads can be drawn in a dense uninflected silverpoint technique or else lightly sketched-in with the stylus and worked up with white body color in both streaks and patches. In contrast to Filippino, for example, whose graphic work, while intensely vital, falls into a limited number of types, Ghirlandaio's drawings differ considerably from one another and were widely influential. His densely crosshatched pen work anticipates that of Michelangelo, for a while his pupil, and his more lightly hatched pen drawings, in which he tends to use accentuated diagonal strokes to produce loosely diamond-patterned surfaces, were taken up by the young Fra Bartolommeo, who may also have spent some time in Ghirlandaio's workshop. Some of Ghirlandaio's preparatory studies are drawn in a very abbreviated pen technique, which certainly

affected Michelangelo, whose sketchy pen drawings made even after 1500 preserve traces of his tricks of handling. And so too do some of Raphael's sketchier compositional studies. Indeed, a degree of direct knowledge of Ghirlandaio's drawings can be assumed. At Chatsworth is a page of replicas of lost drawings by Raphael, the largest and most important of which is a close copy after Ghirlandaio's *Maidservant Pouring Water* now in the Uffizi, one of the developed preparatory studies for the *Birth of the Virgin* in the Tournabuoni chapel of Santa Maria Novella. Raphael adapted this figure for that of the Magdalene in the *Entombment*. And Ghirlandaio's technique in the Uffizi drawing, a more relaxed version of the Lille drapery study (cat. 7), offered Raphael another, less obsessively elaborated model for crosshatched pen drawing than Michelangelo. Dead for a decade by 1504, Ghirlandaio was still, among all the artists who would have come into Raphael's ken when he was in Florence, the model for that combination of creativity and control required for the tasks that confronted him when he removed to Rome in mid 1508.

<div align="center">

IV

</div>

Raphael's graphic work up to around 1512, and as represented in the collection at Lille, synthesized all the trends individuated here. He was intensely competitive, but it would be a mistake to think of his approach as merely competitive. He wished to make himself the master of all the techniques available, both to assist in the production of works of different kinds and styles, for he was in constant stylistic change, and to open for himself paths that he might not initially have been able to foresee. Gradually, following the completion of the Stanza della Segnatura, Raphael seems to have economized more on preparation, and it is clear that, from around 1514–15 onward, he turned some of the preparatory work for his compositions over to assistants. The extent of their input no doubt varied according to the amount of time the killingly overworked Raphael had at his disposal. But even allowing for a reduced output of drawings, it is evident that losses among them are comparatively much higher than for the earlier work. The reasons can only be conjectured, but the survival of a large number of drawings made by Raphael in Umbria and Florence was likely due to their preservation by his Umbrian friends, who no doubt worked with him. Some of them continued to have access to his work during his early years in Rome. Berto da Giovanni, for example, demonstrably knew preparatory studies by Raphael for the *School of Athens,* and Timoteo Viti—who possessed a large collection of drawings by Raphael—is recorded by Vasari as having frescoed the *Prophets* at the upper level of the Chigi chapel in Santa Maria della Pace. The collection at Lille contains no authentic drawings by Raphael datable after about 1513, and even when Wicar's collection as a whole, before the losses, is taken into account, it is doubtful whether the picture would have been radically different. Thus two significant types of drawing by Raphael cannot be illustrated in this exhibition: his work in black chalk and in red chalk, both media that assumed a proportionally larger role in his later work.

Raphael had employed black chalk from his earliest drawings and the various ways in which he used it are reasonably covered in the present exhibition. He continued to employ it both tightly and loosely for figure and drapery studies until early in the second decade. But in preparing the frescoes in the Stanza d'Eliodoro, he indulged himself with freer, rangier chalk drawing than before, with powerful, broad contours and internal modeling partly obtained by stumping in a manner that creates a strongly pictorial smooth effect (fig. 10). Although related to his black chalk studies for the figures in the upper level of the *Disputa,* this style goes beyond those drawings in freedom

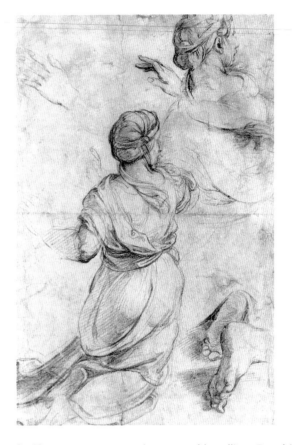

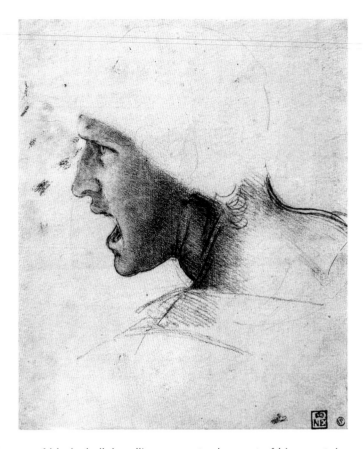

Fig. 10
Raphael. *A Startled Woman, Study for the Expulsion of Heliodorus,* c. 1512, black chalk, 395 x 259 mm. The Ashmolean Museum, Oxford.

Fig. 11
Leonardo da Vinci. *Head of a Warrior for the Battle of Anghiari,* c. 1504, red chalk, 227 x 186 mm. Szépmüvészeti Múzeum, Budapest, 1774.

and energy of handling. But this type of black chalk handling seems to drop out of his repertoire thereafter and does not recur until the studies made at the very end of his life for the *Transfiguration* and the frescoes in the Sala di Costantino. The auxiliary cartoons of heads for the former attain a combination of breadth and precision reminiscent on the one hand of Titian and on the other of Rembrandt, and the vaporous handling of the figure studies for the latter can at times remind one of Prud'hon; but this too can be found in embryonic form in the studies for the upper level of the *Disputa.*

For much of the period 1514–20, Raphael seems to have relied most heavily on red chalk, employed only rarely in Florence and his first years in Rome. It is generally accepted that red chalk was introduced to Italy by Leonardo in the 1490s, and it seems certain that he was the first Italian artist to make extensive use of it (fig. 11). Raphael's c. 1510 Lille study for the *Alba Madonna* (National Gallery of Art, Washington), which cannot be included in the present exhibition, probably reflects Michelangelo's rather open employment of the medium in his sketchier drawings (fig. 12). But this use of red chalk, while effective, does not exploit its capacity either for density or softness. Raphael does not seem to have returned to red chalk in any focused way for three or four years after the *Alba* study. But he then saw, perhaps again affected by Michelangelo's more fully worked studies, that red chalk was an ideal instrument for representing the nude body, and he used it extensively for this purpose in drawings for the Stanza dell'Incendio, the Psyche Loggia (fig. 13), and the nude figure studies—but not the draped ones—for the *Transfiguration.*

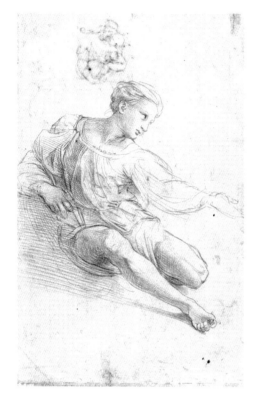
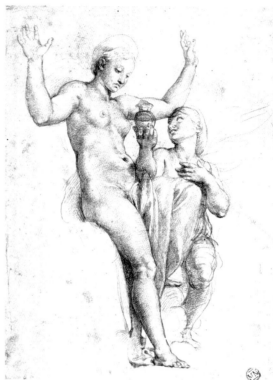

Red chalk could take a sharper, harder point than black chalk but it contained similar possibilities of continuity. It had more limited tonal range overall, but it stretched more widely in the half tones. It thus combined the tonal qualities of multi-media drawing like metalpoint with white body color on prepared ground—and Raphael occasionally used red chalk on gray washed paper—or brush and wash drawing. It retained the precision of pen and metalpoint when that was required but it could be blurred or fused when that was required. Some of Raphael's red chalk drawings of this period are very densely handled, some are quite open. One red chalk drawing at Lille by his pupil Giulio Romano does indicate some part of what Raphael could attain (cat. 49). But, finally, although he produced some red chalk drawings of extraordinary—indeed incomparable—beauty and some also of great freedom, Raphael did not explore the possibilities of the medium as fully as some of his juniors. Red chalk seems for Raphael to have functioned as a synthetic medium and substitute for other media that he would previously have employed in combination or in sequence. Of course, had he been granted more time, Raphael might have taken it further and in new directions. The work of a man who dies at the age of thirty-seven is interrupted.

V

It is in Florence that development of red chalk was taken furthest and fastest. The prime agent seems to have been Andrea del Sarto. Fra Bartolommeo of course made efficient use of red chalk, but he employed it quite densely, without especial flair. Andrea on the other hand saw new possibilities both in red and black chalk, using both in a way that might loosely be compared to drawing in broad pen. It is significant that, of the relatively few pen drawings by Andrea to survive, most are made rapidly and

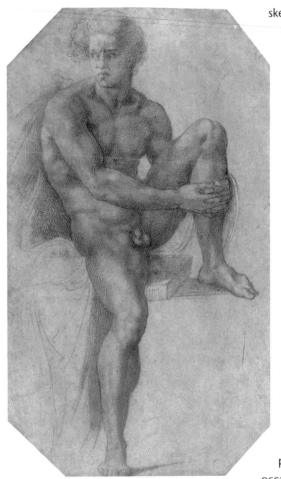

Fig. 14
Baccio Bandinelli.
Study of a Male Nude,
c. 1520, red chalk,
400 x 237 mm.
The Cleveland Museum
of Art, John L. Severance
Fund, 1998.6.

sketchily, with wide lines. The modello for embroidery exhibited here (cat. 52) is a rare exception. It seems likely that he was alerted to the possibilities of this kind of chalk handling by some of Michelangelo's drawings for the Sistine ceiling. As work progressed on that vast scheme, Michelangelo's energies increased rather than diminished, and even when finely finished, his preparatory drawings seem to have been made ever more rapidly. Contours became more emphatic, more variably stressed or broken according to the internal pressure of the form. In drawings of both nude and draped figures, fast and regular hatching in the interiors of the form combine with small areas of stumping to establish the deepest shadows and with zigzag strokes to establish the play of light upon slight changes of plane. Michelangelo's red chalk drawings for the Sistine were of unparalleled flexibility, achieving in a dry medium the speed, authority, and attack previously seen only in the wet medium of pen. And since Michelangelo's chalk line invariably retained more body than all but the broadest pen, and could be controlled much more readily, it communicated an impression of substance and surface texture as well as establishing form.

But while Andrea's starting point as a chalk draftsman may have come from Michelangelo—and it is appropriate that one of his drawings shown here is a copy after Michelangelo (cat. 54)—he developed these insights in a manner entirely his own, producing drawings, primarily in red chalk but in black as well and occasionally employing both on the same sheet, simultaneously structural and pictorial. Whereas Raphael, even in his liveliest chalk drawings, tended to aim for continuity of surface and form, Andrea was not afraid to create form out of juxtaposed patches and lines, strong accentuation, and powerful chiaroscuro. Andrea thought of form as comprising areas of light and shade, as well as the tension between them, before he thought of it as continuous. Even a relatively conventional compositional study such as cat. 53 is assembled out of a honeycomb of different emphases, rather than a form filled in with areas of light and shade.

Andrea's approach was taken further in the work of his remarkable pupil Jacopo Pontormo, an astounding draftsman whose work has been particularly prized over the last century. To Andrea's pictorial application he added more flexible containing contours—he was more interested than Andrea in pure form and less in psychological accentuation, and employed a wider, and wilder, range of hatching techniques. He much expanded Andrea's employment of stumping to create a sheen over the surfaces of flesh, contrasting that with sharp hatching lines to bring various areas of the body into pronounced focus, and added red chalk ground up and applied with water as a wash (cat. 55). More of a formalist than Andrea, looking in this respect to Michelangelo and through him to Botticelli, Pontormo produced some of the most visionary of all Renaissance drawings.

Finally, in contrast to Pontormo and to Andrea del Sarto, Rosso Fiorentino (another of Andrea's pupils) and Andrea's friend the sculptor Baccio Bandinelli were also innovators in the handling of, primarily, red chalk, but innovators of a different kind. Bandinelli introduced a method of handling in which individual strokes of chalk were largely suppressed in order to create broad planes within which occur modulations of extreme subtlety. At its best this method creates an apparently self-formed sculptural image on the page, without hard edges but without that blurring of form seen, for example, in Fra Bartolommeo's most continuous chalk drawings. The effect was achieved in part by the very close side-by-side application of thin chalk strokes, by some very restrained stumping, and in part, probably, by laying all or some of the paper on a lightly roughened support, perhaps a grinding stone, and applying the chalk over that to obtain a granular surface. In the case of Bandinelli, barely active as a painter, this style of drawing was mainly a virtuoso exercise, although the effects he obtained are not without similarities to those of the simplified forms and surfaces of his sculptures of the male and female nude (figs. 14 and 57b). Correspondingly, Bandinelli's drawings tend to emphasize the mass of the form rather than the contour. Rosso, however, often combined this sort of interior modeling with extraordinarily thin contours, of wire-like consistency bounding the form, to produce a high tension between apparently incompatible systems. The planes in such drawings correspond to the diversely colored or toned angularities of Rosso's painting, which gives them an air at once prismatic and luxurious (fig. 15). Bandinelli and Rosso were followed closely by the intensely experimental and mobile Francesco Salviati (cat. 57) whose drawings have on occasion been attributed to both his models—as well as to many other artists.

This is not the place to discuss the further development of, especially, drawing in red chalk by Florentine artists between the second and fourth decades of the cinquecento. It was remarkable and hypersophisticated, but although widely recognized by some art historians and some collectors, its achievements have still not received the credit that is their due: the word Mannerism has not yet entirely lost its deadening weight.

Fig. 15
Giovanni Battista Rosso
[Rosso Fiorentino].
Study of a Female Nude,
c. 1525, red chalk
over traces of black
chalk, 126 x 244 mm.
The British Museum,
London.

Jean-Baptiste Wicar as a Collector of Drawings

by or Attributed to Raphael

Jean-Baptiste Wicar (1762–1834), a draftsman much praised by his master, Jacques-Louis David, was among the most discerning and effective collectors of Italian drawings of his period. He created three successive collections of old master drawings. The first, formed in the 1790s, was in part stolen from him in 1799. A second, brought together beginning in 1801, was mostly disposed of to the English dealer Samuel Woodburn in 1823. The last was built up between 1824, when Wicar recovered many of the drawings stolen twenty-five years earlier, and his death in 1834. He bequeathed his old masters to the museum of his home town, Lille, while leaving many of his own drawings elsewhere. The three collections, therefore, were not entirely separate but overlapped. His group of Raphael drawings is our main concern here.

One of the first generation of David's pupils, Wicar traveled to Italy with his master in 1784 and returned there in 1787. He lived in Florence between 1787 and 1793, executing drawings for a series of engravings of paintings in the city's galleries; the first volume was published in 1789. Previously impecunious, Wicar was well paid for this work and seems to have acquired a reasonable disposable income—in 1792 he sent via David the large sum of 600 livres toward the reconstruction of Lille. It would seem that well before the French invasion of Italy, Wicar "s'était lié d'amitié avec Phillipe Buonarroti, et put alors acheter et choisir un nombre de dessins assez considerable parmi ceux qui avaient été conservé par la famille."[1] If that is correct, Wicar's collection of drawings, or at least his collection of drawings by Michelangelo, was begun in the late 1780s, because Filippo Buonarroti, a perpetual revolutionary, spent very little time in Florence after 1789 and subsequently lived in virtually permanent exile.[2] The relationship with Filippo Buonarroti is a useful indication that in some cases Wicar's political convictions may have helped rather than impeded his acquisition of works of art. Thus he may also have profited from the outbreak of republican enthusiasm in Perugia in October 1797.

Wicar returned to France in 1793 and took his place on the extreme left. He was arrested in 1795 but, after compiling a lengthy self-exculpation, was soon released. He returned to Italy and never thereafter resided in France. He was active from 1797 onward as an adviser for the Napoleonic commission on the sequestration of Italian works of art for the Louvre. He lived in Florence, Naples, and, above all, Rome. The commission concentrated on paintings and sculptures, and few collections of drawings were seized. But Wicar was also active on his own account and by the end of the 1790s had built up a significant collection of Italian drawings. The fate of this collection has been described by many writers, including Samuel Woodburn, Sir J. C. Robinson, and Fernand Beaucamp, but the most complete and circumstantial account is that of Scheller, which included previously unknown correspondence from Wicar himself.[3] Much of the following relies on his article.

Wicar quit Florence in 1798 or 1799, in part because of the fall of the Florentine republic but perhaps also in pursuit of his duties as a commissioner. He apparently left three cases of his possessions—but not, it seems, his entire collection—in the care of one Giuseppe Giustini with whom he

had lodged. Wicar may have left his drawings with Giustini on the understanding that some of them might be sold, and it is possible that some were indeed sold legitimately. Whether or not that is so, however, Giustini passed these cases on, supposedly for better safekeeping, to a father and son named Pampaloni, of whom the son's Christian name was Gaspero. They opened the cases and turned the drawings over to the Florentine painter Antonio Fedi. Wicar's letters of 1801 and another of 1832 indicate that he considered Fedi the real culprit in the matter. To conceal the theft, Gaspero Pampaloni and, presumably, Fedi, ignited the boxes and even went so far as to "recover" a few charred drawings. Wicar initially accepted this evidence as proof that his collection had been destroyed by fire.

Fedi sold an unknown number of Wicar's drawings, primarily, it seems, a group of Raphaels, to the English artist, writer, and dealer William Young Ottley. He certainly sold further drawings by Raphael from Wicar's collection to other collectors—in 1823 Wicar recovered a drawing that he had owned before 1799, Raphael's modello for Domenico Alfani (cat. 34), from his Perugian friend the

baron della Penna who, presumably, had obtained it from Fedi—but Fedi undoubtedly retained the bulk for himself. Ottley returned to England after a long sojourn in Italy in March 1799—he was seen in London in April. It is not fully clear whether Ottley acquired Wicar's drawings directly from Fedi in February 1799 or via an intermediary. One source says that he purchased a group of ex Casa Buonarroti Michelangelos, which may or may not have been owned by Wicar, only in London on his return, and this might have been true of other drawings as well.[4] In his anonymous sale of 1804, however, Ottley does preface the section of Raphael drawings with the statement that he had acquired them in Rome.

Wicar was soon informed by his close friend, the painter Louis Gauffier, of the fraud perpetrated upon him, and he also learned that some of his drawings had been acquired by Ottley. In 1801 he wrote several letters of protest to his friend Humbert de Superville, who he hoped might intervene on his behalf with Ottley, whom Humbert knew. Wicar described the affair and listed some of the drawings he had lost in an *Etat approximatif des dessins*.[5] Before looking at this list in more detail, however, it should be remarked that nowhere in it, or in his letters to Humbert, does Wicar mention drawings by Michelangelo, which Robinson and earlier writers believed also to have been part of Fedi's booty, and sold on to Ottley. In his *Etat* Wicar referred only to the book of architectural sketches that he thought was by Michelangelo but which has now securely been attributed to Raffaello da Montelupo (with a few pages by Aristotile da Sangallo), a book that, with virtual certainty, did not come from Casa Buonarroti.

In his *Etat* Wicar listed thirty-nine drawings or groups of drawings that he believed Ottley might have acquired. Ottley replied via Humbert that he had purchased only some twenty of the drawings by Raphael that had been stolen from Wicar's collection; the remainder, he thought, had probably remained in Florence. Ottley said that he would be prepared to return the purloined drawings to Wicar but required reimbursement. What finally transpired is unknown, but there is no evidence that Wicar pursued the matter further with Ottley, which would have been out of character for a man of his persistence. Perhaps the two reached some form of accommodation. Yet when Ottley included individual drawings that had come from Wicar in his anonymous sales—discussed below—he concealed their provenance. Whether he did so because he did not wish their source to be known or because the issue had already been in some way resolved is a matter for individual judgment.

Wicar prefaced the *Etat* with a brief account of the theft and mentioned that he had reliable testimony that some 150 of the drawings he had owned had been seen in Fedi's possession before the sale to Ottley. Some of the thirty-nine lots that he listed were multiples. The largest and the last, lot 39, was vast, comprising some 300 drawings Wicar said he had acquired from the sculptor, restorer, and large-scale dealer Bartolommeo Cavaceppi. It included works by or attributed to a number of great artists, but not Raphael or Michelangelo. Of the other thirty-eight lots, thirty-one (lots 3–33 inclusive) comprised drawings by or attributed to Raphael. Lot 15 contained four or six (Wicar presumably could not remember) drawings on pink paper; lot 16 included "plusieurs têtes et mains" for the *Disputa;* lot 19 also included "plusieurs études" for the loggia and a sketch for the *Disputa;* lot 20 "plusieurs dessins de son jeune âge"; and lot 21 "plusieurs autres dessins" for the Vatican stanze. Wicar's list, compiled from memory and no doubt in haste, is not always clear. Thus lot 30, which refers to "petites études pour les figures du grand tableau du Palais Pitti," that is, the *Madonna del Baldacchino,* may mean several small sketches on the same sheet or sketches on several sheets. Scheller suggests the "tableau du Palais Pitti" may be a slip for the *Coronation of the Virgin,* for which

Wicar certainly owned several drawings. All told, the number of drawings by or believed to be by Raphael in Wicar's list must amount to at least forty and perhaps as many as eighty, but that group does not necessarily exhaust what Wicar believed to be his collection of Raphael drawings. Wicar might, for example, have been aware that *tranches* of his purloined Raphaels had passed to other collections—for Fedi had not fenced drawings to Ottley alone—and Wicar would obviously not have included those in the list intended for Ottley.

Of the drawings listed, all those that appear to be identifiable were recognized by Scheller and none of them has a known provenance that contradicts Wicar's ownership; most confirm it. The majority of the drawings are either at Lille or Oxford; the remainder, in other collections, have Ottley-Lawrence [Sir Thomas Lawrence, see below] provenances or, in four cases (a pen drawing in Montpellier and three silverpoint drawings on pink or off-white paper now in Cleveland, Rotterdam, and London) provenances from, respectively, the artist-collectors François-Xavier Fabre, Pietro Benvenuti, and Vincenzo Camuccini.[6] All three were contemporaries of Wicar and Fedi, probably acquiring the drawings directly or indirectly, by purchase or gift, from one or the other. Of course, by the time Wicar's third collection came to Lille, it included a number of Raphael drawings not mentioned in the 1801 list, some of which might have been acquired for the first time by Wicar only after that date. Furthermore, it seems clear that when Wicar sold his collection of Michelangelo drawings to Samuel Woodburn in 1823, he also included in the sale a number of drawings attributed to Raphael. But even then, a year before he had recovered most of his first collection from Fedi, Wicar retained some drawings by his favorite master, since Woodburn wrote to Lawrence that it would be impossible to obtain further Raphaels from Wicar.

Of the thirty-nine lots, Scheller calculated that fourteen, among which were eleven lots of drawings by Raphael, can be identified with drawings now at Lille and which Fedi either retained or sold to collectors other than Ottley from whom Wicar re-acquired them.[7] Subsequently, Barbara Brejon de Lavergnée was able to demonstrate that most if not all of lot 39 must also have been recovered by Wicar in 1824; lot 2 may also be identifiable with a drawing at Lille.[8] This leaves twenty-three lots of drawings, including twenty lots or part-lots by—or attributed by Wicar to—Raphael that Ottley could have acquired, which corresponds roughly to the twenty he claimed to have bought.

Woodburn's exhibition catalogue of 1836 of the drawings by or thought to be by Raphael that had been owned by Sir Thomas Lawrence described 100 drawings. For eight, Woodburn gives the provenance simply as Wicar. Of that eight, one seems not to be identifiable, five would today generally be excluded from Raphael's oeuvre, and two others would be accepted as autograph.[9] None of those eight, including the two genuine drawings, is among the works listed by Wicar in his *Etat,* and it seems probable that they were acquired by Wicar after 1801 and sold by him directly to Woodburn in 1823. The two genuine drawings, incidentally, are unconnected with any of those mentioned in the *Etat*. This fact is significant for, if Woodburn's indications are accepted at face value, it means that drawings by Raphael (or other artists) whose provenance includes Wicar but not Ottley were probably acquired from Wicar directly and legitimately by Woodburn in 1823.

Eight other drawings were included in Woodburn's exhibition with a provenance given as Wicar and Ottley and a ninth as Wicar and Dimsdale (Dimsdale had probably acquired it at one of Ottley's sales).[10] Seven of the nine are certainly by Raphael, and four of them can securely be recognized in Wicar's *Etat*. Another two may be included in the group of drawings listed in *Etat* 21 and a third

perhaps under *Etat* 19. Another drawing for an *Aquatic Triumph,* by Gian Francesco Penni, cannot be identified in the *Etat,* but since this drawing, now at Oxford, is a pair to a drawing at Lille (BdL no. 474), it too may have been included in one of the multiple lots. It would seem that in 1836, two years after Wicar's death, there was no barrier to including his name in the provenance of these eight drawings.

More problematical is the third group, comprising twelve drawings whose provenance is given solely as Ottley. Only one of these (1836 no. 31, the *Three Musicians,* now in the Ashmolean Museum, Parker no. 525) can certainly be identified in Wicar's *Etat,* in which it appears as lot 8, although, of course, it cannot be excluded that the others too were his.[11] Finally, one drawing (1836 no. 65, the *Fighting Men,* also in Oxford), with the provenance given as Ottley and Viti-Antaldi (whose familiar "RV" inscription it bears), but not Wicar, may be—and is assumed by Scheller to be— the drawing listed by Wicar as *Etat* 22; but Wicar does not mention that this drawing came from the Antaldi, which one might have expected, had it been the case.[12] Nevertheless, the description does seem to be of the same drawing, and it raises the intriguing possibility—which will be considered below—that Wicar might have obtained some Viti-Antaldi drawings. The 1836 exhibition thus included five drawings certainly and two probably mentioned in Wicar's *Etat,* plus twelve others that seem to be in sequence with drawings owned by Wicar and that may have been his.

Woodburn's exhibition of 1836 did not exhaust the run of drawings attributed to Raphael that he had acquired with the Lawrence collection. He sold sixty-seven of them to King William II of Holland in 1839 and, in all probability, a few to other wealthy collectors (this was also the case with Woodburn's Lawrence Michelangelos). Woodburn re-acquired many of King William's drawings at the monarch's posthumous sale in 1851, some of which he no doubt sold on before his own death in 1853; the remainder of Woodburn's Lawrence drawings were dispersed at auction in 1860.

Woodburn made every effort to ensure that at least some of Lawrence's collection was acquired by public institutions. In 1846, after some years of pressure and persuasion, a run of Michelangelo drawings and a run of Raphael drawings were acquired from Woodburn by the Oxford University Galleries. Of the 190 drawings listed under Raphael's name in the prospectus issued in 1842, twenty-eight are given a provenance with Wicar's name and seven others a provenance listing both Wicar and Ottley (the 1846 catalogue included only 132 of the 190 drawings attributed to Raphael in 1842, and is less valuable as a guide) This total of thirty-five was maintained in the catalogues of both Robinson and Parker.[13]

However, eleven other drawings in the Ashmolean for which a Wicar provenance has never been given, but which all come certainly or conjecturally from Ottley, seem to be en suite with drawings certainly owned by Wicar. Although none of them can be identified with certainty with drawings mentioned in the *Etat,* three do in fact have a good claim to be identical with drawings listed there.[14]

To summarize: The Ashmolean currently houses thirty-five sheets of drawings with an acknowledged Wicar provenance that could reasonably have been attributed to Raphael or his circle. In seven of these thirty-five instances, Ottley's name is also included in the provenance. There are also eleven other drawings, all but one of which has a provenance that begins with Ottley, which were probably—but not provably—owned by Wicar, totaling forty-six. Of them, it might reasonably be concluded, adding together the drawings for which both Ottley and Wicar are given as owners (seven), and those for which only Ottley is given (ten, plus one for which the provenance is given as Sir Benjamin West, who probably acquired it at one of Ottley's sales), that the Ashmolean now

possesses some eighteen of the drawings by or believed to be by Raphael stolen from Wicar in 1799 and acquired by Ottley. As remarked above, those drawings—twenty-eight of them in the Ashmolean—for which only Wicar is given as an owner before Lawrence himself were probably acquired directly from Wicar by Woodburn in 1823.[15]

The British Museum catalogue of 1962 by Pouncey and Gere acknowledged four drawings by Raphael and his circle to have a Wicar provenance. Two (their nos. 3 and 4) were connected with Wicar because both are en suite with drawings now at Lille and both were owned by Ottley.[16] Two others (nos. 21 and 25) were also connected with Wicar based on the information provided in the 1836 Lawrence collection catalogue, but Ottley is not listed as an owner for either of them.[17] This absence, together with the fact that neither of these important drawings is mentioned in the *Etat,* suggests that the latter two were drawings acquired directly from Wicar by Woodburn and never formed part of the stolen group. But in addition to the British Museum's two Wicar-Ottley drawings (nos. 3 and 4), the *Etat,* which was unknown in 1962, makes it clear that Pouncey and Gere's cat. 44 (included in Ottley's sale of 1804 as lot 349, acquired by Richard Payne Knight and bequeathed by him to the British Museum), was also among the drawings stolen from Wicar (*Etat* 12). It may be that Pouncey and Gere no. 23, a sheet from the pink sketchbook with an Ottley-Payne Knight provenance given, was part of *Etat* 15. It was suggested by Scheller that their no. 31, black chalk studies of angels for the *Disputa,* might be the drawing listed in the *Etat* under lot 19 but that drawing was said by Wicar to have writing by Raphael on the verso, which is not true of the sheet now in the British Museum.

In addition to these four drawings,[18] seven others in the British Museum by Raphael whose list of owners begins with Ottley may have come from Wicar.[19] If all eleven were among the drawings stolen from Wicar by Fedi, then, adding the eighteen in Oxford that might be presumed also to be part of the stolen group, a total of twenty-nine is reached. To that total must be certainly added another sheet from the large pink sketchbook, the study for *Diogenes* now in Frankfurt, which is specified among the stolen drawings in the *Etat* (lot 11) and which was also owned by Ottley. In all probability, the two drawings once owned by Ottley that were acquired by the Louvre at the King of Holland's sale should also be added.[20] The number of drawings that Ottley acquired from those stolen from Wicar by Fedi and his accomplices may therefore conjecturally be inferred from the information provided by the various sources to total thirty-two. If so, Ottley's report that he had acquired only about twenty Raphael drawings from Fedi might be considered a deceptive underestimate. However, we should not be too quick to accuse him of dishonesty since this total is presumption, not fact, and some of the smaller drawings may have been mounted two or more to a sheet. If so, Ottley would have been counting lots rather than individual drawings. It nevertheless remains possible that around thirty of Wicar's stolen Raphael or Raphael school drawings came into British collections via Ottley, whereas, to repeat, the other drawings listed with a Wicar provenance were probably among those acquired directly from him by Samuel Woodburn in 1823. Although it seems never to have been owned by Ottley, Pouncey and Gere no. 24, a leaf from the pink sketchbook, has a provenance from Camuccini and may also have been among the drawings stolen from Wicar.

So far, we have looked at the issue of the Raphael drawings stolen from Wicar that were owned by Ottley from the evidence provided by Woodburn's exhibition catalogue of 1836, the listings of the drawings offered to Oxford in 1842 and 1846, and the catalogues of the collections of the Ashmolean Museum and the British Museum of 1956 and 1962 respectively. However, Ottley's

collection of drawings by Raphael can be approached from another direction. Ottley held four sales of drawings—or, at least, four have so far been identified—at Thomas Philipe and Company in London between 1803 and 1814. All but the last were anonymous. The first took place in 1803 and while it included fourteen lots containing twenty-four drawings ascribed to Raphael, most had provenances from English collections, and none of the remainder can either be found in Wicar's *Etat* or reasonably be supposed to have come from him.[21] Ottley's sale of 1804, however, comprised fifteen lots attributed to Raphael containing twenty-three drawings. One of them is definitely listed in the *Etat*.[22] And at least two other drawings came with virtual certainty from Wicar.[23] In Ottley's sale of 1807 none of the seven lots of drawings by or after Raphael seems to have contained ex Wicar drawings. But his sale of 6–8 June 1814, which contained nearly 2,000 items and from which most of the drawings were bought in—to be sold en bloc to Lawrence eight or nine years later—included forty-two sheets of drawings by or attributed to Raphael, each lotted individually. Three have English provenances.[24] Another four are given Italian or French provenances probably incompatible with Wicar's ownership.[25] One other had already appeared in Ottley's 1807 sale and, from its description, seems unlikely to have formed part of Wicar's series; the same is true of a further drawing.[26] This leaves thirty-three drawings by or believed to be by Raphael that could have been owned by Wicar.[27] To them should be added the three ex-Wicar drawings that Ottley had sold in 1804 and that were acquired by Richard Payne Knight and bequeathed by him to the British Museum. Thirty-six is therefore the probable maximum number of drawings by or believed to be by Raphael that might have passed from Wicar to Ottley.

A general caveat is necessary. Ottley was actively collecting in Italy, especially in Rome and Florence, contemporaneously with Wicar, and could well have acquired drawings from the same sources: both certainly bought drawings from Cavaceppi. Therefore while the provenance of a Raphael drawing that begins with Ottley may arouse suspicion, it is not in itself proof that the work was purloined from Wicar. Ottley might have acquired independently drawings en suite with those owned by Wicar. It is worth repeating—as a control—that Wicar's *Etat* lists no drawings by Michelangelo, whereas Ottley certainly owned various Michelangelos originating from Casa Buonarroti by 1804. If, therefore, they were—presumably—not drawings stolen from Wicar, it may be that Ottley had not acquired them, knowingly or unknowingly, illicitly. Ottley may well have bought some drawings by Michelangelo from someone else to whom Filippo Buonarroti had sold them.

Another possibility is suggested by the fact that, by the time of his sale of 1814, Ottley seems to have had Michelangelos—notably the studies of windows and doors now in the Ashmolean included in that sale—that were given a Wicar-Ottley provenance in Woodburn's Michelangelo exhibition of 1836, which is to say the provenances were not concealed. As remarked above, perhaps by 1814 Wicar and Ottley had come to some kind of agreement.

II

The sources of Wicar's Raphael collection are still more obscure than its dispersal. There are very few indications of where he might have obtained his drawings and with rare exceptions the dates of the majority of Wicar's acquisitions cannot be established. His own writings provide few clues and there is little information to be gleaned from the drawings themselves, which are largely devoid of collectors' marks or other indications of provenance. It does seem fairly certain, however, that the great

majority of Wicar's drawings were acquired in Italy, where he spent most of his life, and that no more than a few are likely to have been obtained in France.

It is widely believed that Wicar profited from his position as a Napoleonic commissioner in Italy to obtain drawings for his own collection. No doubt Wicar did use his power to induce owners to sell their possessions to him, paying low prices and obtaining remarkable bargains. But according to his own standards, he probably behaved honestly. Wicar remained in Italy long after Napoleonic protection had passed and seems to have held a high reputation as an artist and connoisseur. He was made a member of the Accademia di San Luca in 1805. Between 1806 and 1809 he was director of the Accademia del' Belle Arte in Naples, a post in which he was strongly supported by Canova, whose devotion to the integrity and the repatriation of Italian art requires no reiteration. Such support and the fact that, while he was certainly attacked by some fellow artists, no legal efforts appear to have been made by Italian families to re-possess works owned by Wicar, suggests that he was not perceived as criminally rapacious. Nor, as far as is known, have specific cases come to light of forced sales or gifts to Wicar from Italian collections: *pro tem,* he perhaps deserves to be given the benefit of the doubt.

In his *Etat* Wicar provides provenances only for four drawings. Two, the modello for Domenico Alfani (*Etat* 14), and a drawing for angels in the *Disputa* (part of *Etat* 19, and, as noted above, possibly to be identified with Pouncey and Gere no. 23 in the British Museum) came from Blanchard. This must be the same Blanchard, identified conjecturally by Scheller as the painter Laurent Blanchard, active in Italy during the 1790s, who also sold a large group of drawings to Vivant Denon: "en septembre 1803 . . . Denon acquiert auprès d'un certain Blanchard et pour 3 600 francs, 160 dessins provenant en partie de la collection Albani. Ayant sans succès tenté de les offrir 'pour le même prix au gouvernement', il garda ces œuvres dans ses portefeuilles. Nous les retrouvons en effet dans la vente de 1826."[28]

Blanchard therefore had acquired an important group of drawings, including some from the Albani collection, from which Ottley also bought drawings, directly or indirectly.[29] Whether all Blanchard's drawings were acquired in Italy is uncertain. The presumption that this was so is qualified only by the mount of the Alfani modello, which is similar though not identical in type with mounts employed by Jabach and may suggest an earlier French provenance. In another case, a drawing owned by Wicar is listed by Parker with an antecedent provenance from Thomas Gibson; if this is correct, then, whether Wicar acquired it in France or Italy, it was not part of a long-formed Italian collection.

In lot 39 of the *Etat,* Wicar listed some 300 drawings, including ones by or attributed to famous masters such as Dürer, Polidoro, Mantegna, Parmigianino, etc., that he said he had acquired from Cavaceppi. Nothing either by Raphael or Michelangelo is mentioned there, but among the Raphaels (*Etat* 24) the copy after the *Resurrection of Christ* in the Scuola Nuova series now in the Ashmolean (Parker no. 665f) is stated to come from Cavaceppi. However, this drawing is, as Wicar no doubt realized, not an autograph Raphael. Cavaceppi was a dealer in bulk and the very absence of his name with respect to the other drawings in the *Etat* indicates that he was not their source. Where, therefore, did Wicar obtain his astounding run of Raphael drawings? If the total that he finally bequeathed to Lille is added to those he can be presumed to have possessed, it must have amounted to between seventy and eighty sheets, the largest gathering of Raphael drawings to have been formed since that of the great eighteenth-century collector Pierre Crozat and probably of better quality.

Scheller was concerned with this issue and suggested that the composition of Wicar's collection, which contained almost entirely drawings dating from before 1514, was so like that owned by Timoteo Viti and his descendants that it came from a "shadow collection."[30] He noted that one drawing that Wicar seems to have owned does bear the Viti-Antaldi's famous RV monogram, the *Fighting Men* in the Ashmolean (Parker no. 537), and if Wicar obtained one drawing from the Viti group he might well have obtained others. However, even assuming this to be correct, Crozat had acquired a group of drawings from the Viti-Antaldi collection in 1715, which came on the market in his posthumous sale of 1741. Wicar might have encountered this drawing on the art marker either in France or in Italy. There are no recorded dispersals of marked drawings from the Viti-Antaldi collection between Crozat's acquisition of a group in 1715 and Woodburn's acquisition of the remainder in 1823. If Wicar succeeded in obtaining an inscribed drawing from the collection, there is no need to assume that this was more than an isolated instance; if Ottley did, the same assumption applies. It is also, in principle, possible that the drawing described by Wicar and that owned by Ottley are different. Thus this one drawing does not make a collection. However, thanks to the research of Forlani Tempesti, it has recently become clear that the formation, composition, and dispersal of the Viti-Antaldi collection is a much more complicated matter than had previously been assumed and that the Antaldi family possessed many more drawings than the core group gathered by Timoteo Viti.[31] It is possible that the Antaldi collection contained a large number of drawings by Raphael extra to the core group once owned by Viti, acquired by the family at other times. The observation of Scheller, that Wicar's drawings shadowed the Viti-Antaldi group, is certainly suggestive, but, finally, it need not reflect more than the fact that the survival rates among Raphael's early drawings are much higher than among his later ones, whoever owned them.

Three categories of clue provide some insight—although sadly not much. One is documentary, statements that Ottley made in his 1804 and 1814 sale catalogues to which insufficient attention has been paid. In the former he wrote:

Almost the whole of the following lots of this divine Artist have been (p?)reserved in his family until the late Revolutions, when they found their way into the market, and were purchased by their present proprietor, at Rome.

In 1814, the statement is modified:

[H]is drawings before the public, are too well known, to require any proof of their originality. They were obtained, with the exception of two or three, during the revolutionary troubles in Italy by their present proprietor, who then sojourned in that country, and there is strong reason to believe that, till that period, they had been preserved in the same state in which they had been left at the death of Raffaele.

However much these statements may omit, there is no reason to assume that they are entirely false. They may indeed record the source—or one of the main sources—whence these Raphaels came on to the market, whether they were purchased by Wicar or Ottley. In the course of the nineteenth century, other Raphael or Raphael school drawings passed out of Italy. The collection of Léon Bonnat, for example, includes drawings originating from the family that owned Raphael's small painted tondo now in Saint Petersburg, the Conestabile. It is very likely that other Umbrian and Marchigian aristocratic

families owned collections of drawings, including, naturally, drawings by Raphael, the most admired of all these regions' artists, from which Wicar might have profited. These families could have included Raphael's own, for although engaged in litigation from early on with his stepmother and her family, he seems to have remained on good terms with that of his father and his mother, whose family, the Ciarla, continued to reside in Urbino.

A second source of information is the numberings found on some of Raphael's drawings at Lille or those linked with them. Analysis of them is complicated by the fact that many of the numbers on the Lille drawings have been erased, perhaps while they were in Fedi's possession, but some remain on drawings that he presumably fenced rapidly. It seems that the pink sketchbook bears or bore a series of numbers, applied in the upper center, that runs—although not quite continuously—in the twenties and thirties. These numbers are found on both the large pink sheets and the half-size ones, but not on all of them. Thus numbers are not found on the Ashmolean's two studies for the *School of Athens,* but one is found on the British Museum's drawing for the *Parnassus,* which is 14 mm higher. If the Ashmolean studies were cut by the same amount, their numbers would have been lost. The green sketchbook, of which no sheets are recorded elsewhere, also bears numbers that run, but not continuously, through the thirties and forties, which are probably en suite with the pink series. These two series of drawings—the pink and the green—were, therefore, presumably once in the same collection and the obvious conclusion would be to say that it was from this collection that Wicar acquired them. However, some—but not all—of the pink sheets (but none of the green) bear other numbers. Thus it may be that some of them passed from one collection to another. The order, of course, is impossible to divine in the present state of knowledge. Two "sketchbooks," the green and the pink, employed by Raphael some three or four years apart, were at one point in the same collection and at another in different collections. They might initially have been together, then separated, only to be rejoined by Wicar, or initially separate, then joined, to be acquired en bloc by Wicar. In fact, one page from the pink sketchbook that has recently been discovered certainly came to England well before Wicar was born, so it follows that this sketchbook lost some of its pages well before 1799.[32] The possible permutations are many, and anyone familiar with the problems posed by provenance will be aware that it is unwise to be dogmatic—common-sense explanations often prove to be wrong.

The first set of numberings are not found on any of the other drawings by Raphael in Lille or elsewhere or, apparently, on drawings by any other artist: they seem to occur only on the pink and the green sketchbooks. Therefore it might be concluded that these two were not part of the same collection as unnumbered drawings in pen and ink or chalk. However, this may not be correct, for there is a third category of evidence: old copies. Few copies of the drawings that concern us survive—or have yet been identified—but one is of especial interest: a sheet in the Louvre (RF 488, Cordellier and Py no. 28), which contains five copies: three after drawings on the recto and verso of a sheet in the Ashmolean (Parker no. 508), a fourth after the study on the verso of the pink sketchbook page at Lille (BdL no. 539), and the fifth after the small sketch at the top of the recto of the sheet of studies for the *Alba Madonna,* also at Lille (BdL no. 545). The last two were certainly, and the first probably, owned by Wicar. If dating of the Louvre copy to the first half of the sixteenth century is correct, as the style of the drawing and the watermark on the paper indicate, this would imply— although not prove—that the three sheets were in the same collection within a few years of Raphael's death. It might also imply— although much less securely—that they remained together until they were acquired by Wicar.[33]

Another instance is the Uffizi copy after three sheets of studies for the *Parnassus*. This copy, as explained in cat. 39 here, cannot be later than 1666, and it reproduces one drawing still in Lille, one now in Oxford, and one in the British Museum. The provenance of the last two is virtually certainly from Wicar. So in this case one can reasonably suggest that the three drawings remained together—if not necessarily in the same collection—until Wicar acquired them. Another drawing in the same series, however, the study for the head of Homer at Windsor, entered the royal collection well before Wicar's time, so it is evident that this entire group at least, did not remain intact.

A third copy might also be mentioned: a drawing in sharp black chalk at Chatsworth that is a same-size replica, with omissions, of a red chalk drawing cited in Wicar's *Etat*, that preparing the Fighting Men for the relief below Apollo in the *School of Athens* (Ashmolean; Parker no. 552). The drawing seems to be of the sixteenth century and might also be by Perino del Vaga, who made other finely worked copies of drawings by Raphael. If this—highly speculative—attribution has any substance, it would fit the suggested provenance of other drawings by Raphael at Lille and elsewhere via Caterina Penni, the sister of Raphael's assistant Gian Francesco Penni, and her husband, Perino del Vaga.

On balance, the information that we have been able to gather would tend to suggest that while most of the drawings by Raphael came into Wicar's hands in large groups, they did not, in all probability, come from a single source.

Notes

1 Piot 1861–62, 145: Wicar's "friendship with Filippo Buonarroti allowed him to purchase several notable drawings among those that had been kept by the family."

2 The question of Wicar's collection of drawings by Michelangelo cannot be dealt with here.

3 Scheller 1973.

4 Gere 1953, 47.

5 Scheller 1973, 126–31; hereafter Wicar's Etat will be referred to as such.

6 Musée Fabre, Montpellier, 3184 (Etat 5); Cleveland Museum of Art 1978.57; British Museum, London [hereafter British Museum], Pouncey and Gere 1962 [hereafter Pouncey and Gere], no. 24; Museum Boymans-van Beuningen, Rotterdam, I, 110.

7 Etat 4, Brejon de Lavergnée 1997 [hereafter BdL], no. 589 (Giulio Romano); Etat 6, BdL no. 545; Etat 9, BdL no. 536; Etat 13, BdL no. 534; Etat 14, BdL no. 531; Etat 15, BdL nos. 539–44; Etat 20, BdL nos. 514, 518?; Etat 25, BdL no. 551?; Etat 29, BdL no. 523?; Etat 31, BdL no. 529; Etat 32, BdL nos. 541, 539 [repeats 15]?; Etat 34, BdL no. 553 (in Etat as Giulio Romano, now as d'après Raphael?); Etat 35, BdL nos. 717–808; Etat 38, BdL nos. 76–89.

8 BdL no. 17; Etat 2, ascribed to Parmigianino, is perhaps identical with BdL no. 419.

9 The current locations of these drawings are given, where known; 1836 indicates Woodburn's 1836 Lawrence exhibition catalogue. [1] 1836 no. 11 (not autograph, Ashmolean Museum, Oxford [hereafter Ashmolean], Parker 1956, vol. 2. [hereafter Parker], no. 625); [2] 1836 no. 14 (not autograph, Ashmolean, Parker no. 572); [3] 1836 no. 16 (lo Spagna, Ashmolean, Parker no. 45); [4] 1836 no. 42 (after Giulio, Ashmolean, Parker no. 590); [5] 1836 no. 44 (not identifiable); [6] 1836 no. 49 (Raphael, British Museum, Pouncey and Gere no. 25); [7] 1836 no. 51 (Raphael, British Museum, Pouncey and Gere no. 21); [8] 1836 no. 92 (not autograph, Ashmolean, Parker no. 649).

10 The current locations of these drawings are given, where known. [1] 1836 no. 36 (Penni, Ashmolean, Parker no. 245); [2] 1836 no. 43 (Raphael, Ashmolean, Parker no. 564); [3] 1836 no. 67 (Raphael, Musée du Louvre, Paris [hereafter Louvre], 3869; perhaps included in Etat 21); [4] 1836 no. 70 (Raphael, Ashmolean, Parker no. 550, Etat 10); [5] 1836 no. 80 (Raphael, Ashmolean, Parker no. 551; perhaps included in Etat 21); [6] 1836 no. 84 (Raphael, Städelsches Kunstinstitut, Frankfurt [hereafter Städelsches Kunstinstitut], 390, Etat 11); [7] 1836 no. 91 (Raphael, Ashmolean, Parker no. 552, Etat 7); [8] 1836 no. 94 (Raphael, Ashmolean, Parker no. 462, Etat 19); [9] 1836 no. 86, with the provenance given as Wicar and Dimsdale, is at present unlocated; representing Joseph Telling His Dreams for the loggia, it re-appeared in the final dispersal of drawings from the Lawrence collection in Woodburn's posthumous sale of 1860 as lot 721, with the same provenance [i.e., Wicar-Dimsdale]; it may be by Penni; perhaps included in Etat 19.

11 They are [1] 1836 no. 1 (Raphael, British Museum, Pouncey and Gere no. 1); [2] 1836 no. 2 (Raphael, Louvre, 3860); [3] 1836 no. 4 (Raphael, Ashmolean, Parker no. 40); [4] 1836 no. 5 (Raphael, Ashmolean, Parker no. 510); [5] 1836 no. 6 (Raphael, Ashmolean, Parker no. 509); [6] 1836 no. 7 (Raphael, British Museum, Pouncey and Gere no. 3); [7] 1836 no. 9 (Raphael, British Museum, Pouncey and Gere no. 9); [8] 1836 no. 12 (Raphael?, Städelsches Kunstitut 377); [9] 1836 no. 18 (Raphael, British Museum, Pouncey and Gere no. 5); [10] 1836 no. 31 (Raphael, Ashmolean, Parker no. 525), Etat 8; [11] 1836 no. 66 (Raphael, Ashmolean, Parker no. 541); [12] 1836 no. 90 (Raphael, Ashmolean, Parker no. 528).

12 1836 no. 65 (Raphael, Ashmolean, Parker no. 537), Etat 22.

13 The following includes the drawings listed in Parker's catalogue of 1956 with a provenance from Wicar, together with the numbers in Robinson's catalogue [R] and the 1846, 1842, and 1836 catalogues. Drawings for which a Wicar-Ottley provenance is given are indicated with a description and an *; those mentioned in Wicar's Etat (where known) are also indicated. [1] Parker no. 27, R16, 1846 no. 64, 1842 no. 118; [2] Parker no. 44, R35, 1846 no. 10, 1842 no. 102; [3] Parker no. 45, R29, 1846 no. 97, 1842 no. 106, 1836 no. 16; [4] *Parker no. 245, R82, 1846 no. 90, 1842 no. 127, 1836 no. 36 (Wicar and Ottley listed); [5] *Parker no. 462, R91, 1846 no. 94, 1842 no. 27, 1836 no. 94 (Wicar and Ottley listed); [6] Parker no. 466, R161, 1846 no. 136, 1842

no. 134; [7] Parker no. 503, R19, 1846 omitted, 1842 no. 190; [8] *Parker no. 515, R26, 1846 no. 40, 1842 no. 90 (Wicar and Ottley listed); [9] Parker no. 519, R77, 1846 no. 29, 1842 no. 61; [10] Parker no. 526, R58, 1846 no. 43, 1842 no. 145 (Gibson according to Parker, but this is perhaps wrong; Gibson is not listed by Robinson); [11] Parker no. 534, R30, 1846 no. 37, 1842 no. 78; [12] Parker no. 541, R69, 1846 omitted, 1842 no. 69, 1836 no. 66, Etat 17 (the Wicar provenance is included neither in 1842 nor by Robinson, but it is given by Parker; [13] Parker no. 544, R66, 1846 no. 133, 1842 no. 46, Etat 21?; [14] *Parker no. 550, R71, 1846 no. 82, 1842 no. 70, 1836 no. 70, Etat 10 (Wicar and Ottley listed); [15] *Parker no. 551, R72, 1846 no. 39, 1842 no. 81, 1836 no. 80 (Wicar and Ottley listed); [16] *Parker no. 552, R73, 1846 no. 38, 1842 no. 77, 1836 no. 91, Etat 7 (Wicar and Ottley listed); [17] *Parker no. 564, R76, 1846 no. 106, 1842 no. 91, 1836 no. 43 (Wicar and Ottley listed); [18] Parker no. 566, R128, 1846 omitted, 1842 no. 44; [19] Parker no. 567, R129, 1846 no. 73, 1842 no. 110; [20] Parker no. 572, R83, 1846 no. 93, 1842 no. 126, 1836 no. 14; [21] Parker no. 576, R57, 1846 no. 4, 1842 no. 75 [22] Parker no. 580, R139, 1846 no. 122, 1842 no. 24; [23] Parker no. 581, R140, 1846 no. 14, 1842 no. 157; [24] Parker no. 582, R141, 1846 no. 125, 1842 no. 144 (Parker gives the provenance as Antaldi and Wicar, both with ? Wicar is not mentioned in either 1842 or 1846, but the drawing is en suite with the previous number); [25] Parker no. 590, R146, 1846 no. 12, 1842 no. 128, 1836 no. 42; [26] Parker no. 592, R171, 1846 no. 24, 1842 no. 147; [27] Parker no. 625, R164, 1846 no. 17, 1842 no. 11, 1836 no. 11; [28] Parker no. 639, R68, 1846 no. 48, 1842 no. 28; [29] Parker no. 643, R89, 1846 no. 15, 1842 no. 92; [30] Parker no. 645, R90, 1846 omitted, 1842 no. 82; [31] Parker no. 649, R131, 1846 no. 137, 1842 no. 84, 1836 no. 92; [32] Parker no. 658, R106, 1846 no. 77, 1842 no. 121; [33] Parker no. 659, R107, 1846 no. 79, 1842 no. 139; [34] Parker no. 665f, R125, 1846 no. 2, 1842 no. 172; [35] Parker no. 692, R130, 1846 no. 23, 1842 no. 101. Thirty-five total.

14 They are [1] Parker no. 31, R20, 1846 no. 105, 1842 no. 160; [2] Parker no. 509, R25, 1846 no. 92, 1842 no. 113; [3] Parker no. 510, R14, 1846 no. 111, 1842 no. 7;

[4] Parker no. 511, R9, 1846 no. 50, 1842 no. 33; [5] Parker no. 525, R43, 1846 omitted, 1842 no. 115, Etat 8; [6] Parker no. 528, R51, 1846 omitted, 1842 no. 72; [7] Parker no. 535, R28, 1846 no. 33, 1842 no. 79; [8] Parker no. 536, R52, 1846 omitted, 1842 no. 130, Etat 23 (Parker does not include Ottley among the owners of this drawing whose provenance starts with West. However, it is very likely that West acquired it at one of Ottley's sales); [9] Parker no. 537, R102, 1846 no. 16, 1842 no. 93, Etat 22; [10] Parker no. 553, R70, 1846 no. 94, 1842 no. 164, ?Etat 3; [11] Parker no. 624, R151, 1846 omitted, 1842 no. 39. Eleven total.

15 To this total should be added the three drawings whose provenance in the 1836 exhibition catalogue is given solely as Wicar and which did not go to Oxford, to make at least thirty-one drawings presumably acquired directly from Wicar by Woodburn.

16 Pouncey and Gere no. 3, 1836 no. 7; Pouncey and Gere no. 4, Ottley sale 1804 [hereafter 1804], lot 348.

17 Pouncey and Gere no. 21, 1836 no. 51; Pouncey and Gere no. 25, 1836 no. 49.

18 That is, Pouncey and Gere nos. 3, 4, 23, and 44, but not 21 and 25 or, probably, 31.

19 Pouncey and Gere nos. 1 (1836 no. 1), 5 (1836 no. 18, en suite with Lille BdL no. 516), 6 (1804, part of lot 335), 9 (1836 no. 10), 13 (1836 no. 9); 15 (Ottley sale, 1814, lot 1074, bought Payne Knight, bequeathed to the British Museum), and 29 (Ottley sale, 1814, lot 1685, bought Payne Knight, bequeathed to the British Museum, en suite with Lille BdL nos. 537, 538).

20 1836 no. 2, Louvre 3860; and 1836 no. 67, Louvre 3869.

21 Gere 1953, 48, doubted that this sale was of drawings owned by Ottley and suggested that he may simply have catalogued it.

22 Lot 349, Etat 12, British Museum, Pouncey and Gere no. 44.

23 Lot 347, Head of the Madonna, British Museum, Pouncey and Gere no. 3; lot 348, British Museum, Pouncey and Gere no. 4.

24 They are lots 1771 [Sir Peter Lely, Ashmolean, Parker no. 559], 1772 [Sir Peter Lely, Richardson, private collection, England]; and 1774 (Richardson, Städelsches Kunstinstitut 4303].

25 They are 1215 [Duke of Modena, Parker no. 532]; 1598 [Capo di Monti at Naples, Ottley sale 1804 lot 345; British

Museum, Pouncey and Gere no. 134]; 1689 [Palazzo Albani, Parker no. 556]; 1775 [D'Argenville, Parker no. 820].

26 No. 1211, probably identical with 1804 lots 337 and Ottley sale 1807 lot 477, and Ashmolean, Parker nos. 655, 1218. One—a leaf of studies of eagles—masterly pen, unidentified.

27 They are [1] 1069, a St. Jerome, unidentified; [2] 1070, perhaps Frankfurt 377; [3] 1071, Lo Spagna, Parker no. 45; [4] 1072, Pouncey and Gere no. 1; [5] 1073, Pouncey and Gere no. 5; [6] 1074, Pouncey and Gere no. 15; [7] 1075, Louvre 3869, Etat 16?; [8] 1076, Parker no. 506?; [9] 1077, Louvre 3860; [10] 1078, 1804 lot 347?, Pouncey and Gere no. 3; [11] 1208, Parker nos. 625, 627?; [12] 1209, Parker no. 555; [13] 1210, Parker no. 541; [14] 1212, Parker no. 501?; [15] 1213, Parker no. 511; [16] 1214, Parker no. 508, whose provenance begins with Lagoy who also owned the Louvre copy; [17] 1216, probably Parker no. 514; [18] 1217, Parker no. 564?; [19] 1219, Parker no. 510; [20] 1593, Etat 3, Parker no. 553; [21] 1594, Pouncey and Gere no. 23; [22] 1595, Parker no. 511; [23] 1596, Parker no. 552; [24] 1597, Parker no. 40. [25] 1599, Penni, Parker no. 245; [26] 1683, Parker no. 525; [27] 1684, Pouncey and Gere no. 13; [28] 1685, Pouncey and Gere no. 29; [29] 1686, Parker no. 462; [30] 1687, ?Parker no. 539; [31] 1688, Parker no. 528; [32] 1770, Parker no. 551; [33] 1773, Diogenes; Etat 11; Städelsches Kunstinstitut 380.

28 Denon 1999, 430: "In September of 1803 . . . Denon bought from a certain Blanchard, for 360 francs, 160 drawings, some of which had been in the Albani collection. Having tried without success to offer them 'to the government for the same price,he kept them in his portfolios. In fact, we encounter them again in the 1826 sale."

29 The Ashmolean's cartoon fragment of the horse's head for the Expulsion of Heliodorus (Parker no. 556) came from the Albani Collection, via Ottley.

30 Scheller 1973, 128, pursuing a suggestion by Gere.

31 Forlani Tempesti 2001, xxxix–xlix.

32 Rubinstein 1987.

33 I am grateful to Dominique Cordellier for clarifying this issue for me. These copies are in sharp pen, like all the originals except that in Lille (BdL no. 539 verso), which is executed with the point of a brush. It is the copy of this drawing that betrays the hand of the draftsman most clearly and its long hatching lines are similar to those employed by Perino.

Drawing
in Florence

in the Later Quattrocento
and Early Cinquecento

1. ALESSANDRO BOTTICELLI

*Two Standing Men, for
the "Adoration of the Magi"*
1475

Metalpoint heightened with white on
pink prepared paper, 165 x 100 mm

For Botticelli, aptly characterized by
Berenson as Europe's greatest mas-
ter of linear design, drawing was an
independent, self-sufficient art; his
illustrations to Dante's *Divine
Comedy* form the most extensive
series known by a major master.
Although it is probable that it was initially intended to
color them, that plan seems soon to have been abandoned
in favor of pure line illustrations. Like Leonardo, Botticelli
also made drawings as presentation pieces. His *Allegory of
Autumn* (British Museum, London), although unfinished,
is much more elaborate than what was required as prepa-
ration for a painting. Only a limited number of working
drawings by Botticelli survive, although he must have
made them in great quantities. The uniquely tense
contours that so electrify his greatest paintings, the
expressive simplifications and distortions of his late work,
are unthinkable without constant practice as a draftsman,
and such exercise is implied also by his representation of
physical action. The falling figures on the left side of his
Punishment of the Sons of Korah of 1483 in the Sistine
chapel hardly find an equal before the invention of high-
speed photography. Although the dreamy, poetic,
"Pre-Raphaelite" side of Botticelli still dominates popular
conception of him, much of his work is highly energetic.
A contemporary described his work as having a virile air.
The present drawing is a study for the *Adoration of the
Magi* (fig. 1), commissioned around 1475 by Gasparre di

Zanobi Del Lama as an altarpiece for his chapel in Santa
Maria Novella. A complex work, it contains nearly
twenty figures. Around half, including Botticelli himself,
are identifiable, arranged in two arcs before and on
either side of the Holy Family. Displaying complete
control of perspective, the composition recalls work of
Donatello, such as the *Ascension* (Victoria and Albert
Museum, London), and anticipates Leonardo's *Adoration
of the Magi* (Galleria degli Uffizi, Florence). Del Lama was
a Medici supporter and Botticelli gave the Magi
Medicean identities, which was particularly appropriate
since the family patronized a confraternity dedicated to
the Magi. The two figures represented here are Giuliano
de' Medici, murdered three years later in the Pazzi
conspiracy, and, probably, his friend Angelo Poliziano.
Made in metalpoint heightened with white body color,
the drawing prepares poses, indicates the fall of light,
and establishes a grouping very close to the final one.
"Impartial," simplified, and without expressive flour-
ishes, it was long thought to be after the painting. But
there is none of the detail or concentration on faces that
one would expect from a copy, and it was rightly restored
to Botticelli by Ragghianti and dalli Regoli. And, as
Goldner emphasized, Botticelli introduced a significant
change. In the full-length drawing, Poliziano's right hand is
behind Giuliano's right arm, as though picking his pocket.
In the larger scale study at the top left of the sheet,
Poliziano's hand encircles Giuliano's right forearm, as it
does in the painting. Such focus on a meaningful detail,
and its placement on the sheet, looks forward to metal-
point studies made by both Perugino and Raphael, who
may well have known some of Botticelli's drawings.

Fig. 1
Alessandro Botticelli.
*The Adoration of the
Magi,* c. 1475, tempera
on panel, 111 x 134
cm. Galleria degli Uffizi,
Florence.

References
Benvignat 1856, no. 398; Gonse 1877, 397; Pluchart 1889,
no. 77; Berenson 1903, no. 838; Berenson 1938, no. 838;
Berenson 1961, no. 838; Viatte 1963, no. 57; Ragghianti
and dalli Regoli 1975, 87; Brejon de Lavergnée 1990, no. 7;
Brejon de Lavergnée 1997, no. 106; Goldner 1997, no. 4.

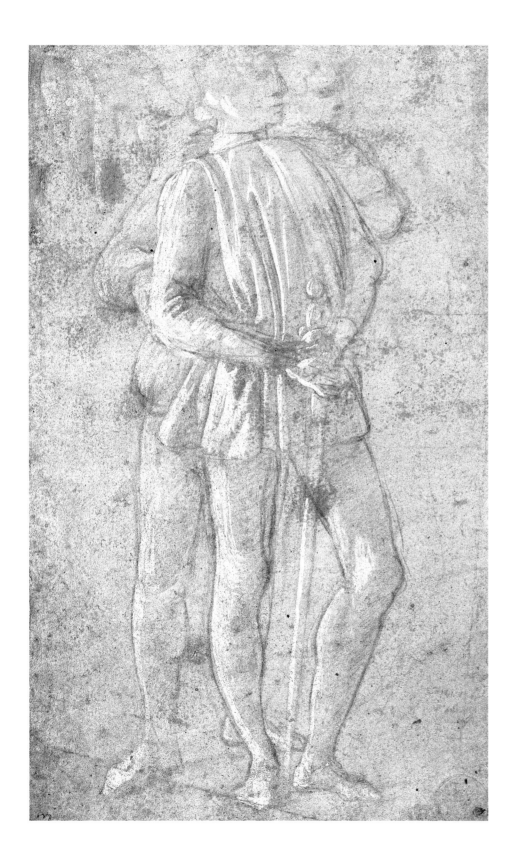

2. FILIPPINO LIPPI (attributed to), after Filippo Lippi

Saint Luke Seated

c. 1480

Pen and ink, wash, heightened
with white on pink washed paper,
217 x 240 mm (maximum),
trimmed to an arch at the top

The historiography of this drawing is revealing. Traditionally attributed to Filippo Lippi and given in 1903 by Berenson to Jacopo del Sellaio, in 1917 Fischel assigned it to Perugino, without explanation. Fischel dated it to the 1480s but did not connect it with a specific work; indeed, no comparable figure by Perugino survives or is recorded. In 1938 Berenson recognized that the figure was a slightly varied copy of the figure of Saint Luke in the vault of the choir chapel of Prato Cathedral (fig. 2), frescoed by Filippo Lippi between 1452 and 1465. Filippo's scheme was one of the grandest executed by a Florentine artist in Florence or its hinterland between the Brancacci chapel of the mid 1420s and Ghirlandaio's Sassetti chapel of the early 1480s. Filippo's frescoes were an important source for Ghirlandaio, generally and specifically. A copy after two of Filippo's figures from the *Feast of Herod* (Hessisches Landesmuseum, Darmstadt, A.E.1284) is on the verso of a study for

Fig. 2
Filippo Lippi. *Saint Luke,*
early 1450s, fresco.
Main Chapel, Prato
Cathedral.

Ghirlandaio's *Judith* of 1489 (Gemäldegalerie, Berlin), so it was not made at the beginning of his career.

Although tentatively accepting Fischel's re-attribution in 1938 and 1961, Berenson retained the drawing under the name of Sellaio who, of course, worked with

Ghirlandaio. But while his identification of the source does not definitively rule out Perugino's authorship, it seriously undermines it, as argued in 1997 by Brejon de Lavergnée, who returned the drawing to anonymity. In fact, it does not much resemble drawings certainly by Perugino. Its closest relation is to one in Düsseldorf (Kunstmuseum, Fischel 1917, no. 20) but that is on a metalpoint base and lacks the present drawing's substantiality of modeling. Perugino was certainly working in Florence in 1472, probably in association with Verrocchio, and he might, in principle, have made such a copy. But Perugino's secure work of the 1470s shows minimal trace of Filippo Lippi's influence. Compositionally Perugino's art is inherently different, cooler, with more widely spaced figures statically arranged; the forms, color, and technique of his earliest paintings owe most to the brothers Pollaiuolo.

More likely, this copy is by a Florentine artist, as Berenson first thought. Filippo's son, Filippino, is the most plausible candidate. The facial type is very like that found in Filippino's work, notably cat. 4, and the vigorous, widely spaced hatching lines, accentuated chiaroscuro, and rugged modeling of drapery are close to his and much more energetic than other copies after Filippo, such as those in the Louvre (10247 and 10248). If this attribution is correct, the drawing is probably of c. 1480, when Filippino was commissioned to complete the Brancacci chapel frescoes. It would have been natural for him, then, to turn for guidance to the work of his father, Masaccio's pupil. Because the forms in the drawing differ slightly from those in the fresco, he may have been copying one of his father's designs.

Later in his career Filippino himself executed vault frescoes in both Florence and Rome (see cat. 5). His *Prophets* in the Strozzi chapel in Santa Maria Novella were, in turn, copied by Raphael.

References
Benvignat 1856, no. 394; Pluchart 1889, no. 291; Berenson 1903, no. 2507; Fischel 1917, no 10; Berenson 1938, no. 2507; Berenson 1961, no. 2507; Viatte 1963, no. 155; Châtelet 1970, no. 68; Oberhuber 1983, 29; Brejon de Lavergnée 1990, no. 4; Brejon de Lavergnée 1997, no. 1129.

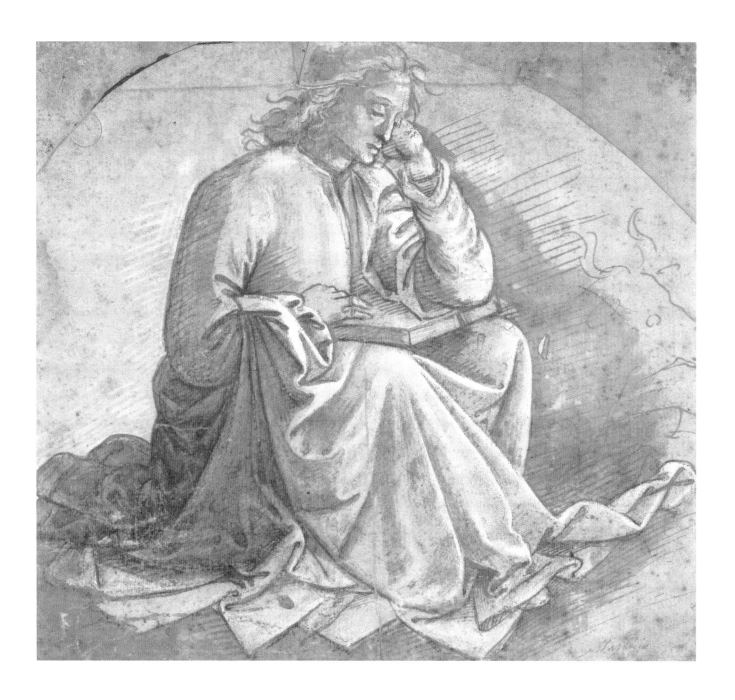

3. FILIPPINO LIPPI

Virgin and Child

c. 1500

Metalpoint heightened with white on pink prepared paper, 179 x 86 mm

Until recently the drawings of Filippino Lippi and his circle, although far from ignored, were relatively undervalued. They are, of course, discussed in the standard works on Florentine drawing, notably by Berenson, and were the subject of a 1975 thesis by Innis Shoemaker, but they have not been admired or analyzed to the extent they deserve. This situation is changing, however, and the New York exhibition of 1997–98 organized by Goldner and the forthcoming publication of a comprehensive monograph on his work by Jonathan Nelson and Patrizia Zambrano will surely lead to a fuller appreciation of Filippino's achievement.

The body of his graphic oeuvre, currently accepted as some 150 sheets (a total that will probably expand), is larger than that of any other major Florentine painter of the second half of the fifteenth century. Yet this picture is somewhat blurred by a considerable number of studio drawings, for Filippino evidently had a large and active workshop. His drawings naturally include many different types. Taken as a whole, his graphic work displays an approach to the creation of panel paintings and frescoes that approaches in thoroughness that of his slightly older contemporary Ghirlandaio, and one that anticipates, at least in part, Raphael's rigorous preparatory processes. Such a method would not necessarily be inferred from his paintings, which, particularly in the second half of his career, often strive for forms and arrangements that might appear casual and not composed. This is not to characterize him as a fifteenth-century Degas, but it is evident that after completing the Brancacci chapel in the early 1480s, he gradually diverged from the Florentine grand style (that of the Masaccesque tradition), toward an art of more scattered groupings, figures caught in movements that sometimes seem ungainly, and lively and exotic decorative adjuncts.

The present drawing, obviously made for a Virgin and Child in a *sacra conversazione* or just possibly an Adoration of the Magi, cannot be connected with a specific project. Although the pose is static, the drawing crackles with life: draperies and limbs move in spiky angularities. The elongated forms are a recurrent but not invariable feature of Filippino's work that he would have imbibed from his association with Botticelli in the 1470s. But within this vivacious ensemble, the disciplines of vertical and horizontal give structure to the poses, and geometric alignments organize the drapery and limbs. The Virgin's mantle, for example, drawn together across her breast, falls outward in two folds that form a neat equilateral triangle on the surface of the paper.

This drawing has been diversely dated, but Berenson's late dating, supported with strong arguments by Goldner, is convincing. The vitality might at first sight seem more appropriate to a young artist, but it also denotes constant practice and great security in the use of metalpoint, as the lines are dashed down on the surface. Although Filippino died prematurely in his mid forties, his work seemed to increase in energy during his last decade.

References

Benvignat 1856, no. 46; Gonse 1877, 397; Pluchart 1889, no. 78; Berenson 1903, no. 1342; Berenson 1938, no. 1342; Berenson 1961, no. 1342; Viatte 1963, no. 56; Brejon de Lavergnée 1990, no. 6; Brejon de Lavergnée 1997, no. 393; Goldner 1997, no. 106.

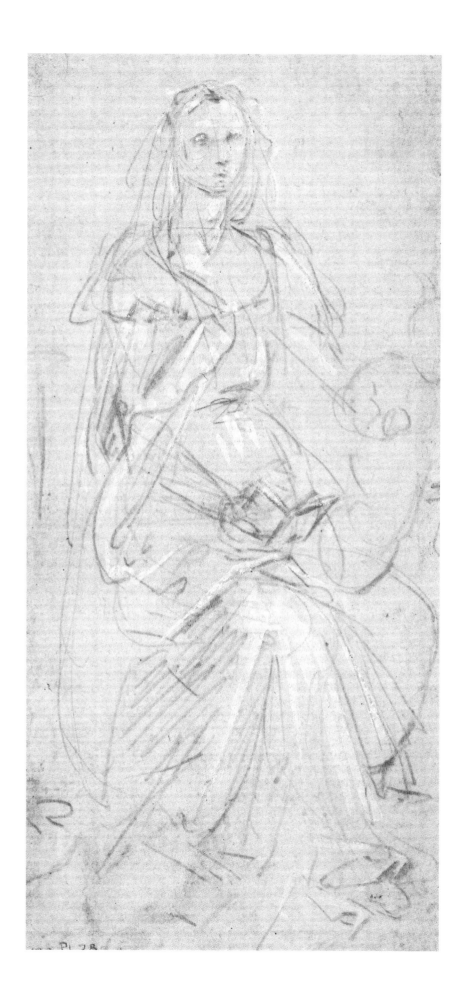

4. FILIPPINO LIPPI

Seated Man Raising His Right Arm

c. 1485

Metalpoint heightened with white on prepared paper, 170 x 99 mm

Filippino's graphic oeuvre includes a large number of figure studies, both draped and nude. They are often drawn two or three to a sheet, but the figures are generally unrelated to one another and, in the past, many sheets have been dismembered in order to create self-sufficient drawings. These studies are almost always made in metalpoint with the addition of white body color on prepared paper. Filippino used different colors for his grounds: often blue, gray, or blue-gray but also light brown and salmon-pink. Few of his studies of this kind can be connected with specific projects, and it seems clear that he and members of his studio made them to practice the representation of the movements both of nude and draped figures and of the expressive potential of drapery forms. Filippino's draperies are often of extraordinary complexity and vitality, and it is evident that he was fascinated by the activity of the inanimate, which can sometimes impart a wave-like motion to his compositions. Filippino, indeed, is one of the great exponents of movement in the later quattrocento. But, unlike his master Botticelli, he employs it less for concentrated and explosive dramatic purposes than in the service of an all-pervading agitation. In this respect he anticipates elements of the later style of Giulio Romano, who was surely aware of, and responded to, this and other aspects of Filippino's work.

The present drawing, however, is less complex in its pose and drapery forms than many of Filippino's metalpoint figure studies. That may be the reason it was re-attributed by Berenson to Davide Ghirlandaio in 1903, although Gonse gave it to Filippino in 1877. It was returned to Filippino only in 1956, following an opinion expressed by Popham in a communication to the Musée de Lille in 1948. As noted by Goldner in 1997, it is very close in type and style to a drawing in Frankfurt (fig. 4) that is similar in size, on paper prepared with a related if not identical color of ground, and looks to have been drawn from the same model. The two sheets could well have originated at the same session. They probably date from the first half of the 1480s; their forms have a Masaccesque substantiality, which intimates they were drawn not long after Filippino had completed work on the Brancacci chapel. No suggestion has been advanced as to the purpose of the two drawings, and they, too, may be no more than exercises. However, the pose in the present drawing, although not of that in Frankfurt, would be suitable for Christ in a composition of Christ crowning the kneeling Virgin. Indeed, it is not unlike that employed by Raphael and his school in the *Monteluce Coronation* (Pinacoteca, Vatican City) as it was completed in 1524.

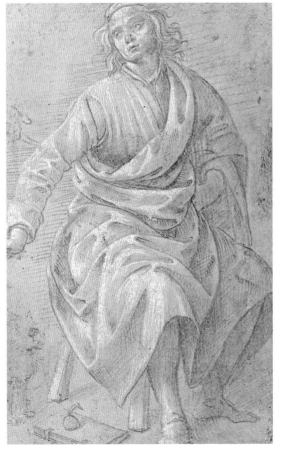

Fig. 4
Filippino Lippi. *Seated Man*, 1480s, metalpoint and wash on beige prepared paper, 173 x 105 mm. Städelsches Kunstinstitut, Frankfurt, 418.

References

Benvignat 1856, no. 247; Gonse 1877, 396; Pluchart 1889, no. 232; Morelli 1891–92, 443; Berenson 1903, no. 842; Berenson 1938, no. 842; Laclotte 1956, no. 142; Berenson 1961, no. 842; Viatte 1963, no. 53; Châtelet 1970, no. 52; Ragghianti and dalli Regoli 1975, no. 130; Brejon de Lavergnée 1990, no. 9; Brejon de Lavergnée 1997, no. 394; Goldner 1997, no. 39.

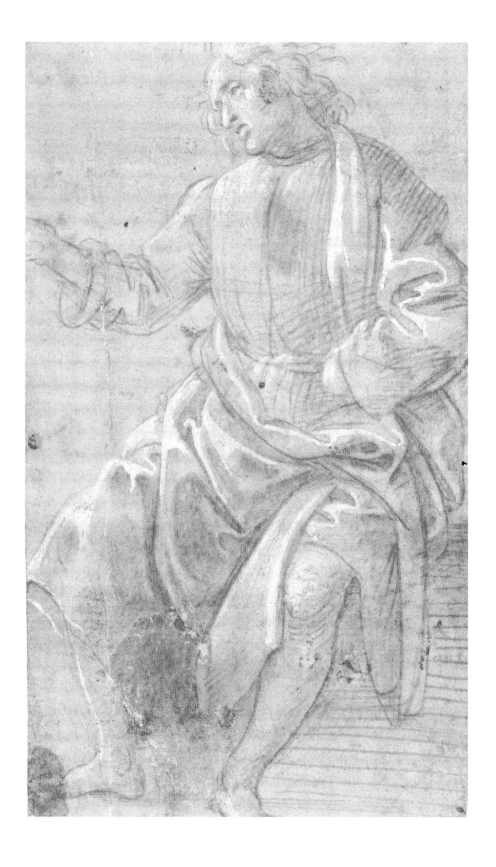

5. FILIPPINO LIPPI

A Seated Sibyl and Two Angels Holding Books

c. 1488

Pen and ink, 81 x 144 mm

Fig. 5
Filippino Lippi. *The Cumaen Sibyl,* c. 1490, fresco. Caraffa Chapel, Santa Maria sopra Minerva, Rome.

Although this drawing was given to Filippino by Gonse as long ago as 1877, that attribution was subsequently ignored. Filippino's authorship was not firmly established until it was recognized as his by Pouncey, whose attribution was published by Berenson in 1961. Pouncey suggested that the drawing was a study for the Cumaen Sibyl (fig. 5), one of four Sibyls frescoed in the vanes of the vault of the chapel of Cardinal Oliviero Caraffa in the Roman church of Santa Maria sopra Minerva. Executed by Filippino between 1488 and 1493, the Caraffa chapel was the most significant decorative scheme by a Florentine artist in Rome following the wall frescoes in the Sistine chapel of the early 1480s. It was a commission for which Filippino was recommended by Lorenzo the Magnificent, and it indicates the reputation he had by then acquired in his native city. Pouncey's attribution has not subsequently been questioned nor has a connection with the Caraffa chapel, but there has been some debate about which Sibyl this drawing prepares, since it displays features common to several. As Goldner has suggested, it was probably made before the poses of the Sibyls, and the roles of their attendant figures were finalized, and it could have served for more than one. It must be a chance survival from a large group.

It is, as Goldner has observed, Filippino's earliest securely datable pen drawing, and it is one of his liveliest and most enchanting pure pen drawings to survive. Filippino's penwork here displays consummate skill, and in a great variety of techniques. They range from dense crosshatching in the shadows through the parallel linework establishing the ground and the broader planes, formed, as Goldner notes "mainly with parallel strokes of a broad pen, made largely with highly charged sweeping lines that lend animation to the entire composition." Curved and even bracelet hatching is employed in the drapery over the Sibyl's right thigh and right arm to define the varying curvatures of their forms, and an inflected contour—probably Pollaiuolesque in inspiration—establishes the pose of the left-hand angel. Pen drawing of this level of verve and excitement is rare, but this manner was taken up by Raffaellino del Garbo and Piero di Cosimo, both of whom worked with Filippino during the 1490s. Certain features of the drawing also recall aspects of Michelangelo's early pen drawing, and that he had some familiarity with Filippino's graphic work should be considered. The Sibyl's pose, too, is of a complexity and contained energy that would have attracted Michelangelo. Raphael was deeply interested in Filippino's work and although no copies by him after the Caraffa chapel are known, he did study the vault figures in Filippino's Strozzi chapel in Santa Maria Novella in drawings of c. 1507 in Paris (Louvre, 3848 recto and verso) and recalled them a decade or so later in his designs of the *Four Evangelists,* engraved by Agostino Veneziano in 1518.

References
Benvignat 1856, no. 1153; Gonse 1877, 396; Pluchart 1889, no. 633; Berenson 1961, no. 1343; Viatte 1963, no. 54; Châtelet 1970, no. 53; Shoemaker 1975, no. 54; Brejon de Lavergnée 1990, no. 10; Griswold 1992, no. 47; Brejon de Lavergnée 1997, no. 397; Goldner 1997, no. 49.

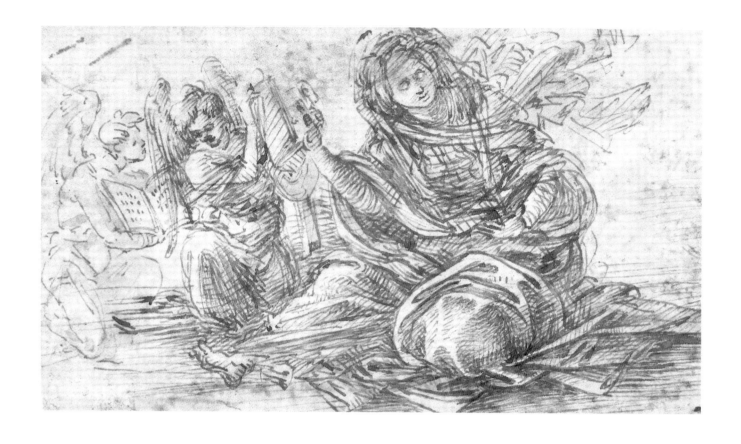

6. CIRCLE OF BENEDETTO DA MAIANO?

a. *Studies of Children* (recto)
c. 1500
b. *Two Banks of Choir Stalls* (verso)
Pen and ink with traces of black chalk,
170 x 179 mm

This sheet bears very different types of drawing. The recto carries a freehand study of putti; the verso has a small-scale design, made with ruler and compasses, for two banks of choir stalls. This double presence is a reminder that we should not be surprised to see different types of drawing made by the same hand at the same time. It also demonstrates the different roles an artist might perform. The sheet suggests the work of a lively figure draftsman, active also as a designer-architect. There were no hard and fast distinctions among roles, and many artists, such as Giuliano da Sangallo, were involved in sculpture and decorative design as well as architecture and painting. However, Giuliano is probably not the author of this sheet because his figure drawings are more closely dependent from Botticelli than the putti here, and the forms of the stalls are not near anything known by him. The earlier attribution of this sheet to Verrocchio has not

been followed by modern scholars. Although the recto drawing is vivacious and accomplished, and suggests knowledge of such drawings as Verrocchio's famous study of putti in the Louvre (fig. 6), the handling is sufficiently different to preclude the likelihood that they are by the same hand. As Lanfranc de Panthou has noted, Verrocchio's pupil Francesco di Simone Ferrucci can also be ruled out; his drawings, which are well known, entirely lack the vitality and verve of these sketches. They might have been drawn by a sculptor contemporary with Verrocchio, such as Benedetto da Maiano, who died only six years after Verrocchio, in 1494. The infants' lively movements have distinct similarities with those of the putti carved by Benedetto above the portal of the Sala dei Gigli in the Palazzo Vecchio in the second half of the 1470s, and he may have made similar carvings of putti later. But they were most likely made by an artist a generation younger, perhaps around 1500, demonstrating the continuity of rhythmically related figures, seen also in sketches by Piero di Cosimo and Filippino Lippi, between the work of

Fig. 6
Andrea del Verrocchio.
Putti, c. 1480?, pen
and ink, 158 x 209 mm.
Musée du Louvre,
Paris, RF2.

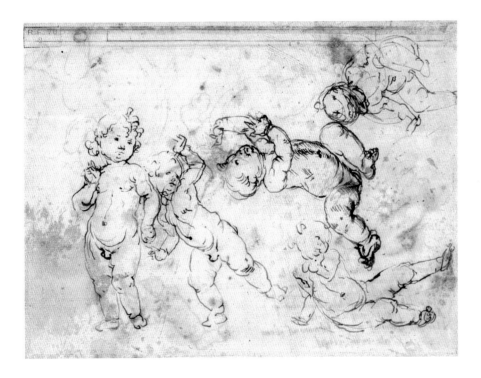

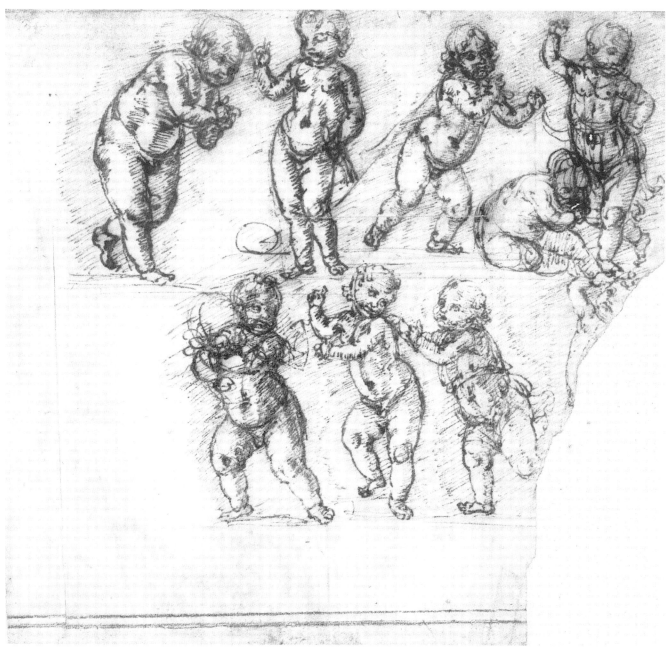

Cat. 6a

Verrocchio and Leonardo in the 1470s and the Florentine drawings of Raphael. Indeed, the arrangement of the pair on the far right comes close to one tried by Raphael in a drawing of 1505 in Vienna (Graphische Sammlung Albertina 207), a study for the *Madonna del Prato* painted in that year.

As a design for an elaborate piece of ecclesiastical furniture, the verso drawing is a relatively rare survival and of great interest. The two banks of choir stalls are of emphatically different types. The lower one is "Renaissance" in style; the upper is richly decorated with stiff leaf carving in a distinctly "Gothic" manner, and not a recent one at that. While the design of different banks of choir stalls within the same complex might vary, such extreme contrasts would not have been directly juxtaposed. The designer was no doubt offering alternatives, in Renaissance or Gothic manners, which returns us to Benedetto da Maiano, for there is also a connection between the verso and his work. The heavy scrolls of the lower Renaissance stalls resemble quite closely the supporting brackets of the Mellini Pulpit in Santa Croce, executed by Benedetto in the first half of the 1480s. But he is not known to have designed choir stalls. His brother Giuliano did—the celebrated "sede intarsiate" of the Duomo of Pisa, now largely lost—but they were begun in 1460, certainly too early for the present drawing.

References

Benvignat 1856, nos. 1419–20; Gonse 1877, 398; Pluchart 1889, nos. 564–65; Morelli 1891–92, col. 443; Gronau 1896, 66; Berenson 1903, 1: 37; Cruttwell 1904, 201; Popham and Pouncey 1952, no. 57a; Viatte 1963, no. 102; Châtelet 1970, no. 103; Brejon de Lavergnée 1997, no. 681.

7. Domenico Ghirlandaio

a. *Drapery Study for "Augustus and the Sibyl"* (recto)

c. 1480

b. *Decorative Motives* (verso)

Pen, 247 x 122 mm

Fig. 7b
Unidentified artist, after Raphael. *Copy of a Figure by Ghirlandaio and Other Studies* (original, c. 1507), pen and ink, 247 x 197 mm. Devonshire Collection, Chatsworth.

Fig. 7a
Domenico del Ghirlandaio. *Augustus and the Sibyl*, c. 1480, fresco, Sassetti Chapel, Santa Trinita, Florence.

Several scholars in the past attributed this drawing to Michelangelo, and although the opinion never gained wide acceptance, even De Tolnay, in 1975, was reluctant to detach it from his oeuvre. But its identification by Fahy in 1977 as a drapery study for Augustus in the *Augustus and the Sibyl* frescoed above the entrance of the Sassetti chapel in Santa Trinita (fig. 7a), a scheme on which Ghirlandaio worked between 1480 and 1485, effectively resolved the issue. Other scholars have demoted it (in the compiler's opinion too pessimistically) to the workshop of, or copy after, Ghirlandaio.

It is easy to see why Michelangelo's name arose. The drawing displays a controlled and effective crosshatching, and this style—like that Ghirlandaio sometimes employed for preparatory sketches in pen—was clearly significant for his one-time pupil. The crosshatching here is executed with a fine pen. While the majority of Michelangelo's cross-hatched pen drawings employ a somewhat wider pen, a more varied delivery of ink, and a less regular mesh than the present drawing, he too on occasion employed finer pen lines, as seen in the drawing recently discovered by Julien Stock at Castle Howard. Indeed, Stock's discovery has helped to demonstrate the indebtedness to Ghirlandaio of another facet of Michelangelo's drawing style.

The present drawing serves also as a bridge between the beginning and end of the Florentine quattrocento. It marks Ghirlandaio's assumption of the grand style, his rapprochement with the most heroic phase of Masaccio, whose frescoes the young Michelangelo was to copy in drawings of similar type. Furthermore, although the surface is hard, the command of shadows and handling of light is notably Lippesque (see cat. 2). Of course, the employment of dense crosshatching was not unique to Florence. But Florentine drawings of this kind, whose source may lie in Masaccio, are more varied and flexible than those developed in

the school of Perugino, particularly by Berto di Giovanni, who seems to have specialized in making impersonal copies of sections of Perugino's paintings in a technique anticipating the duller kind of reproductive engraving (see Ferino Pagden 1982). Raphael, whose omnivorous interest extended beyond the art of his immediate contemporaries to that of the preceding generation, certainly appreciated Ghirlandaio's vitality. At Chatsworth is a copy of a lost pen drawing by Raphael (fig. 7b) after a pen drawing by Ghirlandaio in the Uffizi (289E), whose handling he reproduced, although not slavishly; Raphael then employed Ghirlandaio's figure for the running Magdalene in his Borghese *Entombment*.

Raphael also, of course, studied Ghirlandaio's work in Santa Maria Novella. The *Coronation of the Virgin* on the end wall of the choir was an important referent for the heavenly section of Raphael's *Disputa,* and the front face of Ghirlandaio's high altarpiece (Alte Pinakothek, Munich), which shows the Virgin enthroned in the sun, was surely in Raphael's mind when he designed the *Madonna di Foligno* (Pinacoteca, Vatican).

References

Benvignat 1856, no. 246; Pluchart 1889, no. 231; Berenson 1903, no. 984; Berenson 1938, nos. 840A, 984, 1475A; Dussler 1959, no. 547; Viatte 1963, no. 118; Berti 1965, 2: 382; Châtelet 1970, no. 61; Fahy 1976, 8; Ames-Lewis 1981a, 87; Ames-Lewis 1981b, 51–52; Cadogan 1983, 285–86; Bambach Cappel 1990, 496; Brejon de Lavergnée 1997, no. 280; Cadogan 2001, no. 95.

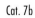

8. RAFFAELLINO DEL GARBO

Saint Bartholomew

c. 1510?

Pen and ink, black chalk, ocher wash, heightened with white, 215 x 106 mm

This badly damaged drawing, pounced for transfer, was made in preparation for an embroidered figure on an ecclesiastical vestment, although it has not been connected with a specific commission. No doubt its use for this purpose left it so depleted. A companion study representing Saint Nicholas of Bari (fig. 8), still more damaged, is also in Lille, and a number of other drawings made by Raffaellino for vestments are known. Two of them, in the Uffizi, of Saint Barbara and Saint Paul (347E and 348E), might have formed part of the same ensemble.

Although the forms demonstrate some knowledge of Perugino's work, they owe much more to Florentine art and they strongly suggest that Raffaellino was not responsible for other drawings, perhaps also made for embroidery (see cat. 14), in which Perugino's influence is all pervading. Here, the solidity of the form and the complexity of the drapery is close both to the work of Ghirlandaio—to whom the drawing was once attributed—and to that of Filippino Lippi, Raffaellino's master. The expressive range, in particular the type of the head and beard, is particularly like that of the latter, whose influence dominated Florentine art in the decade between Ghirlandaio's premature death in 1494 and Filippino's own premature death in 1504. However, Raffaellino's drapery forms lack the wild exuberance of Filippino's later work, and he retained a strong allegiance to the grander, more

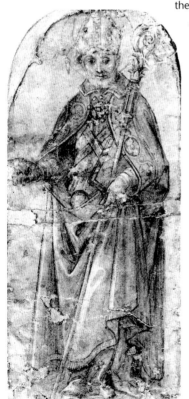

Fig. 8
Raffaellino del Garbo. *Saint Nicholas*, black chalk, pen and ink of two hues, brown wash and white body color on prepared paper, 216 x 100 mm. Palais des Beaux-Arts, Lille.

stately forms of Ghirlandaio, with whom he may also have worked in his youth.

Raffaellino, although not blessed with great powers of invention, was a painter of considerable talent and sensitivity and a designer of great competence. He clearly made designing embroidery something of a specialty, and it is likely that he communicated this taste and skill to Andrea del Sarto, who as Shearman plausibly suggested in 1965, may have worked for a period with Raffaellino. Andrea, the son of a tailor, was the Florentine artist of the succeeding generation who worked most extensively for embroidery (see cat. 52). Raffaellino also trained Agnolo Bronzino, and his penchant for highly finished, lustrous surfaces remained with his pupil. Raffaellino's influence may also account for Bronzino's habit, continued until quite an advanced stage in his career, of employing the quattrocento technique of making highly finished *modelli* on colored paper, in contrast to the practice of his second master, Pontormo.

The date of the present drawing and its companion is uncertain, but they were probably made c. 1510. Although Saint Bartholomew holds the knife with which he was flayed, the accent is not on his martyrdom but on his learning: the book takes precedence over the blade. The firm but complex organization of the drapery, which is subtly volumetric, suggests both delicacy and resolution. The pose implies statement rather than outward engagement, while Saint Nicholas of Bari, noted for his acts of charity, communicates directly with the viewer. His pose may, indeed, suggest knowledge of Saint Augustine in Raphael's *Madonna del Baldacchino* (Palazzo Pitti, Florence), in which case Raffaellino is more likely to have been debtor than creditor.

References
Benvignat 1856, no. 320; Gonse 1877, 399; Pluchart 1889, no. 264; Morelli 1890, 147; Berenson 1903, no. 633; Berenson 1938, no. 633; Berenson 1961, no. 633; Viatte 1963, no. 48; Châtelet 1970, no. 91; Westfehling 1990, no. 18; Brejon de Lavergnée 1997, no. 503.

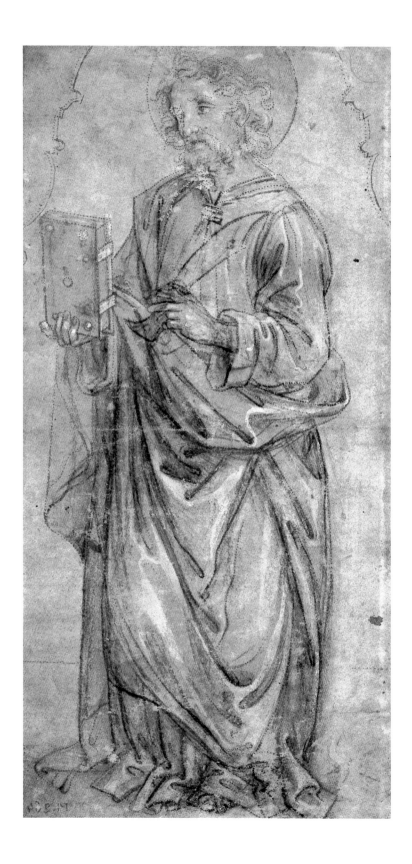

9. FRA BARTOLOMMEO

a. *Drapery Study, for "Saint Vincent Ferrer between Saints Roch and Sebastian"* (recto)
1495?

Metalpoint with white, with traces of black chalk, on gray-blue prepared paper

b. *Saint Sebastian* (verso)

Black chalk, 285 x 197 mm

The present sheet is both controversial and inherently fascinating. The recto study was published by Fahy, in brilliant articles reconstructing the early career of Baccio della Porta (who took the religious name Bartolommeo—by which he is universally known—only after 1500), as a study for the kneeling figure of Pandolfo Malatesta in the altarpiece of *Saint Vincent Ferrer between Saints Roch and Sebastian* (fig. 9), painted for the Malatesta chapel in San Domenico at Rimini. The painting is well documented. It was commissioned from Domenico Ghirlandaio in 1492 and worked on in 1493, apparently in Rimini rather than Florence, but was unfinished at Ghirlandaio's death in January 1494. It was completed, ostensibly by Davide Ghirlandaio, by September 1496, provoking complaints from the patrons. It is clear that the criticism primarily concerned the figures of the donor and the three members of his family who kneel in the lower register. On the expulsion of the Malatesta from Rimini in 1528, their figures were covered, only to be brought to light again in 1924. All scholars are agreed that the lower section bears little resemblance to work of the Ghirlandaio studio, and that it must have been completed by other artists. No documentary evidence links the young Baccio—already active as an independent master—with the altarpiece, nor does he have any documented association with the Ghirlandaio studio. However, as Fahy pointed out, there is a strong resemblance between the head types of the portraits and that of the archangel Gabriel in his earliest surviving securely dated work, the *Annunciation* of 1497 in the Duomo at Volterra. While there remains a margin of uncertainty, as Fischer has noted, Fahy's bold attribution has proved remarkably resilient. Given that the altarpiece was not executed in Florence, Bartolommeo, as the most talented young artist available in Florence in the mid 1490s (an unpropitious moment for commissions), might have been subcontracted by Davide Ghirlandaio to go to Rimini to finish it.

Fahy's attribution is supported—but also complicated—by the drawings. At least six sheets have been connected with the Malatesta donors. All are in metalpoint supplemented with washes and white body color on prepared paper of varying colors. The present drawing is clearly for Pandolfo, and others prepare the figures of Pandolfo's wife and son. Two of the sheets, those in the Uffizi (13279F) and formerly in the Drey Collection, also bear studies of the Virgin and Child that are inherently Bartolommesque. The resemblance of the metalpoint technique to that of Lorenzo di Credi, which might seem to count against Bartolommeo's authorship, in fact supports it since the drapery forms and the surface qualities of the Volterra *Annunciation* reveal that he looked closely at Credi.

Fig. 9
Domenico Ghirlandaio and others. *Saint Vincent Ferrer between Saints Roch and Sebastian with the Malatesta Family*, 1492–96, oil on panel, 198 x 230 cm. Pinacoteca, Rimini.

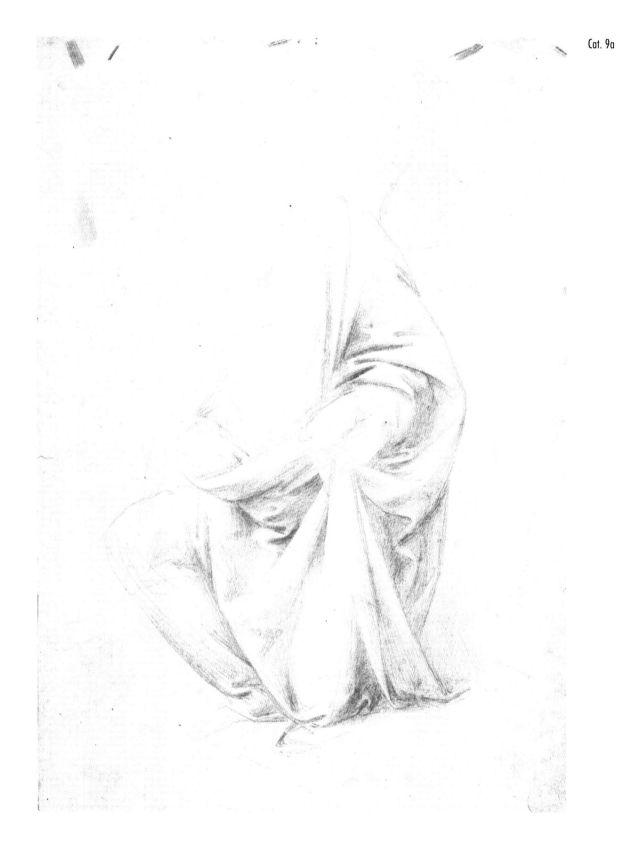

This is not to say that all the difficulties of attribution have been resolved. The present study, for example, seems less accomplished than a flowing, luxuriant, and more Leonardesque study in the British Museum (Turner 1986, no. 27), which might also be a study for Pandolfo. But since the Lille drawing is much closer to the pose of Pandolfo as painted, it must succeed the London sheet, implying regression on Bartolommeo's part. Alternatively, it might be argued that several artists competed for, or collaborated on, the project, but no plausible candidates have been put forward for the other drawings and subdividing them among different hands creates more problems than it solves. Thus, while in principle Mariotto Albertinelli, Bartolommeo's partner, might share responsibility for some of the drawings, this has not been demonstrated. It therefore seems best, at present, to leave them under Bartolommeo's name. At all stages of his career, Bartolommeo was inclined to repetition, and the British Museum drawing might represent a subsequent reworking of Pandolfo's pose for another, unexecuted, project.

The presence of Saint Sebastian on the verso could be taken as evidence that Bartolommeo was also involved in designing the altarpiece's upper register. But the saints are securely by Ghirlandaio. Sebastian is close to other figures in his work, and Roch is posed in a manner based on a Donatellesque *David,* seen in a relief in the Tempio Malatestiano. The Saint Sebastian here, posed in a form dependent from Perugino, is unrelated to the Rimini commission and was probably planned for a single-figure pillar altarpiece, a type quite common in Florence of which examples exist by Botticelli and Botticini among others. Perugino remained a significant influence on Bartolommeo's work for some years, and at this point in his career he may have been on the verge of discovering Perugino's value. Bartolommeo took up this pose of Saint Sebastian again in 1512 in a preparatory drawing for the unexecuted Panciatichi Altarpiece in the Uffizi (Fischer 1990a, fig. 160).

Black chalk was the medium most favored by the artist in later years, but while this drawing does not particularly resemble the figure studies in that medium that he later executed, the structure of the torso, notably the geometrical alignment of the breastbone and the definition of the head, remain constants. In style and technique it has something about it of Signorelli, who had been active in Florence c. 1490. It may be that c. 1495–96, Fra Bartolommeo was still a debutant in black chalk.

References

Benvignat 1856, no. 376; Pluchart 1889, no. 193; Berenson 1903, no. 2763; Berenson 1938, no. 2763; Berenson 1961, no. 2763; Viatte 1963, no. 119; Fahy 1966, 456–63; Dalli Regoli 1966, 201; Châtelet 1967, no. 16; Fahy 1969, 150; Châtelet 1970, no. 17; Griswold 1987, 514; Fischer 1994, no. 1; Brejon de Lavergnée 1997, no. 47; Cadogan 2001, 270–73.

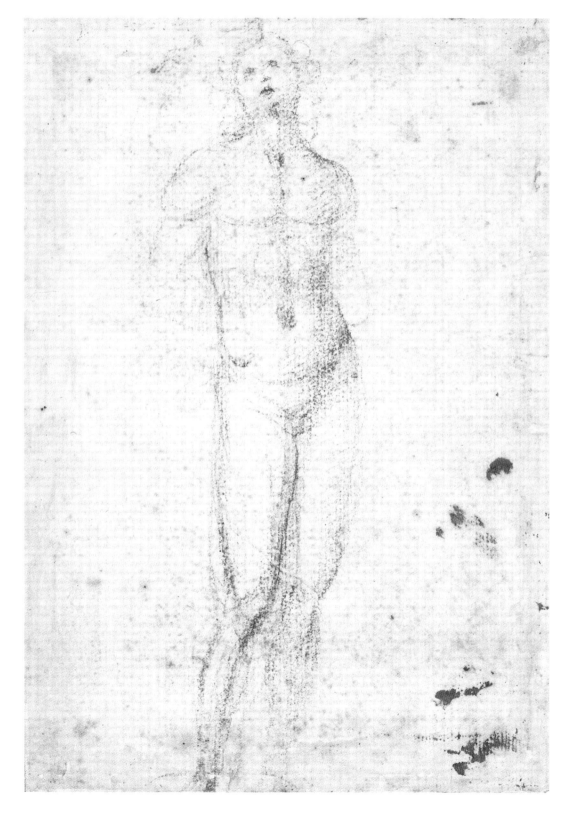

10. Fra Bartolommeo

A Draped Figure from the Back, for the "Last Judgment"

1499

Black chalk heightened with white,
280 x 147 mm

Fig. 10
Fra Bartolommeo and
Mariotto Albertinelli.
The Last Judgment,
1499–1501, fresco.
Museo di San Marco,
Florence.

This drawing's connection with the fresco of the *Last Judgment* (fig. 10), proposed by Viatte, was confirmed by Holst and Borgo. Several scholars have linked the breadth and grandeur of this figure to the tradition of Giotto and Masaccio, and Fischer notes that a response of comparable power at this period is found only in the drawings of Michelangelo. Both owed a debt to Ghirlandaio, the most significant master of the grand style in Florence in the immediately preceding period, Michelangelo's master, and a posthumous collaborator of Bartolommeo.

But the density and richness of this drawing, its freshness and frankness of definition, transcend anything known by Ghirlandaio or even Luca Signorelli, the most persistent black chalk draftsman of his generation. Bartolommeo, of course, studied Signorelli (some of the figures in the lower level of the *Last Judgment* are directly derived from him), but even access to Signorelli's drawings would not explain the present study, for nothing that survives by Luca remotely approaches it, either in the breadth of handling or the force of chiaroscuro. Perhaps the depth of emotion that Bartolommeo evoked here was influenced by the increasing religious conviction—heavily affected by Savonarola's preaching—that culminated in his entering the Dominican order in July 1500. This study of a monk confronting damnation conveys a remorse and depression all the more affecting for their internalization. This sinner's acceptance of justice is expressed not with gestures of fear, but in compactness and withdrawal. The light he rejected falls powerfully upon his back; his shadowed front anticipates his unending night.

The *Last Judgment* was commissioned from the company of Bartolommeo and Albertinelli in January 1499. It was completed by the latter in March 1501, Bartolommeo having begun his novitiate in the Dominican monastery at Prato in July 1500. Most of the preparatory drawings were made by Bartolommeo, and they demonstrate a great variety of technique, anticipating Raphael's employment of different media in the drawings for the *Disputa* whose debt to the *Last Judgment* is fundamental.

Some of them for the upper section are in metalpoint, similar in handling to the studies for the Rimini altarpiece. Indeed, a study for the upper section (Collection of Her Majesty Queen Elizabeth II, Windsor Castle), bears on its verso an outline study of a woman that could well be for Pandolfo's wife. But these drawings were then worked up in a series of splendid sheets executed in black chalk heightened with white, completed with studies of the drapery of the judging Christ in brush and tempera on linen. This contrast between relative timidity and great confidence within the preparatory stages can also be seen in the drawings for the figures on the lower level, many of which are executed in delicate pen lines. Gradually the Frate's preparatory processes became more homogeneous. But at this early period, the contrast not merely in technique, but in the power with which those techniques are employed, is revelatory.

References
Berenson 1903, no. 393; Berenson 1938, no. 393; Berenson 1961, no. 393; Viatte 1963, no. 39; Holst 1971, 283; Borgo 1976, no. 13; Brejon de Lavergnée 1989, no. 12; Fischer 1994, no. 11; Brejon de Lavergnée 1997, no. 41.

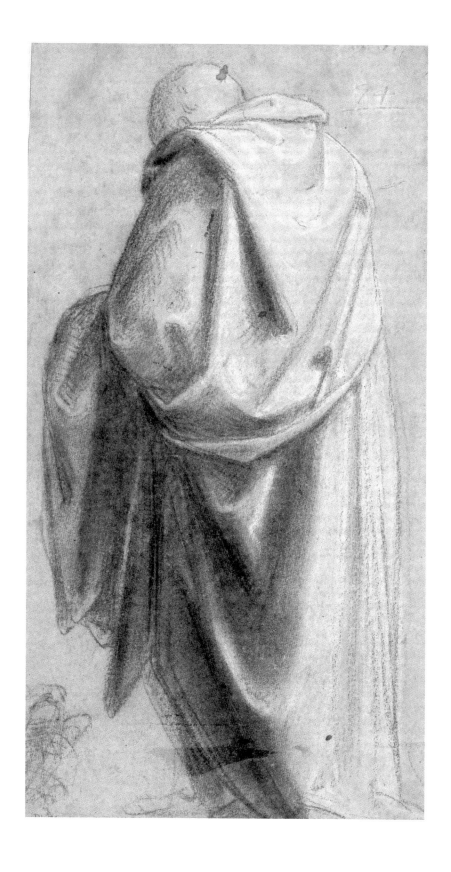

71

11. FRA BARTOLOMMEO

a. *Two Heads of a Saint, Three Studies of Hands, and Bust Study of Christ Carrying the Cross* (recto)

1511 or 1514

b. *Full-Length Study of Saint Vincent Ferrer* (verso)

Red chalk on white paper
210 x 260 mm

This drawing contains detail studies for *Saint Vincent Ferrer* and *Christ Carrying the Cross,* two works now in the Museo di San Marco in Florence. The first study, for *Saint Vincent Ferrer,* was well documented by Vasari. The picture was commissioned by the brothers of Fra Bartolommeo at the monastery of San Marco. According to the anonymous author of the *Codex Magliabacchiano* (about 1516), the work was destined for the altar of the sacristy but was placed above the door leading from the church to the sacristy, which is where Vasari saw it.

Originally, the expressive gesture pointed to a little tondo that treated the theme of Christ at the Last Judgment and was placed at the top of the frame, which was then in the form of a pinnacle. Clearly this work alluded to Saint Vincent Ferrer's sermon on the Last Judgment, which brought many Catholics back to the Church. Painted about 1511, the picture quickly deteriorated. When Vasari published the revised edition of his *Lives* in 1568, the picture was already damaged. "It is a shame that the work is spoiled and does not cease to crack, because the colors were placed upon a fresh ground." Therefore, the drawings give us the best image of the saint, with "an attitude and expression that have the violence and pride of preachers when they strive,

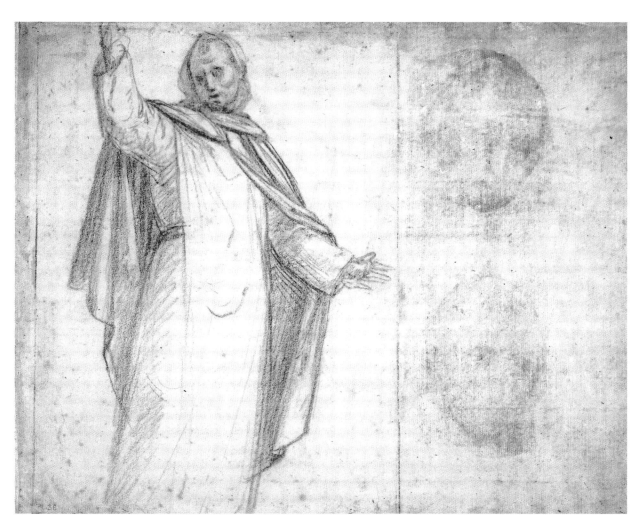

Cat. 11b

through the threat of God's Justice, to lead men toward a perfect life of purity." (Vasari 1879, 4: 189)

Other studies of Saint Vincent in the Boymans Museum in Rotterdam were carefully analyzed by Fischer (1990a). The Lille sheet is interesting primarily because of the variety in the page layout—both on the verso, where the saint is seen from afar and possesses a monumental and vigorous style, and on the recto, where the faces appearing just on the surface of the paper give it a great delicacy. The red chalk served the artist marvelously, permitting precision and being "an ideal technique for rendering skin, muscles, faces, and limbs," according to Fischer in 1994.

Barbara Brejon de Lavergnée

References

Benvignat 1856, nos. 252–53; Gonse 1877, 402; Pluchart 1889, nos. 37–38; Morelli 1891–92, 377; Berenson 1903, no. 2724; Knapp 1903, 319; Gabelentz 1922, 1: 165–69, 2: no. 259; Berenson 1938, no. 2724; Bacou 1957, 62; Berenson 1961, no. 2724; Viatte 1963, no. 45; Fischer 1990a, 199, 201, figs. 114–15, 187 n. 23; Fischer 1990b, 204 and fig. 19; Fischer 1994, no. 65; Brejon de Lavergnée 1997, no. 44.

12. FRA BARTOLOMMEO

a. *Saint Francis and Saint Dominic Embracing, Reprise of One of the Two Saints, Drapery Study, and Two Studies of a Little Seated Figure* (recto)

c. 1511

b. *Semi-reclining Man* (verso)

Black chalk with white heightening on beige prepared paper, 214 x 276 mm

Three of the studies that appear on the recto of this sheet are preparatory sketches for *The Mystic Marriage of Saint Catherine,* dated 1511 (fig. 12). Today this work is in the Louvre, but originally it was in the church of San Marco in Florence. The retable represents the spiritual marriage of Saint Catherine of Siena with the infant Jesus in the presence of the Virgin and eight saints. The story is told in *The Legend Maior,* written between 1385 and 1395 by the saint's confessor, Raymond de Capua.

The drawing on the recto includes two studies of Saints Francis and Dominic embracing. Here Fra Bartolommeo has illustrated a passage from *The Golden Legend,* the collection of readings on the lives of the saints compiled in the thirteenth century by Jacobus de Voragine, a Dominican cleric who was beatified in the nineteenth century: "Saint Dominic recognized [Saint Francis] from his dream. Throwing himself in his arms, he kissed him with piety and said, 'you are my companion, you follow the same course as I: let us stay together, and no adversary will triumph.' Saint Francis told him that he had experienced exactly the same vision: and from that moment on, they shared one heart and soul."

These two studies in black chalk represent a stage in the elaboration of the picture. The artist set off the modeling by adding white heightening to the black chalk. The motif of embracing was dear to Bartolommeo and recurs frequently in his work. A drawing in Rotterdam, *Two Studies of Saint Francis and Saint Dominic Embracing* (Boymans-van Beuningen Museum M 122), is similar to

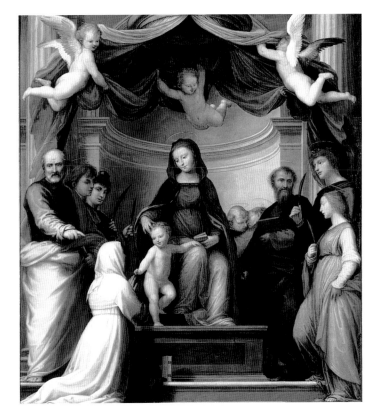

Fig. 12
Fra Bartolommeo. *The Mystic Marriage of Saint Catherine of Siena,* 1511. Oil on panel, 257 x 228 cm. Musée du Louvre, Paris.

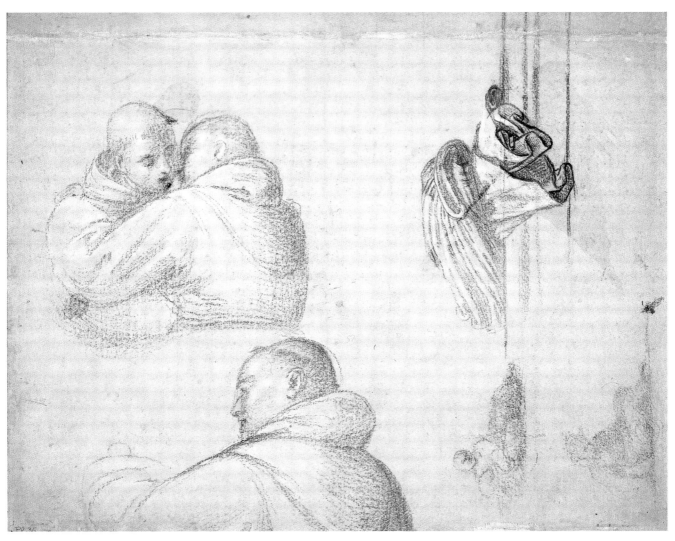

this study in that the artist sketched the brothers' embrace twice. The theme appears for the first time in a drawing in Berlin (Kupferstichkabinett KdZ. 1547 verso) representing the two saints in a medallion that dates from the end of the 1490s. One also finds the gesture of the two saints in a lunette of the Ospizio della Maddalena near Le Caldine in Italy. This fresco is one of the artist's last works, executed between 1514 and 1517 according to Fischer 1994. The embrace symbolizes the alliance of the two orders that Christ designated in the dreams to fight against avarice and pride.

Fischer (1982) identified several preparatory drawings for the composition of *The Mystic Marriage of Saint Catherine:* this one in Lille, another in the Uffizi in Florence (408), and the last in the Victoria and Albert Museum in London (Dyce 150). In each, the two saints embrace in the foreground of the composition, at the foot of the Virgin. In the retable they appear in the background, a modification likely requested by the Dominicans of the monastery, since the Franciscans were in fact partly responsible for the arrest and execution of Savonarola, the prior of the monastery, who had established a new constitution in Florence.

There is also a sketch of a drapery on a stairway on the recto. Gabelentz recognized that it was a preparatory study for the drapery in the foreground of the *Mystic Marriage of Saint Catherine.* Here again the artist used a contrast of shadows and lights for modeling.

Finally, on the verso is a study of a seated man related to the small figure on the recto just below the drapery. The verso figure is rapidly sketched, and Gabelentz has connected it with the Visconti Venosta tondo of the Museo Poldi Pezzoli in Milan, in which Joseph adopts the same posture.

Barbara Brejon de Lavergnée

References

Benvignat 1856, nos. 251, 254; Merson 1862, 2: 166; Gonse 1877, 401–2; Gruyer 1886, 41; Pluchart 1889, nos. 36, 39; Berenson 1903, no. 394; Knapp 1903, 264, 318–19; Gabelentz 1922, 2: no. 258; Venturi 1925, 9: part 1, 290 n. 1, fig. 203; Berenson 1938, no. 394; Berenson 1961, no. 394, 3: fig. 395; Viatte 1963, no. 43, 43 bis; Fischer 1982, 173, fig. 9; Fischer 1990a, 211, 213, 249, 251, 287 n. 33, 290 n. 112; Fischer 1994, no. 60; Brejon de Lavergnée 1997, no. 43.

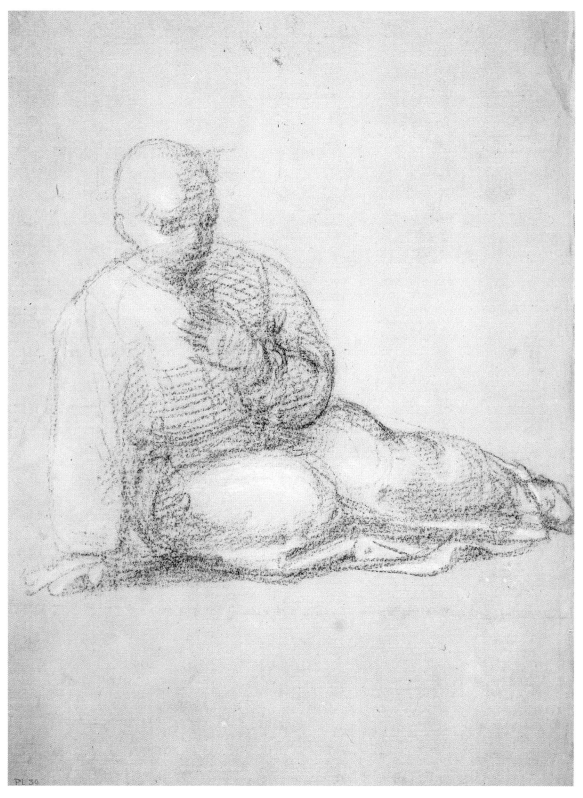

PL 30

13. FRA BARTOLOMMEO

The Virgin and Child Enthroned with Saint Anne and Other Saints

1510

Black chalk heightened with white
351 x 285 mm

Fig. 13
Fra Bartolommeo.
The Virgin and Child Enthroned with Saint Anne and Other Saints,
oil and charcoal on panel,
356 x 270 cm. Museo di San Marco, Florence.

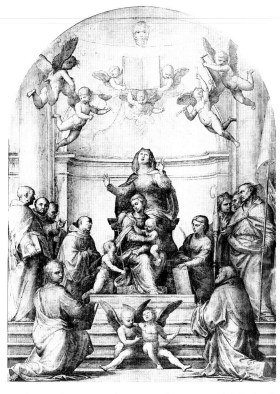

This drawing, as all scholars have realized, is a study for the altarpiece of the *Virgin and Child Enthroned with Saint Anne and Other Saints* (fig. 13) commissioned from Fra Bartolommeo in November 1510 for Florence's great council hall in the Palazzo Vecchio by the government of the republic. Abandoned when the republic was overturned in 1512, it would have been the grandest of all the Frate's panels.

The commission had originally been awarded to Filippino Lippi, and why the government waited six years to transfer it to the Frate is unclear. The planned layout of the hall is still disputed, but the altarpiece was probably to be placed in the lower center of the west wall. Facing it, on a higher level, would have unfurled the murals of republican victories. But by 1510 it was clear that Leonardo would never complete his *Battle of Anghiari;* of the *Battle of Cascina* from Michelangelo, who was detained in Rome in work for Pope Julius II, there was little hope. Perhaps the 1510 commission signaled a new beginning and the hope that, with the chamber's spiritual center in place, the historical episodes would follow.

The iconography focuses on city and republic. Saint John, Florence's patron saint, joins the holy group; Saint Anne, the Virgin's mother, on whose feast day in 1348 the tyrant duke of Athens was expelled, raises her arms in wonder at the sight of the Trinity and the angels carrying books bearing the Alpha and Omega. According to Vasari, the saints depicted are those on whose days notable Florentine victories were achieved, thus maintaining the martial theme of the unexecuted murals.

The commission was the largest the Frate had received since the *Last Judgment* and the single most important of his career. It identified him as Florence's most important resident artist. His preparation was of exceptional care; that the painting was virtually completed as a massive drawing awaiting only the superposition of colors—not his standard method of laying in a composition—demonstrates the effort he put into it. By then, Fra Bartolommeo had largely abandoned pen. Chalk was used at all stages of preparation to establish both breadth of effect and homogeneity of tone. Here the main standing figures seem to be established in their poses, with only the angels before the throne left to be finalized. But, in the event, virtually everything was changed. Without the central group, the drawing could not be connected securely with the Palazzo Vecchio commission. Yet, although the process evinces obsessive care on Fra Bartolommeo's part, it is one of ever greater local refinement within a scheme whose main lines are determined. That the internal space of the altarpiece should be a continuation of the hall, thus establishing a direct human relation between the saints within the painting and the representatives of the republic, was probably a requirement of the commission.

References
Brejon de Lavergnée 1989, no. 14; Fischer 1994, no. 56; Brejon de Lavergnée 1997, no. 45.

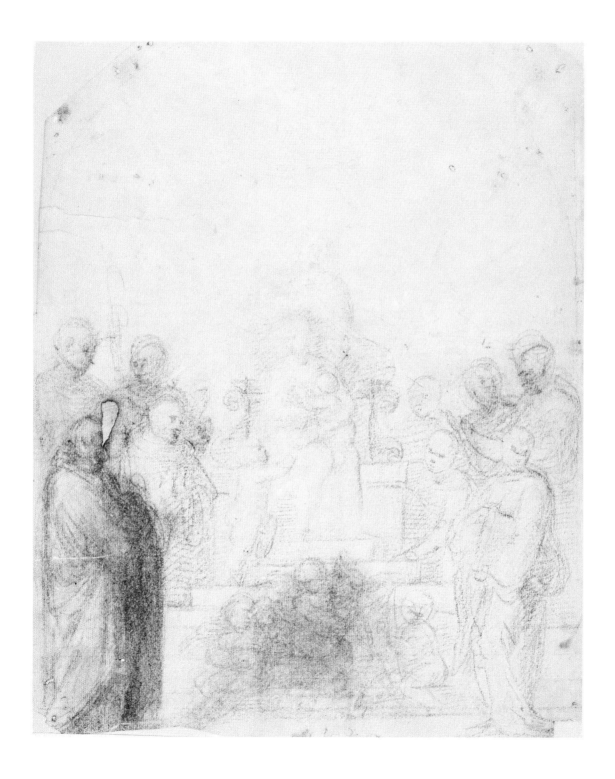

Drawing
in Umbria

around 1500

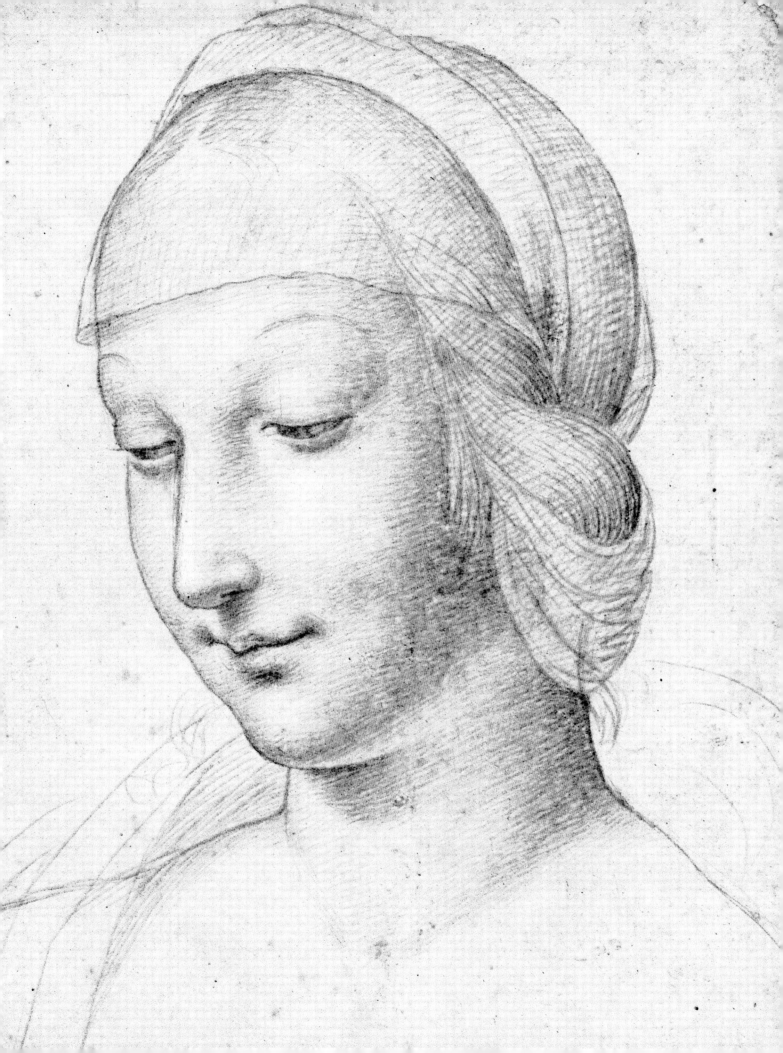

14. Circle of LO SPAGNA

a. *Saint Louis of Toulouse*

c. 1508?

b. *Saint Francis*

c. 1508?

c. *Saint Agnes*

c. 1508?

d. *Saint Catherine of Sweden?*
(Saint Claire?)

c. 1508?

Black chalk, pen and ink, wash,
heightened with white, 126 mm diam.

The function of these drawings—four out of a group of five roundels owned by the Palais des Beaux-Arts that are identical in size and technique—is uncertain. They may have been made for execution in embroidery on an ecclesiastical vestment, perhaps part of an altar cloth rather than a cope. Alternatively, they might prepare roundels to go beneath an altarpiece. Such arrangements, in place of narrative panels, were common in Umbrian predellas (fig. 14).

Two of the roundels, those depicting Saint Bernardino of Siena and Saint Catherine of Sweden (Saint Claire would also be a possibility), include framing decoration in the form of looped ribbons. This pair was presumably intended to be placed in a special relation, distinct from the other three. The complement of saints might suggest a Franciscan commission, but it is difficult to be certain. Whether the five roundels created the whole or whether the scheme might have contained other elements is also entirely conjectural.

These drawings were attributed by Berenson to Raffaellino del Garbo as copies after Perugino and are

Fig. 14
Unidentified Umbrian artist (circle of Lo Spagna), *The Blessed Giacomo della Marca*, oil on panel, diam. 15.3 cm. Current location unknown.

currently classed as from Raffaellino's studio, following a suggestion by Pouncey, who also considered Bartolommeo di Giovanni. While they have generally been thought of as Florentine, there seems to the compiler to be no secure basis for this view. Because embroidery design was a specialty of Raffaellino, it is easy to understand why they were linked with his name. His antecedents and sources are primarily Florentine, yet none of his secure surviving work shows a close relation to Perugino's forms and ideas. Both the heads and the draperies here are much less plastic in modeling than the design by Raffaellino discussed in cat. 8. In any case, as Berenson acknowledged, all the figures are highly Peruginesque, and they should surely be attributed to an artist in his immediate circle.

Although Perugino is the dominant influence on the poses, draperies, and facial types, none of the figures is an exact reproduction of a known work by him. The arrangement of the roundels of Saints Bernardino and Francis—with right arm bent at the elbow and aligned horizontally with the waistband of the habit—is a Peruginesque cliché, but his use of this formula is rarely so rigid. Similarly, the folded arms of Saint Agnes and the vertical fall of her mantle are more severe and restricted than in any prototype by Perugino. Following Pluchart, Viatte tentatively advanced the name of Spagna as the author of these drawings. Although this suggestion was rejected by Gualdi Sabatini in her monograph on the artist, the compiler, too, feels these drawings come close to Spagna's purified and schematized versions of Perugino's forms. Another candidate is Andrea d'Assisi, known as l'Ingegno, who also practiced a solid and restrained type of Peruginism, but no drawings by him have yet been identified.

References

Benvignat 1856, nos. 1113–116; Pluchart 1889, nos. 517–20; Berenson 1938, nos. 635–38; Berenson 1961, nos. 635–38; Viatte 1963, nos. 151–54; Gualdi Sabatini 1983, 362; Brejon de Lavergnée 1997, nos. 506–9.

Cat. 14a

Cat. 14b

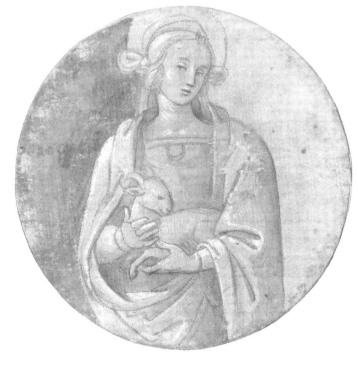

Cat. 14c

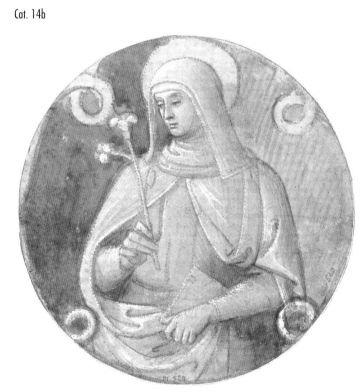

Cat. 14d

15. EUSEBIO DA SAN GIORGIO (attributed to)

Head of a Woman

c. 1505

Black chalk, 152 x 120 mm

Fig. 15a
Eusebio da San Giorgio. *Head of a Woman,* c. 1505, black chalk, 162 x 155 mm. Current location unknown (formerly in the Gathorne Hardy Collection; sold at Sotheby's London, 24 November 1976, lot 10).

Fig. 15b
Raphael and associate. *The Northbrook Madonna,* c. 1505, oil on panel, 58 x 42.7 cm. The Worcester Art Museum, Massachusetts, Bequest of Mary G. Ellis as part of the Theodore T. and Mary G. Ellis Collection, 1940.39.

This drawing and another similar one, certainly by the same hand (fig. 15a), are generally attributed to Eusebio da San Giorgio. In both, the lines lie heavily on the bonnet and mouth. The necklines are pedantic. Hair on the right curls round behind the neck and spikes outward from the left-hand side of the face. The facial types in both drawings resemble the ovoid formulation of the Virgin's head in Raphael's *Ansidei Altarpiece* (National Gallery, London), but whereas in that painting Raphael adjusted the Virgin's eyelids so that she gazes convincingly downward, the half-lowered eyelids in both drawings give the faces a sleepy expression, implying that the artist, too, was not fully awake to Raphael's achievements.

Eusebio seems to have been born around 1460, and numerous paintings by him survive, the majority in Perugia and its environs. Most are routine in composition and figural detail, and it is evident that Eusebio was a competent artisan rather than a creative artist. Some elements in his later works reveal Raphael's influence, but Eusebio did not attain any understanding of Raphael's inventiveness in interval, employment of space, or dramatic characterization. He is documented as working with Timoteo Viti, and his knowledge of Raphael's work may have come as much from Timoteo as directly from Raphael. In its simplification of Raphaelesque form, the present drawing bears some relation to one in the British Museum by Timoteo Viti (Pouncey and Gere no. 262), even though that one is broader and softer, the qualities of chalk more fully exploited.

Nevertheless, a closer association with Raphael cannot be ruled out. Eusebio was one of the first artists in Umbria to respond to the younger man's work and might have collaborated with him. The type of the head of the Virgin in the present drawing is very like that of the *Northbrook Madonna* (fig. 15b), a painting that hovers on the margin of Raphael's oeuvre and which has sometimes been attributed, as a whole or in part, to Eusebio. The panel was certainly designed by Raphael, by whom a preparatory drawing for the Christ child of perhaps 1505 survives in the Ashmolean Museum (Parker no. 524 verso, laid down), but it may well have been executed in part by another artist. Raphael no doubt turned some lesser commissions over to others, and on occasion certainly provided his friends with drawings for works that they undertook by themselves (see cat. 34). But it is difficult to see how a painting such as the *Northbrook Madonna,* imbued with Raphaelism—the type of the Virgin is very close to that in the *Ansidei Altarpiece*—could have been executed even in part by Eusebio acting alone, and if he was involved it must have been under Raphael's close supervision and, presumably, in his workshop.

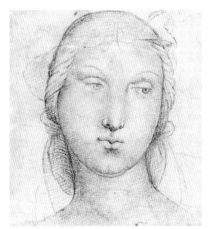

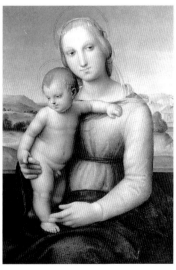

References
Benvignat 1856, no. 675; Pluchart 1889, no. 460; Fischel 1917, no. 146; Ferino Pagden 1982, 59; Viatte and Goguel 1983, 322; Westfehling 1990, 68; Brejon de Lavergnée 1997, no. 205.

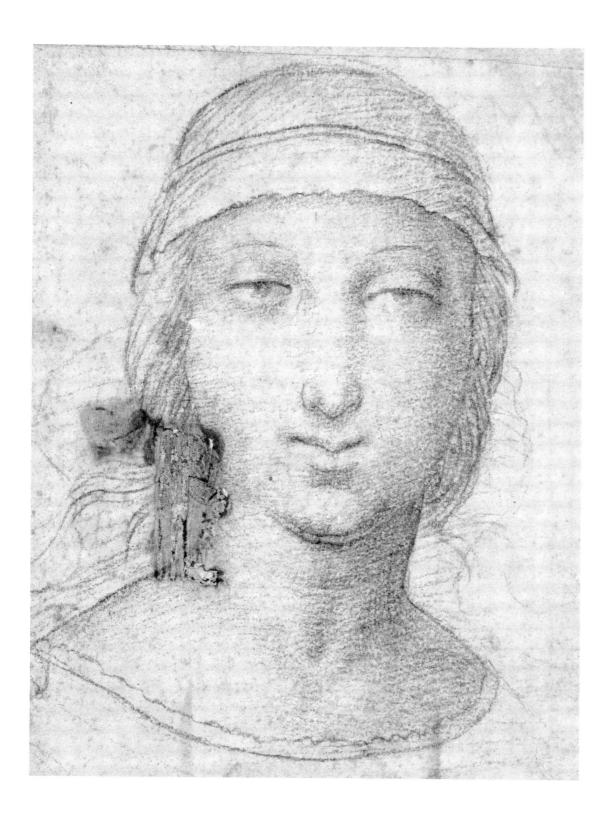

16. EUSEBIO DA SAN GIORGIO (attributed to)

Bust of a Woman

c. 1507

Black chalk, 300 x 220 mm

Fig. 16a
Raphael. *The Bridgewater Madonna*, c. 1507, oil on panel transferred to canvas, 82 x 57 cm. Duke of Sutherland Collection, on loan to the National Gallery of Scotland, Edinburgh.

Fig. 16b
Eusebio da San Giorgio. *Virgin and Child with Saints Peter, Paul, Catherine, and Agatha*, dated 1509, oil on panel, 271 x 209 cm. Galleria Nazionale dell'Umbria, Perugia.

The formulation of this head and bust displays knowledge of the later Florentine Madonnas of Raphael, those in which the artist tried to emulate the flowing mobility of the Virgin and Child and Holy Family compositions executed by Leonardo after his return to Florence in 1501. It is particularly closely related to the head and bust of Raphael's *Bridgewater Madonna* (fig. 16a), a painting whose composition emulates Leonardo's *Madonna of the Yarn Winder* (Duke of Buccleuch Collection, Drumlanrig Castle, Scotland). A closer variant of Leonardo's painting, no doubt after a lost drawing by Raphael, is to be found on page 8r of the Venice sketchbook (see cat. 19). In the present drawing the cast of the features reveals this filiation, since they are more Leonardesque than those of Raphael's painting.

The hatching is painstaking and careful, close in type to Raphael and much influenced by his metalpoint drawings of c. 1504–5. Like the previous drawing, it is made with a sharpened chalk handled as though it were metalpoint. It would seem that these drawings were made by an artist who, if not actually working with Raphael at the beginning and end of his Florentine period, had an intimate knowledge of his paintings and, more significantly, of his drawings.

The attribution to Eusebio da San Giorgio was made by Fischel—following Pluchart, who had first connected this drawing with a figure in Eusebio's altarpiece of the *Virgin and Child with Saints Peter, Paul, Catherine of Alexandria, and Agatha* once in the church of San Agostino in Perugia (fig. 16b). Commissioned in 1506 and dated 1509, the altarpiece is a technically competent but unimaginatively Raphaelesque work, partly based on his two Perugian sacra conversazioni: the *Ansidei Altarpiece,* then in the church of San Fiorenzo; and the *Pala Colonna* (Metropolitan Museum of Art, New York), then in the convent of San Antonio. That there is a connection between the drawing

and the bust of Saint Catherine seems clear, but it is hard to credit that the drawing was made with Eusebio's saint in mind—the present image is complete in itself and was probably intended for a bust-length saint; it could even have been a portrait. Furthermore, the figure in the drawing is lit sharply from the right whereas in the altarpiece light falls from the left. It was no doubt made for another purpose and re-used in the altarpiece.

That Eusebio knew this drawing and adapted it for his own purposes is not proof that he executed it—he could have made use of a group of drawings executed by an artist closer to Raphael than himself. But in the current state of knowledge there is no other artist to whom it might more plausibly be given, and it must be assumed that Eusebio gained access to drawings made by Raphael after 1505, perhaps on one of Raphael's return visits to Perugia or, conceivably, on a visit of his own to Florence. Although Eusebio is not recorded outside Umbria, he could have made excursions to Tuscany.

References
Benvignat 1856, no. 680; Pluchart 1889, no. 489; Fischel 1917, no. 145; Ferino Pagden 1982, 59; Viatte and Goguel 1983, 322; Westfehling 1990, no. 17; Brejon de Lavergnée 1997, no. 206.

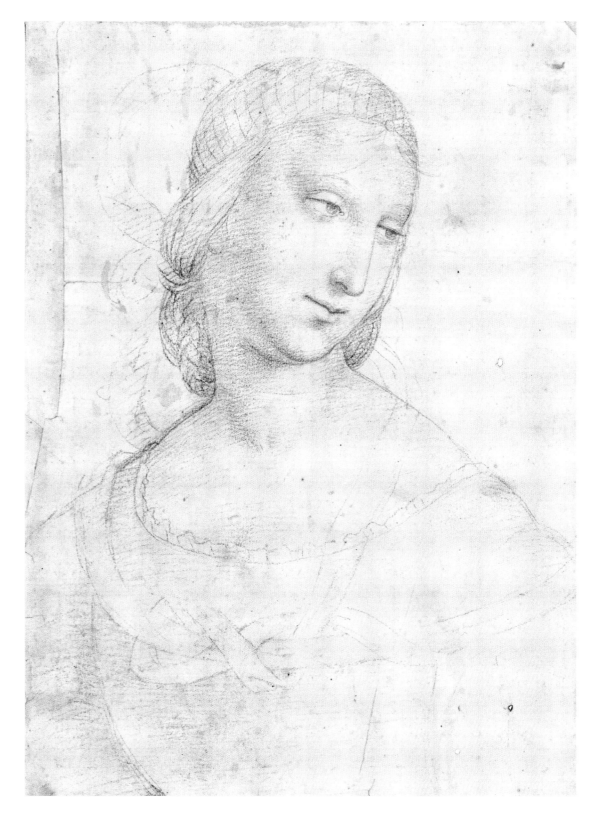

17. Eusebio da San Giorgio (attributed to)

Head of a Woman

c. 1507

Metalpoint heightened with white,
127 x 88 mm

Whether the present drawing is by Raphael or another artist has long been debated, and although scholars remain divided, the weight of opinion probably discounts Raphael's authorship, a view shared by the compiler. It has been linked with Raphael's so-called green sketchbook, but the color of the preparation does not favor this connection and the execution is much less vigorous even than the most finished drawings from that group.

This drawing, like cat. 16 whose facial forms are similar, seems to show knowledge of a phase of Raphael's Florentine work that just postdates the green sketchbook. The complexly coifed head is close to that of the *Belle Jardinière* in the Louvre, the reading of whose date is disputed but which is probably of 1507; and it is also close to the *Holy Family* in Saint Petersburg (fig. 17), which was no doubt painted in 1506–7. Thus this drawing reinforces the impression created by cat. 16: that the artist was acquainted with work produced during the second half of Raphael's sojourn in Florence. Like that drawing, but more strongly, this one also suggests an unmediated knowledge

of work by Leonardo. The strong Leonardesque cast to the features, with a facial surface more shadowed, smoothed, and polished than is ever seen in Raphael's work, seems unlikely to have been absorbed indirectly. Such a resemblance would reinforce the possibility that Eusebio at some time visited Florence, one of the few places where work by Leonardo or his immediate followers might have been seen.

Like cat. 16, but on a smaller scale, the present drawing is efficient in its description of form, and it evokes flawless features. But the heavy and very careful working creates a final effect that is lifeless and sterile in its regularity, as though it were made by machine—a quality we would not find in Raphael. It embodies considerable technical skill but minimal imagination. It seems best for the present to leave this drawing, too, under the name of Eusebio, to whom it was first attributed by Morelli. Yet nothing in his painted work resembles closely enough the forms seen here to put his authorship beyond doubt. Indeed, this head is very similar in type to that of the Virgin in a *Madonna* offered at Sotheby's, New York (24 January 2002, lot 32), as Domenico Alfani, following an attribution by Fahy.

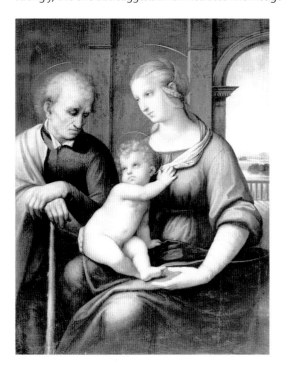

Fig. 17
Raphael. *The Virgin and Child with Saint Joseph,* c. 1506, oil on panel transferred to canvas, 72.5 x 56.5 cm. State Hermitage Museum, Saint Petersburg.

References
Benvignat 1856, no. 681; Passavant 1860, no. 381; Pluchart 1889, no. 478; Morelli 1891–92, 377; Fischel 1913–41, no. 70; Viatte and Goguel 1983, 205, no. 39; Oberhuber 1983, no. 107; Brejon de Lavergnée 1997, no. 548.

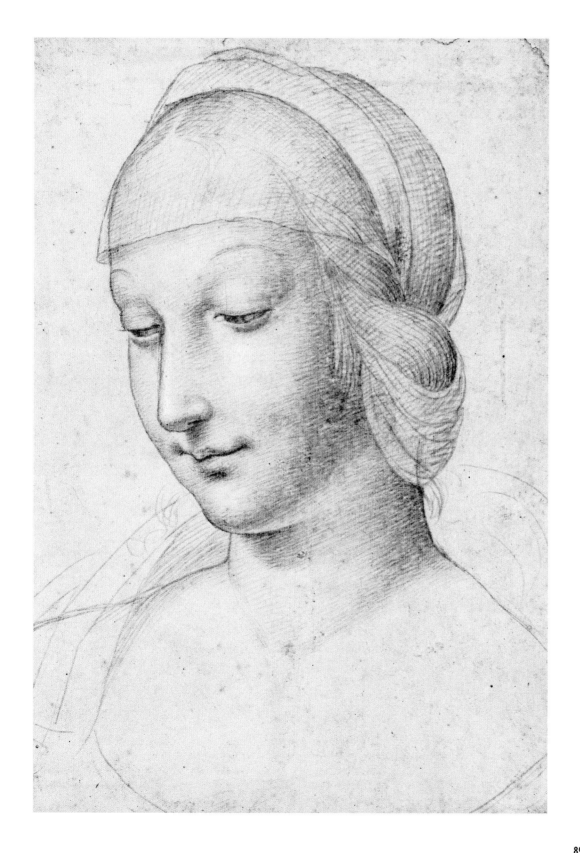

18. TIMOTEO VITI, after Raphael

The Last Supper of Saint Benedict and Saint Scholastica

c. 1505

Pen and ink, 244 x 400 mm

Another version of this design, omitting Saint Scholastica and somewhat more delicate in handling (fig. 18a), was given by Pouncey and Gere to Timoteo Viti, following a Viti-Antaldi attribution. Like the present drawing, it also bears an old inscription on its verso: "Timotteo Vitte." Whether these drawings are by or after Viti is moot, but the compiler is inclined to think that both drawings are probably autograph. A third version, in Perugia, is more clearly a copy.

use of at least one drawing by Raphael. But the present episode is not included at Monteoliveto, and there is no good reason to believe that Raphael supplied designs specifically for it. Instead, the ratio of figures to field suggests a predella panel, and it could have been planned to go beneath a Saint Benedict in a sacra conversazione. However, no altarpiece by Viti containing a Saint Benedict has yet been identified.

An alternative, of course, is that the design was not made by Raphael for his friend but for a project of his own and that Timoteo simply copied it. In Raphael's work, Saint

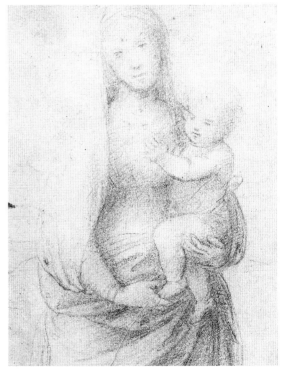

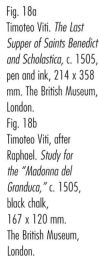

Fig. 18a
Timoteo Viti. *The Last Supper of Saints Benedict and Scholastica,* c. 1505, pen and ink, 214 x 358 mm. The British Museum, London.
Fig. 18b
Timoteo Viti, after Raphael. *Study for the "Madonna del Granduca,"* c. 1505, black chalk, 167 x 120 mm. The British Museum, London.

Pouncey and Gere and Brejon de Lavergnée were surely correct to see this composition not as an original invention by Timoteo but as a copy by him of a design by Raphael. The rhythm is wonderful and achieved without apparent effort. There is also a close relation between the compact but rounded pose of the central figure here and that of the sleeping disciple in the predella panel of the *Agony in the Garden* to Raphael's *Pala Colonna,* probably completed in 1505. Other copies by Timoteo after Raphael drawings of this period survive, including one in the British Museum (fig. 18b) after Raphael's study for the *Madonna del Granduca* (Uffizi, Florence).

The purpose of the design is conjectural. It might have been made for an episode in a cycle of paintings devoted to Saint Benedict or, less likely, Saint Scholastica. A Benedictine cycle was frescoed at Monteoliveto by Signorelli and Sodoma, where the latter certainly made

Benedict occurs only in the fresco the *Trinity with Saints* commissioned by the Camaldolese monks of San Severo in Perugia c. 1505 (see fig. 31b). Raphael included six saints: Mauro, Placidus, and Benedict the Abbot on the left, and Romuald, Benedict the Martyr, and John the Martyr on the right. When in 1521, following Raphael's death, Perugino was commissioned to complete the fresco, he did not follow Raphael's compositional plans—which he may not have known. Yet there is no reason to believe that he changed the iconography: he added Saints Scholastica,

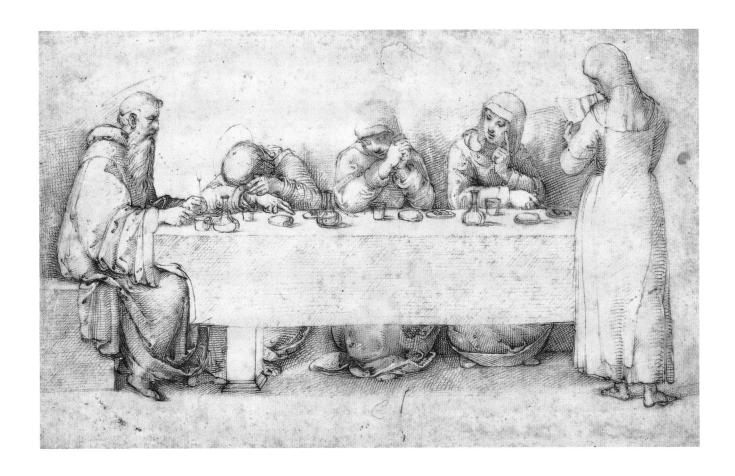

Jerome, John the Evangelist, Gregory the Great, Boniface, and Martha. Given that the fresco includes two of the saints found in the present drawing, Raphael may have planned it as a predella. The space available at the base of the fresco would have taken six good-sized scenes.

References
Benvignat 1856, no. 1085; Pluchart 1889, no. 364; Fischel 1917, 208; Delacre and Lavallée 1927, pl. 5; Pouncey and Gere 1962, 158; Carli 1979, 28; Brejon de Lavergnée 1997, no. 552.

19. THE MASTER OF THE VENICE SKETCHBOOK

a. *Four Standing Men, for a Lamentation over the Dead Christ* (recto)
c. 1504?

b. *Acanthus? Leaves* (verso)
Pen and ink with black chalk, 260 x 166 mm

Fig. 19a
Master of the Venice Sketchbook. *Study of an Acanthus Leaf Capital,* pen and ink, 231 x 169 mm. Venice Sketchbook, fol. 23r/n.88r. Galleria dell'Accademia, Venice.

Following the analysis of Ferino Pagden (1982), there seems to be little doubt that this sheet is by the same hand as the Venice sketchbook. But it is much too large to have formed a part of that sketchbook, and it seems always to have been an independent sheet. A mounting stain runs along the top, bottom, and left of the recto but not on the right, from which it is clear that the sheet was cut at this side and that its present verticality is deceptive. At least half the design is missing. Originally it was horizontally oriented. The theme, not immediately clear, is apparent on close examination. A head can be descried at the lower right, that of Christ, whose corpse must be imagined laid out on the ground in an elongated Lamentation over the Dead Christ. Four apostles stand beside his head; an equivalent number, presumably, would have been placed at his feet and the remainder no doubt at intervals behind him. The image would have been as much mystical as historical, but the implied moment is that just before Christ's body was laid in the tomb. The elongation of the composition suggests either a place in a frescoed narrative cycle or, more probably, a predella panel. However, no corresponding painting has so far been located either in the original or in copies.

Although the figures are highly Peruginesque, they do not seem to be based on specific models by Perugino. In his highly influential *Pietà* of 1495 (Palazzo Pitti, Florence), Christ's body is on the ground, but not so flatly as here. The present arrangement is more similar in design to a predella panel by Benozzo Gozzoli, generally dated c. 1480 (formerly in the Melbourne Collection), but there again the torso of Christ is lifted. The rigid alignment of body and ground here creates considerable discomfort, and only a powerful artist could exploit this productively on a large scale. The most famous and influential treatment of such a motif is that by Sebastiano del Piombo, working to Michelangelo's design, in the *Pietà* of c. 1514 in Viterbo (Duomo).

The architectural drawings on the verso, no doubt made after an antique prototype, are very close indeed to those on fols. 22v and 23r of the Venice sketchbook (fig. 19a), and a similar leaf form was copied by Raphael on a sheet in the Ashmolean (fig. 19b).

Believed in the nineteenth century to be a compilation by the young Raphael, the Venice sketchbook was discussed at length as such by Crowe and Cavalcaselle in their life of Raphael. It has also been argued—the opposite extreme—that it is an early nineteenth-century forgery by Giuseppe Bossi, who once owned it. But while this view is entirely untenable, no serious twentieth-century scholar was able to find in the sketchbook any drawing that could be attributed confidently to Raphael, despite wide agreement that it reflects the sort of album of studies that Raphael must have made. Indeed, of a close link with him there can be little doubt. The book, which contains sketches after known or surmised works by other artists, parallels at least part of Raphael's educational trajectory. It also contains versions of what are in

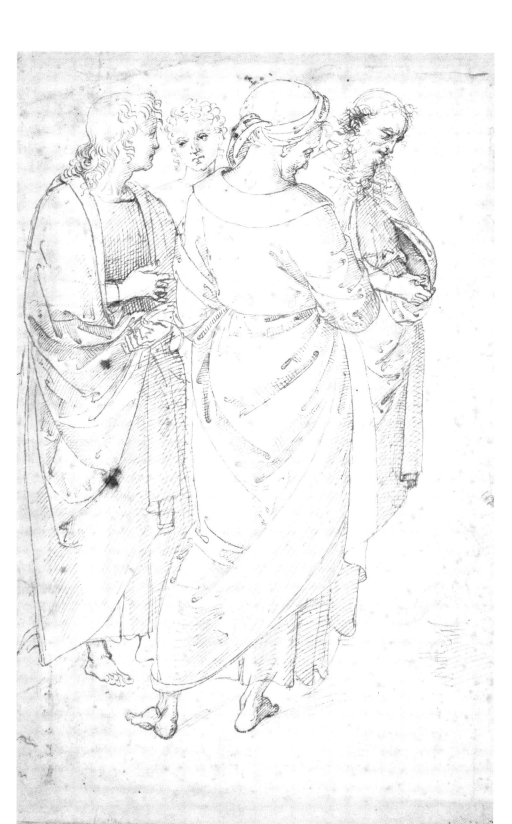

some cases certainly, and in others probably, compositions and sketches by Raphael himself. For example, a fragmentary sheet by Raphael in the Ashmolean (Parker no. 512), with a sketch for the head of Saint James in the *Coronation of the Virgin* on the recto, and a part study of the legs of the antique *Marsyas* on the verso, was known to the executant of the sketchbook. The recto is copied precisely on fol. 15r; the verso is rendered on fol. 6v in a slightly different form, which probably means that the model was a companion drawing by Raphael, rather than a variant by the copyist.

However, the two sides of Raphael's sheet are not reproduced in their original relation, indicating that the Venice sketchbook is not a facsimile of a lost sketchbook by Raphael, although it no doubt reproduces a number of drawings by him. Various drawings in the sketchbook are replicated on isolated sheets in other collections, but in no case can it be securely stated that such drawings were either the source of those in the Venice sketchbook or copies of them. This difficulty is annoying for scholars but not inherently strange. As Nesselrath 1986 has demonstrated, the partial or complete copying of sketchbooks was common. An analogy might be a group of students sharing one an-other's notes.

In this context, a further contribution by Ferino Pagden (1984, 20–22) should be stressed. She suggests that the

Venice sketchbook is by Domenico Alfani. Closely associated with Raphael (see cat. 34), Alfani was aware of Raphael's drawings, which he sometimes used in unexpected ways, and of work produced by him between c. 1505 and c. 1512. No independent drawings by Alfani are known, and no drawing by him for one of his own paintings has emerged, but he remains the most plausible candidate so far suggested. Another, intriguing, possibility is suggested by a passage from a later sixteenth-century source, Filippo Alberti, a friend of Torquato Tasso (cited by Gnoli 1922, 305), about Raphael's friend, the goldsmith Cesarino Roscetto (see cats. 34 and 43):

> Fu quest'huomo coetaneo et compagno di Raffael d'Urbino et insieme con esso imparò da m. Pietro Perugino l'arte del disegno, nella quale riusci di tanta eccellenza che il sig. Astore Baglioni, il quale comprò a grandissimo prezzo un libro di disegni fatto parte dall'uno et parte dell'altro di questi due elevatissimi spiriti, soleva dire di aver legato due giole in un anello. (This man [Cesarino Roscetto] was a contemporary and companion of Raphael of Urbino with whom he learned the arts of design from Pietro Perugino, in which he attained such excellence that Sig. Astore Baglione, who purchased at a very high price a book of drawings made partly by the one and partly by the other of these two elevated spirits [that is, Cesarino and Raphael], used to say that he possessed two jewels mounted in a single ring.)

This passage both justifies the prospect of finding more than one hand in the same sketchbook and also opens the possibility that Cesarino might be the author of that in Venice.

Fig. 19b
Raphael. *Studies of Figures and of Part of an Antique Capital,* c. 1507, pen and ink, 194 x 273 mm. The Ashmolean Museum, Oxford.

References
Benvignat 1856, nos. 721–22; Pluchart 1889, no. 486; Fischel 1898, no. 31; Ferino Pagden 1982, 189; Viatte and Goguel 1983, no. 113; Brejon de Lavergnée 1997, no. 410.

pl. 486

The Drawings
of Raphael in
Umbria, Florence,
and Rome

c. 1503–c. 1512

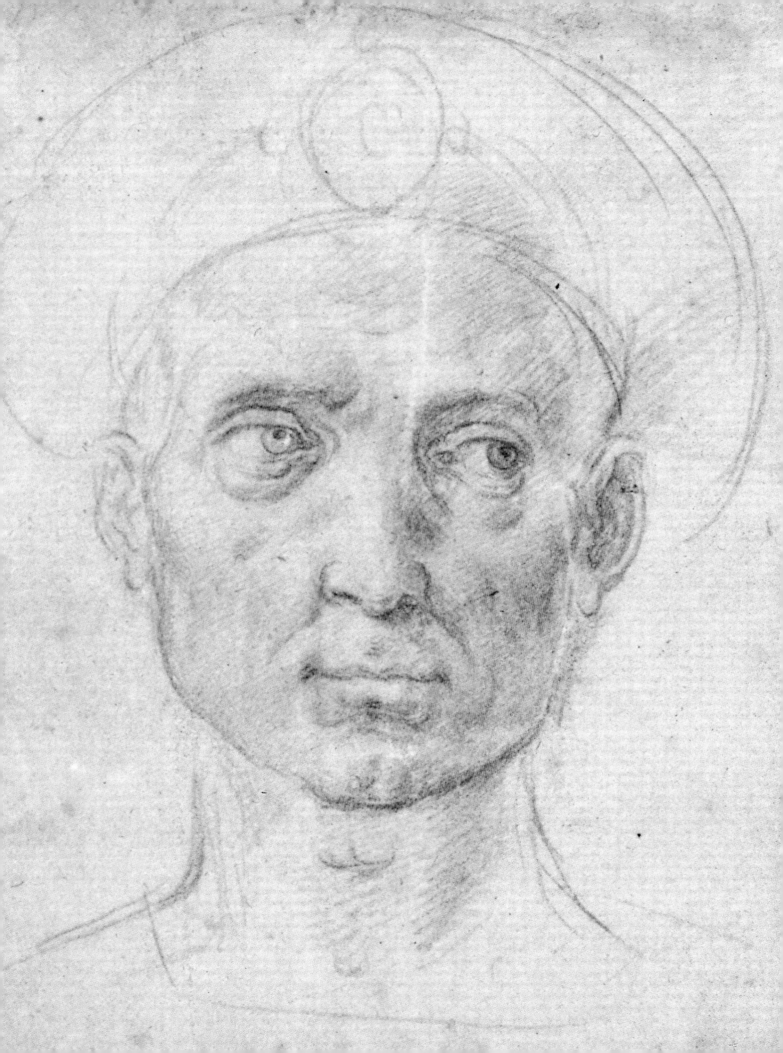

20. RAPHAEL

a. *Two Angel Musicians, for the "Coronation of the Virgin"*

(recto)

1503

Metalpoint on gray-mauve prepared paper

PERINO DEL VAGA?

b. *Studies for Decorative Frescoes and Stucco Framing*

(verso)

c. 1540

Pen and ink, wash , traces of red chalk, 200 x 223 mm

Fig. 20a
Raphael. *The Coronation of the Virgin,* c. 1503, oil on panel transferred to canvas, 267 x 163 cm. Pinacoteca, Vatican.

While the date of the *Coronation of the Virgin,* painted for the degli Oddi family and placed in their chapel in the church of San Francesco in Perugia (fig. 20a), is not documented, it is usually—but not invariably—dated to 1503, and placed just after the *Mond Crucifixion* in London (National Gallery). The composition is innovative in that the apostles who stand around the sarcophagus that housed the Virgin's body in the lower register (a motif proper to the Assumption) are combined with her Coronation in the upper.

In Umbria the most influential altarpiece of the Coronation was that by Ghirlandaio and his studio, executed for the cathedral of Narni between 1484 and 1486, in which the apostles and saints kneel on the ground in mystical contemplation of the heavenly event. Ghirlandaio's panel became the model for numerous Umbrian variants; it was referred to in the contract signed by Raphael in 1505 for a Coronation for the Perugian convent of Monteluce.

The most significant recent painting of the Assumption was by Pinturicchio—with whom Raphael may already have been associated—in the Bufalini chapel in Santa Maria in Aracoeli in Rome. It shows the Virgin standing upright, rising heavenward, while the apostles cluster around an obliquely angled tomb. In his panel Raphael thus combined two different formulae and two different moments. He tried both to link and to explain them by placing flowers in the sarcophagus, which implies time passed since the instant of her Assumption; however, Saint Thomas still holds the Virgin's girdle, which implies that her elevation has only just occurred.

This juxtaposition, although not unsuccessful, was forced, the result of a change of program while the project was under way. Raphael had originally intended to paint an Assumption. His highly finished pen modello (often mistakenly rejected), now divided between the Louvre and the Szépmüvészeti Múzeum in Budapest (fig. 20b), includes a grouping of apostles similar to that in the painting as executed, but the sarcophagus is angled the other way round, the distribution of light is different, and the apostles' upward gaze, hence their emotional focus, is less pronounced. Above them, the Virgin rises heavenward in a standing pose.

Of the two drawings of angels on the present sheet, the lute player was not used; the right-hand angel, playing the lira da braccio, is closer to that in the modello than the painting. This angel was developed in a drawing in the British Museum (Pouncey and Gere no. 4), probably also from Wicar's collection, which restudies the head and the hand in a different position. This alteration implies a different arrangement for the upper half of the painting.

En suite with the present drawing and once together on a

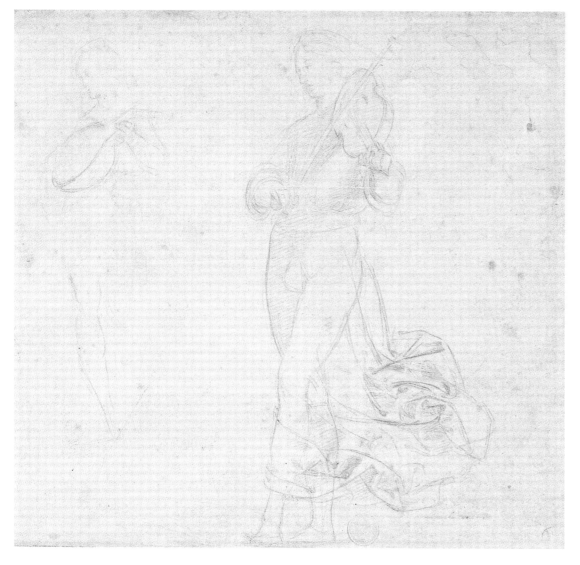

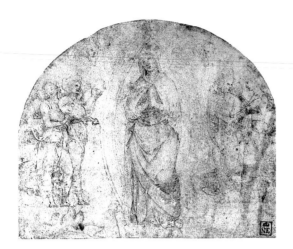

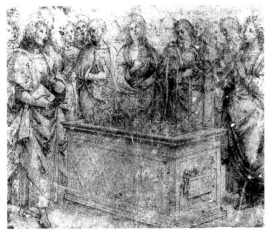

was partly responsible. Although it is possible that the drawing was done during Perino's Genoese period, nothing like it occurs in the Palazzo Doria, and it seems more probable that it was made in Rome, where Perino designed and oversaw decorative schemes in several private palaces—notably the Palazzo Massimi. But even buildings under papal control, such as the Castel Sant'Angelo, contained public rooms decorated with secular and even erotic themes, so it was not necessarily planned for a private chamber.

At the right, oriented differently, is the head of a putto, winged in the manner of a cherub; whether it would have been part of the same scheme is entirely speculative.

Perino's wife, Caterina Penni, inherited at the death of her brother Gian Francesco a mass of drawings including many by Raphael. Clearly Perino studied them, and while it is disconcerting to think of his making drawings of his own on the verso of a sheet employed by Raphael some forty years earlier, the physical evidence is unequivocal that he—or someone else—did so. Perino is probably also responsible for the copy of a lost drawing by Raphael on the verso of a sheet in Frankfurt, whose recto bears an autograph study by Raphael for the *Sistine Madonna* (see fig. 44a).

The verso also contains an eye and a profile in red chalk. Although mediocre in quality, they are not part of the group of childish scrawls found on a number of Raphael's drawings of this period, and they may be slight early drawings by Gian Francesco Penni himself, who probably joined Raphael toward the end of his Florentine period. It may be entirely fanciful, but it is tempting to propose that the person responsible for the genuinely childish scribbles on the recto may be Perino and Caterina's little daughter. She is the only child who springs to mind who might have had casual access to drawings by Raphael.

sheet of similar size and color, are two further silverpoint studies for angels (Ashmolean Museum, Oxford, Parker no. 511), also probably from Wicar's collection. They too seem to have been made prior to the modello.

The verso is obviously by a different hand and was made very much later, perhaps c. 1540. Although the small sketch is probably by Perino del Vaga, to whom it was attributed some years ago by the compiler (it compares well in style with the figurated rectangles frequently found in his modelli), it cannot be connected with any known or surviving work. It seems to show a woman and child (or perhaps two children) together with an eagle and may depict one of the loves of Jupiter. This scene no doubt formed part of a secular ceiling design of small frescoes set within elaborate stucco surrounds. Such schemes became popular toward the middle of the century—a fashion for which Perino, an excellent and innovative *stuccatore*,

References
Benvignat 1856, nos. 707–8; Passavant 1860, no. 383; Pluchart 1889, nos. 444, 492; Fischel 1913–41, no. 21; Joannides 1983, no. 43; Oberhuber 1983, no. 39; Viatte and Goguel 1983, no. 24; Brejon de Lavergnée 1997, no. 517.

21. RAPHAEL

Head Study of an Apostle (Saint Andrew?), for the "Coronation of the Virgin"

1503

Black chalk over traces of stylus indentation and pouncing marks, 220 x 193 mm

Fig. 21
Raphael. *Auxiliary Cartoon for the Heads of Two Apostles,* c. 1503, black chalk, 238 x 186 mm. Royal Library, Windsor Castle.

This drawing was made in preparation for the apostle in the *Coronation* generally identified as Saint Andrew (the third figure from the left). It is an "auxiliary cartoon" (a term coined by Oskar Fischel), a type of drawing that, while not invented by Raphael, features more extensively in his work than that of any earlier painter. Made on a separate page over pouncing marks transferred from the full-size cartoon, it provides more detailed study of an area that the artist considered key, or whose rendering in the cartoon did not fully satisfy him. He would refer to this supplementary study when he came to execute the final painting. The majority of surviving auxiliary cartoons by Raphael come from three projects: the degli Oddi *Coronation of the Virgin,* for which two others survive in addition to the present one; the *Parnassus* (Stanza della Segnatura, Vatican), for which two are known; and the *Transfiguration* (Pinacoteca, Vatican), for which there are six. All three are complicated projects in which facial expression is of particular importance, and all three were made at key moments in Raphael's career. However, these works are not alone in being of great significance, and it is more than likely that Raphael made auxiliary cartoons, now lost, for other paintings he considered vital or found particularly difficult. The Borghese *Entombment,* where dramatic expression was singularly important, is a case in point. Raphael's surviving cartoons are all of heads, but two for the *Transfiguration* include hands, and it may be that Raphael also made auxiliary cartoons of hands for paintings in which gestures were vital.

An observer as acute as the young Raphael would soon have realized that the repetition of facial types and the narrow repertoire of gestures deployed by Perugino was a serious weakness of his work. One way in which even relatively conventional poses and forms could be enlivened was by a more portrait-like concentration on individuals and by a greater awareness of psychological instantaneity. Raphael's aim was a combination of portrait and study, and he no doubt looked also to Northern art, with which he

would have been familiar from his earliest youth. To some extent in these early years he aimed for a Northern focus and precision within a Peruginesque matrix. But even though the *Coronation* shows Raphael breaking through Perugino's shell and employing physical types not found in his work, it still shows respect for his master's treatment of the venerable: the features fall in regularized lines and wrinkles, and the long bipartite beards, found in the present drawing and in the paired heads at Windsor, are very much from Perugino's stable. Interestingly, these heads look very similar in the drawings, whereas in the painting as executed Raphael varied the color and texture of the beards and in effect recharacterized them. Having taken preparatory work well beyond a point that would have satisfied most artists, Raphael's critical self-awareness continued to function long after others would have switched to automatic pilot.

References

Benvignat 1856, no. 720; Passavant 1860, no. 412; Pluchart 1889, no. 470; Fischel 1913–41, no. 25; Joannides 1983, no. 48; Oberhuber 1983, no. 48; Viatte and Goguel 1983, no. 25; Brejon de Lavergnée 1990, no. 20; Brejon de Lavergnée 1997, no. 516.

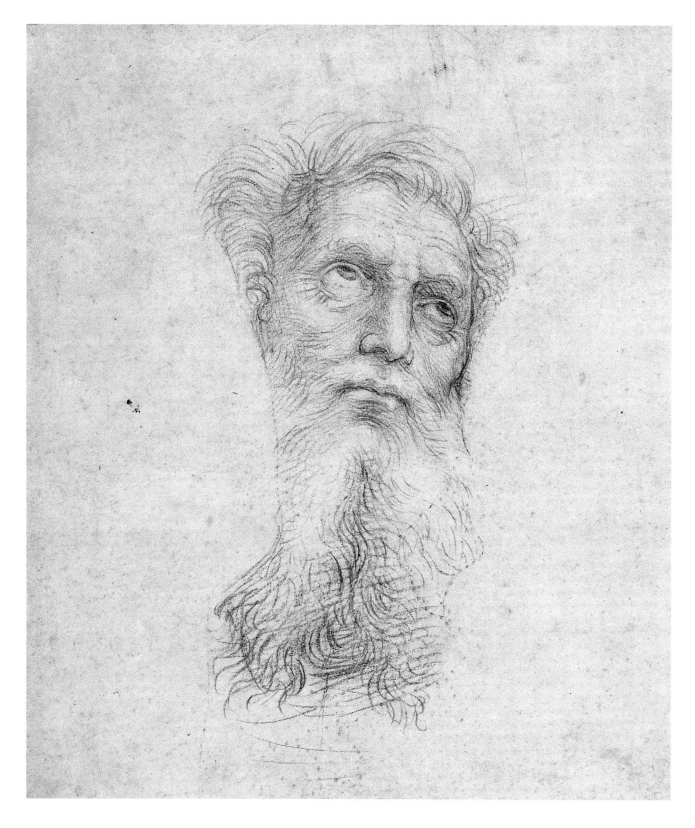

22. RAPHAEL

a. *Head and Hand Studies, for Saint Thomas in the "Coronation of the Virgin"*
(recto)

1503

Metalpoint on gray prepared paper

Umbrian associate of RAPHAEL
b. *Two Models Posed as Christ Crowning the Virgin, for the "Coronation of the Virgin"*
(verso)

Pen and ink over stylus indentations and traces of black chalk, 266 x 196 mm

In this drawing Raphael focused on the head and the hands of Saint Thomas, the central figure in the lower part of the *Coronation of the Virgin* (see fig. 20a), omitting the connecting limbs. The omission makes Raphael's selective focus clear. Whereas the drawings of Perugino and his immediate followers tended to bestow an approximately equal emphasis on all parts of the form, Raphael deliberately concentrated on the key expressive features. The use of metalpoint to provide a crystalline modeling, with the sharpest possible contour, gives a firm plastic presence to the center of the composition by creating chiseled forms for the head and hands—one of the means by which Raphael articulates and directs the viewer's attention. Although the figure is similar in type to that seen in cat. 23 and may well have been studied from the same model, Raphael's use of metalpoint indicates that this figure was to be the more prominent.

The absence of connection between the hands and shoulders, while they are placed in roughly their real relation, creates a slightly wide-angle effect that is adventitious and was not employed in the painting. Raphael does not seem to have made use of such perspectival distortions in this period, although he did so on occasion in his Roman work. A similar but less extreme juxtaposition of a head and hands is seen in a drawing in the British Museum (fig. 22a) for the angel at the upper right playing the lira da braccio in the *Coronation*. This drawing is also in metalpoint on paper prepared with a white ground and was no doubt part of the same gathering of sheets. Another drawing in Lille (Brejon de Lavergnée no. 518), a study for the *Norton Simon Madonna* in Pasadena, is made in the same technique on the same type of prepared paper, helping confirm that this *Madonna* is contemporary with the *Coronation*.

The present head may well have been followed by an "auxiliary cartoon" in chalk, now lost. That for Saint James in the British Museum keeps the tone remarkably light. One of the ways that Raphael characterizes the younger figures is to give them lighter skin than the others; such a tonal accent was evidently in his mind for this figure from the beginning.

All scholars have rejected the penwork on the verso from Raphael's oeuvre, but it is more difficult to be certain about the underdrawing, executed both in faint black

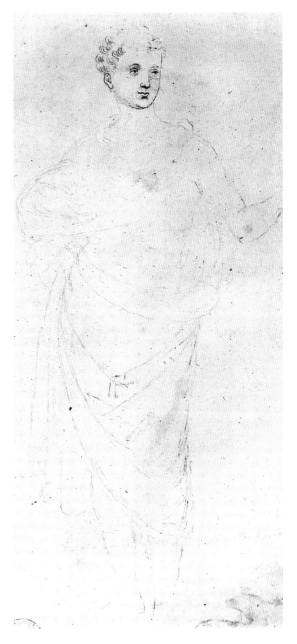

Fig. 22a
Associate of Raphael.
Standing Figure,
c. 1502, pen and
ink over leadpoint,
window mounted,
225 x 114 mm. The
British Museum, London.

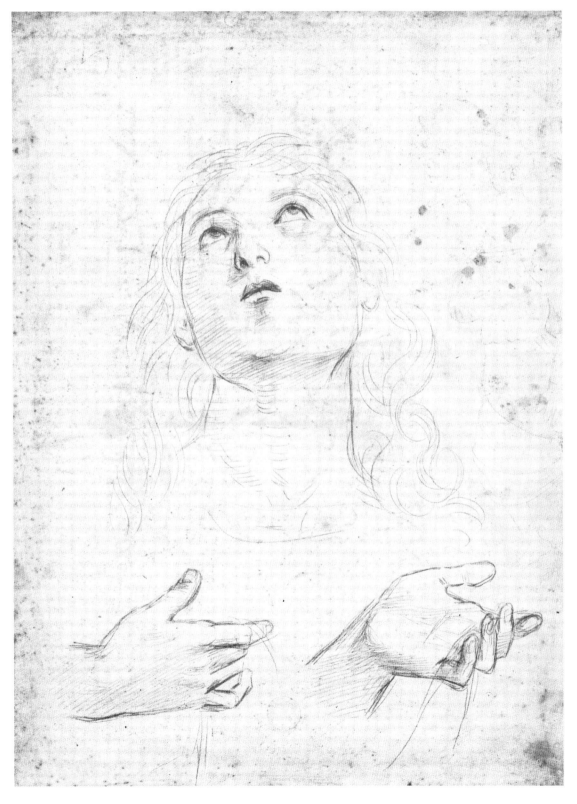

chalk and—slightly divergent—stylus indentation, which could in principle be Raphael's as a guide for the pen-work. It is also debatable whether the present drawing is a copy of a lost *garzone* study drawn by Raphael, or whether he simply handed this task over to an assistant. In any case, this drawing—or its lost original—was made for the degli Oddi altarpiece, as was the recto, but for the upper section depicting the Coronation proper. It must postdate the metalpoint study for an angel (cat. 20), which was made when the painting was still envisaged as an Assumption.

Later in his career, and when pressed for time, Raphael often delegated some of the preparatory graphic work to assistants, and this practice may have originated earlier than scholars tend to assume. A considerable number of sheets by Raphael of all periods contain drawings by other hands on their versos, a feature that invokes the collaborative aspect of studio practice and also the use of the master's drawings by his pupils and assistants. And it is clear that he worked with others from his earliest years.

The contract for the *Coronation of the Virgin* does not survive, but those for the *Saint Nicholas of Tolentino Altarpiece* of 1500 and for the *Monteluce Coronation* of 1505 show that some—but not the same—measure of collaboration was envisaged from the outset.

The verso drawing is no doubt by the same artist who made the variant copy after Signorelli on the verso of Brejon de Lavergnée no. 518 (fig. 22b). Thus two metal-point drawings by Raphael carry on their versos two pen drawings by another artist, obviously implying a close if not necessarily protracted association. A third, unfinished pen drawing in London that seems to be by the same hand and whose provenance is also from Wicar (British Museum, Pouncey and Gere no. 3 verso) is on the verso of an autograph study by Raphael for the *Norton Simon Madonna*. This associate, who has not been identified, was probably an Umbrian contemporary of Raphael; his penwork does not suggest reproduction of Raphael's handling and seems tighter and less varied in stroke than one would expect from a pupil, who would naturally have attempted to reproduce his master's style.

The verso drawing is distinct from the childish scrawl on the right of the recto—a scrawl found on several other drawings of this period, including Pouncey and Gere no. 3. It seems that a child had access to Raphael drawings; it is a reasonable, although far from secure, assumption that this happened before they became precious objects.

Fig. 22b
Associate of Raphael, after Signorelli. *Crossbowmen,* c. 1503, pen and ink over stylus indentation, 254 x 181 mm. Palais des Beaux-Arts, Lille.

References
Benvignat 1856, nos. 700–01; Passavant 1860, no. 384; Pluchart 1889, nos. 440–41; Morelli 1891–92, 377; Fischel 1913–41, no. 16; Joannides 1983, no. 47; Oberhuber 1983, nos. 47, 38; Viatte and Goguel 1983, nos. 21–22; Brejon de Lavergnée 1990, no. 19; Brejon de Lavergnée 1997, no. 514.

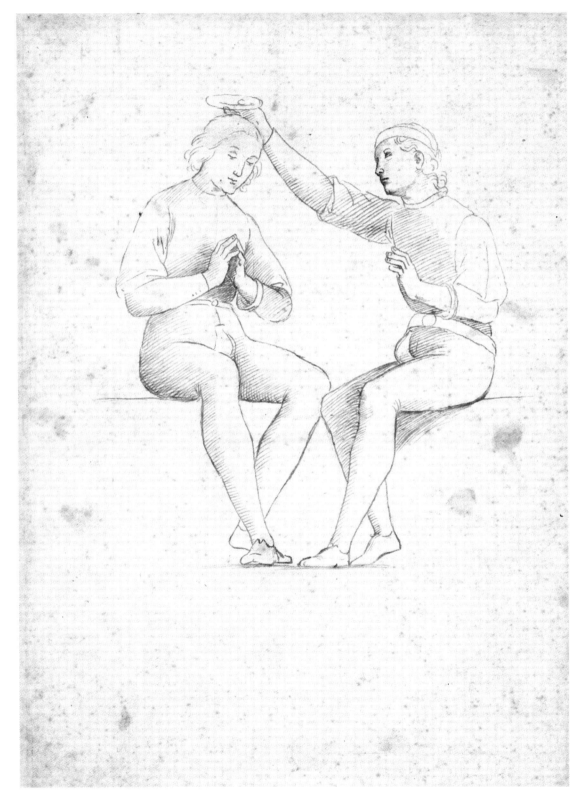

23. RAPHAEL

a. *Head Study for Saint Thomas? for the "Coronation of the Virgin"* (recto)

1503

Black chalk over traces of stylus indentation

b. *Drapery Studies* (verso)

Black chalk, 336 x 192 mm

In this drawing, which was also made in preparation for the degli Oddi *Coronation* (see fig. 20a), Raphael employed black chalk rather than metalpoint on prepared paper, as in cat. 20. Its strength of contrast has been diminished by exposure to light, but it must always have been fairly faint. The pose and angle correspond to heads in neither the modello nor the finished painting, and at which stage in the development of the composition it was made, or precisely for which figure it was intended, is not certain. Both the facial type and the emotional focus ally it closely with the study for Saint Thomas. While it could have been a preliminary idea for that figure, in both modello and painting Saint Thomas is placed centrally, facing directly forward, and it is hard to imagine that Raphael would have considered an alternative to this organization at any stage. More likely, it was made in preparation for another figure. Raphael carefully grouped the apostles he characterized as young in the center and at the sides of his composition, in both the modello and the painting. But in the modello, the apostle on the right-hand side does not look upward, as he does in the painting, and the present drawing may have been part of the process that led to this change, which gives this apostle, simultaneously, a more intense individual definition and a more integrated structural role. In Raphael's refocusing of this apostle, the auxiliary cartoon of his head in the British Museum marks the penultimate phase.

The drapery studies on the verso, very similar in type to those on the verso for the compositional drawing for the altarpiece of *Saint Nicholas of Tolentino* (fig. 23b), are loosely and broadly handled, with the chalk sparely applied in widely separated strokes. They evoke the general form of the material rather than its texture, but the clarity with which the fold structures are rendered would make an excellent foundation for more detailed studies. The purpose of these drawings is conjectural. There is an immediate temptation to assume they were made for some part of the *Coronation* altarpiece; Fischel connected them with the figure of the young woman bearing doves at the right-hand side of the altarpiece's right-hand predella panel, the *Presentation in the Temple*. But the drapery forms of both drawings are also very like those of Saint James, who stands at the right-hand side of the main panel, and they could as well have been made for him. Arguing against either linking however, is the illumination, which in both drawings is from the left—although not emphatically so. Throughout the ensemble of the *Coronation*, and in all the preparatory drawings

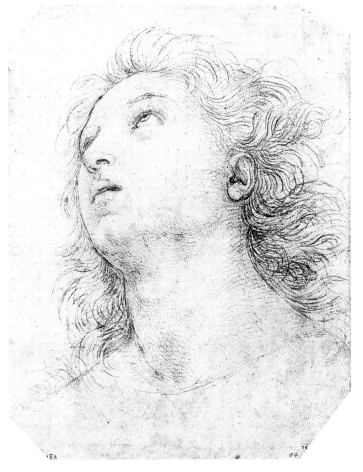

Fig. 23a

Raphael. Auxiliary *Cartoon for the Head of Saint James*, c. 1503, black chalk, 274 x 216 mm. The British Museum, London.

Fig. 23b
Raphael. *Drapery and
Other Studies,*
1500–01, black chalk,
pen and ink,
394 x 263 mm. Palais
des Beaux-Arts, Lille.

securely connected with it, light falls from the right. It is, of course, possible that in a moment of distraction Raphael might have forgotten this, or so have concentrated on structure that he ignored lighting, but neither explanation seems likely from so focused and rational an artist, and it remains open whether these studies were made in preparation for some other project.

The tiny sketch of a horseman, who may well represent Saint George (as noted by Brejon de Lavergnée), is obviously not connected with the *Coronation,* and its presence shows that the verso of this sheet was used for another project. The obvious candidate would be Raphael's small panel of *Saint George* in the Louvre, half of a diptych of military saints painted c. 1503–4, whose counterpart, also in the Louvre, depicts *Saint Michael.* However, there is no visual relation between the two, and if this sketch was made with the painted *Saint George* in mind, Raphael must very soon have decided on entirely another form. Of course, George was an exceptionally popular saint and Raphael might well have designed and painted more than one at this period. Yet, from surviving drawings and copies of lost ones from early on in his career, it is also clear that Raphael designed battle compositions—perhaps for friezes in private palaces—and the present sketch could well have been made for one of them. Whether any battle paintings by Raphael or to his designs were executed in Umbria is unknown, but the possibility should not be ruled out. Raphael's later work demonstrates a long-standing interest in scenes of battle or violent action and, of course, at the end of his career, in *Constantine's Victory over Maxentius at the Milvian Bridge,* he designed one of the most influential of all Western battle paintings, executed after his death by his assistants.

References
Benvignat 1856, nos. 702–3; Passavant 1860, no. 385; Pluchart 1889, nos. 482–83; Fischel 1913–41, no. 26; Joannides 1983, no. 46; Oberhuber 1983, nos. 46, 52; Viatte and Goguel 1983, no. 26; Brejon de Lavergnée 1997, no. 515.

Cat. 23b

24. RAPHAEL

Head of a Young Man Wearing a Hat

c. 1503

Black chalk heightened with white,
212 x 186 mm

The sitter's face seems to recur in Raphael's two silverpoint studies of angels for the upper level of the *Coronation* when it was still planned as an Assumption (see cat. 20). But both figures—one bowing a rebec, the other palming a tambourine— were modified in the painting as executed and their heads were idealized.

Although illuminated from the right like the painting, this drawing is probably not preparatory for it, but simply a portrait study of a youth who modeled for Raphael. He may have made this drawing as a gift, recompense to a friend for his services, since it is unusual among Raphael's drawings of this period in its unused verso. Young artists no doubt took turns sitting for one another to practice their portrait skills or record valued friends. At Christ Church, Oxford, for example, is a portrait drawing by Sodoma that is plausibly identified as of the young Raphael.

The face and head here are firmly evoked but the rendering is not particularly flattering. The mouth and eyes are both small, and the comparative fleshiness of the face gives the sitter a somewhat porcine appearance. There is some influence from Northern portraiture, with its accent on realism; the vital play of the curly hair against the simplified form of the cap was a feature that Memling had much exploited. Memling was an important source for Perugino, and the present drawing is also reminiscent of the latter's most realistic type of portraiture. Raphael has adjusted the form and the way the nose is angled slightly differently than the face. The eyes swivel to the sitter's right, giving an image that could have been a little stolid an air of immediacy. The apparent dimple in the chin, however, seems to be no more than a smudge.

In the last decade or so of his career, Raphael was to become the most inventive and sought-after portraitist in central Italy, matched in the peninsula only by Titian. Even in his Florentine period, which ran, with interruptions, between 1504 and 1508, Raphael's portraiture was well in advance of that of his Florentine contemporaries. Only Leonardo, from whom Raphael learned much, was his superior. To be able to attain such a level so rapidly Raphael must already have had considerable exercise as a portraitist well before he left Umbria. The abraded and softened painting, the *Portrait of a Young Man* in Budapest (Szépmüvészeti Múzeum) is very similar in its structure to the heads in the *Coronation*, especially that of Saint James, and it seems likely that it was executed c. 1503–4. Two further paintings, the possible *Self-Portrait* in the Royal Collection and the *Portrait of a Man* in the Getty Museum—neither unquestioned— have a sharpness of definition and a solidity that suggest they, too, may be approximately contemporary with the *Coronation*.

Fig. 24
Raphael. *Portrait of a Man*, c. 1504, black chalk over stylus indentation, 255 x 190 mm. The British Museum, London.

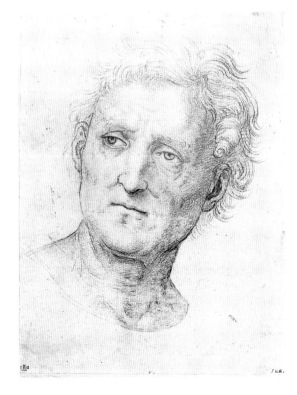

References

Benvignat 1856, no. 684; Passavant 1860, no. 407; Pluchart 1889, no. 461; Fischel 1913–41, no. 20; Châtelet 1970, no. 77; Joannides 1983, no. 42; Oberhuber 1983, no. 75; Viatte and Goguel 1983, no. 29; Brejon de Lavergnée 1990, no. 21; Brejon de Lavergnée 1997, no. 519.

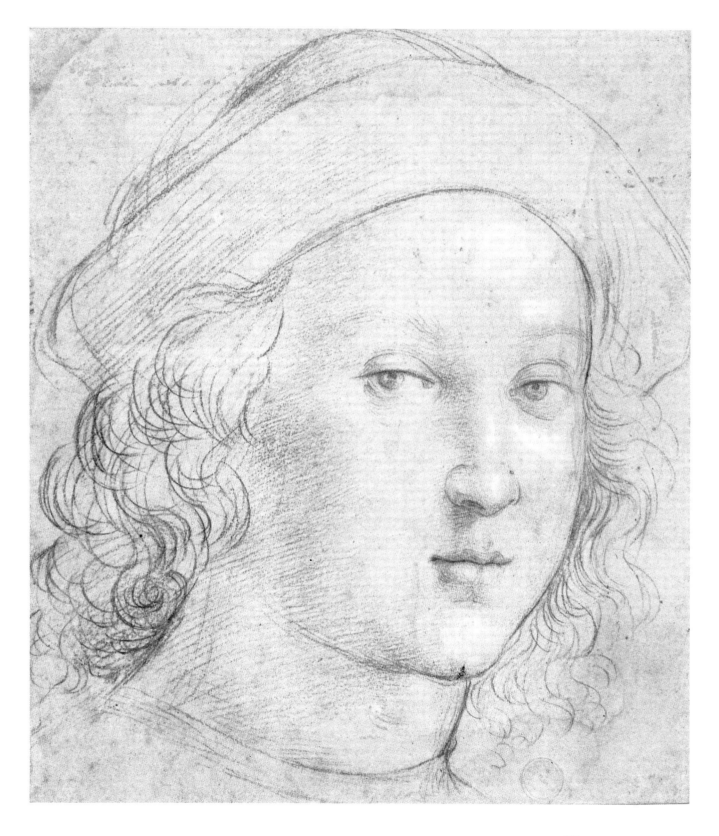

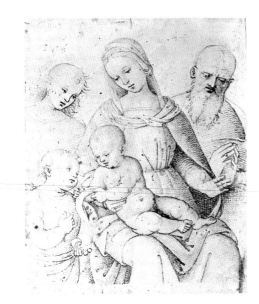

25. RAPHAEL

The Holy Family with Saint John the Baptist and an Angel

c. 1504

Pen and ink, 167 x 159 mm (sheet composed of two irregular sections)

Fig. 25a
Umbrian school, after Raphael? *Virgin and Child with Saints,* pen and ink, Kupferstichkabinett, Berlin.
Fig. 25b
Raphael. *The Terranuova Madonna,* c. 1504, oil on panel, diam. 88.5 cm. Gemäldegalerie, Berlin.

This drawing is generally considered to be a damaged Raphael restored by a later hand, with the left and top of the sheet Raphael's work and the lower-right corner a restoration. It is further suggested that a copy drawing in Berlin represents its original state (fig. 25a).

However, close examination suggests a more complicated situation. The larger fragment as it was presumably once completed is not, in fact, copied exactly in the Berlin drawing. In the parts of both that correspond, draperies and characterizations differ slightly but unmistakably. Thus the Berlin drawing must be either a copy of a later development of the composition or a copy of a variant of it (it is too dry itself to be that variant), by Raphael or by a close follower, and it is only partly germane to the present drawing.

There is a very close match of ink between the two parts, much closer, for example, than in a certainly restored drawing in Lille, *Saint Sebastian* (Brejon de Lavergnée no. 513). And in substance, the alteration—in relation to the Berlin drawing—of the Virgin's pose in the addition, bending her left arm inward, is accomplished and clever. More significant, Joseph's left hand in the larger fragment has been scraped out and redrawn. Thus whoever added the lower-right corner modified at least one of the remaining parts of the original. The lines of both parts are well linked, and there may be some overdrawing from one fragment to the other. Therefore, while the "restorer" did not follow exactly the lead of what was on the original page, he did make every effort to join it seamlessly with the larger fragment. So if the lower-right corner is by another hand, it does not attempt an exact reconstruction of Raphael's intentions, it modifies them. Could it therefore be an addition by Raphael himself? The shape of the loss as a whole is hard to reconcile with an accident, and the profile of the cut across the body of the Christ child is particularly difficult to explain. The movement of the Virgin's legs to her left, in part to balance Saint John on her right (not a feature of the Berlin drawing) also suggests the mind of an artist very

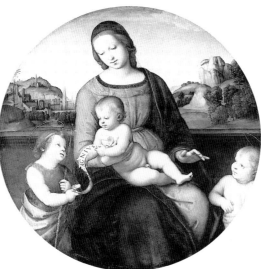

close to Raphael. Raphael did occasionally cut away parts of drawings in order to modify them on attached pieces of paper; in principle, he, not an assistant, would be expected to undertake such changes.

However, although the approach to form in the lower-right section is sophisticated, the handling of pen is less so. Indeed, the pen work of the smaller section seems to reflect a slightly earlier phase of Raphael than that of the larger section, which would rule out the addition being by Raphael. Yet it might well suggest that this section is the work of a close follower, not a later attempt at completion by an anonymous restorer, who would scarcely have imitated an earlier phase of Raphael's pen work.

References

Benvignat 1856, no. 686; Passavant 1860, no. 377; Pluchart 1889, no. 431; Fischel 1913–41, no. 54; Châtelet 1970, no. 81; Joannides 1983, no. 69; Oberhuber 1983, no. 98; Viatte and Goguel 1983, no. 34; Brejon de Lavergnée 1997, no. 521.

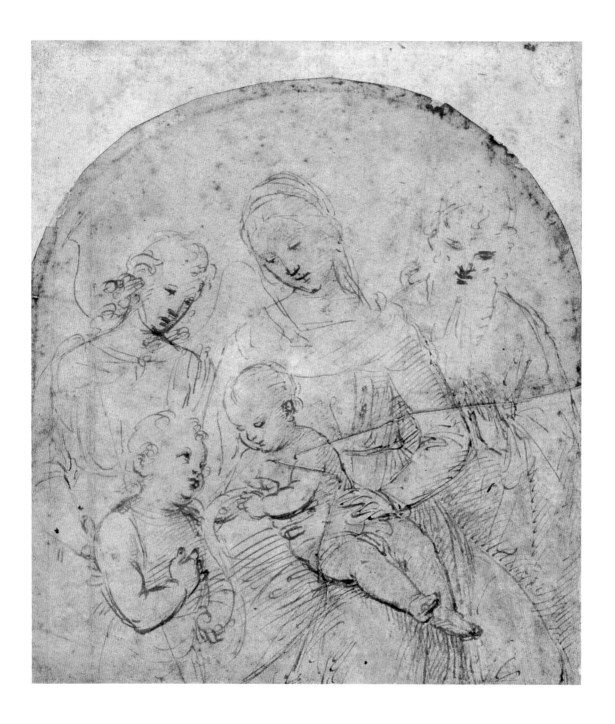

26. RAPHAEL

Head of a Man Wearing a Turban

c. 1504–5

Metalpoint on gray prepared paper,
127 x 103 mm

Fig. 26
Pinturicchio. *Aeneas Piccolomini Presents Frederick II to Eleanor of Portugal*, fresco, c. 1505. Piccolomini Library, Siena.

The pages of Raphael's so-called green sketchbook, with drawings made in stylus on paper prepared in hues of gray and green, number seven. There may once have been more, but no solid evidence, such as copies, can be adduced to reconstruct lost sheets. The green sketchbook probably dates mainly to the late Umbrian and early Florentine period, c. 1504–5, but its use could have stretched beyond that. Art historians tend to assume that sketchbooks were employed over relatively short time spans, but because some artists—Raphael among them—demonstrably used the recto and verso of the same sheet of paper several years apart, such assumptions can be fragile. Conversely, excessive weight can be placed upon slight variations and insufficient allowance made for the fact that artists produce drawings of different styles and types at the same time.

The present drawing seems more casual and immediate than the others in the sketchbook, all of which look "composed." This drawing seems to fulfil Leonardo's dictum that the artist carry notebook and stylus and sketch motifs from life. Here, in a direct frontal representation, Raphael has sketched a forceful, lived-in face, with the accent on character and personality. The turban eliminates any need to treat hair and produces an effect at once decorative and sculptural. While the shape of the head and the treatment of the face is still reminiscent of Perugino in the accent on the brow and the folds on either side of the mouth, this portrait escapes conventionality. Raphael's subject is a man in early middle age, perhaps a soldier, and his study is unusually vernacular in feeling—indeed, Passavant and Morelli wanted to give it to Franciabigio. While the drawing might simply have been done for reference, it may have had a more specific purpose. At an uncertain date, perhaps beginning as early as c. 1503, and probably stretching over two or three years, Raphael made a series of highly finished drawings for Pinturicchio, laying out the great fresco cycle of the life of Pius II, Aeneas Silvius Piccolomini, that still covers the walls of the Piccolomini Library, situated off the left aisle of Siena Cathedral. That the young Raphael should have planned a fresco scheme by a vastly experienced painter old enough to be his father is remarkable; although we have no detailed knowledge of the nature of the collaboration—contractual or informal, known to the patron or covert—it shows the high regard in which the twenty year old's designs were held.

The Piccolomini frescoes depict primarily public occasions (fig. 26). They contain, in addition to the central players, large numbers of bystanders, and this head could well have been made in preparation for one of them that was not, in the end, used. The direction of the gaze might suggest a soldier standing guard at an important event. No earlier artist would have gone to such effort to think about and characterize extras in such a group scene.

References
Benvignat 1856, no. 679; Passavant 1860, no. 490; Pluchart 1889, no. 429; Morelli 1891–92, 441; Berenson 1903, no. 753; Fischel 1913–41, no. 69; Châtelet 1970, no. 79; Joannides 1983, no. 77; Oberhuber 1983, no. 108; Viatte and Goguel 1983, no. 38; Brejon de Lavergnée 1990, no. 23; Brejon de Lavergnée 1997, no. 522.

117

27. RAPHAEL

Bust-length Portrait of a Young Woman

c. 1504–5

Metalpoint on gray-green prepared paper, 127 x 101 mm

This portrait of a young woman resembles another, larger one in black chalk in the British Museum (fig. 27), once too probably owned by Wicar. The facial types are similar and the sitters could well be two members of the same family. One or other, even both, could have been made with a painting in mind, but the present drawing could also be a study for another portrait drawing on the scale of the British Museum sheet. Self-sufficient portrait drawings were common in northern Italy, especially in the circle of Mantegna. While less frequent in central Italy, some examples exist, and at least one surviving drawing by Perugino could well be an independent portrait.

Some precedent for the pose and arrangement may be found in the work of Leonardo, in particular his *Belle Ferronière* in the Louvre, in which a geometrical solidity of form is emphasized. That painting is a version of the "window view," a formula recommended by Leonardo

Fig. 27
Raphael. *Bust-length Portrait of a Young Woman*, c. 1505, black chalk, 259 x 183 mm. The British Museum, London.

in which the sitter is seen as though framed in a window, set in a dark interior. The density of the hatching here, and the low-toned paper, likewise suggest an interior setting. But in the *Belle Ferronière*, the sitter's arms act as little more than a support for the bust. In Raphael's drawing we are brought closer to the sitter, whose arms are outstretched as though she has just put down a book on her lap, an action that conveys an impression of immediacy and, to some extent, of intimacy.

The handling is refined and dense, with great subtlety of expression. Raphael focuses on the face, the other forms gradually fading out around it. The shadow of the veil falling down the left side of the face and that on the near cheek brings the center of the face into prominence, simultaneously creating volume and defining character. The girl's hair is virtually excluded from this drawing, as in most of the others in the green sketchbook. But although hair is not shown, Raphael was interested in the effect of different types of headdress. The girl in the British Museum drawing has her hair up under a veil. This young woman wears a headdress whose silk(?) tongue extends onto her forehead, bringing into her sculpturesque image an element of decoration. Nor is the range of emotion that of the British Museum drawing, which, incidentally, is lit from the opposite direction. In that drawing, the sitter looks toward the viewer with black-currant eyes, responding to a gaze. Here the sitter, looking slightly to one side, acquires a range of thought and an interior life missing from the other.

Raphael does not seem to have pursued this scheme in painted portraits of women during his Florentine period. In the *Maddalena Doni* (Palazzo Pitti, Florence), for example, or the *Young Woman with a Unicorn* (Galleria Borghese, Rome) he adopted the other Leonardesque model, that of the *Mona Lisa* (Louvre, Paris) in which the hands were included as an expressive feature and a sign of beauty.

References
Benvignat 1856, no. 719; Passavant 1860, no. 411; Pluchart 1889, no. 469; Morelli 1891–92, 441; Fischel 1913–41, no. 75; Châtelet 1970, no. 82; Joannides 1983, no. 78; Oberhuber 1983, no. 103; Viatte and Goguel 1983, no. 42; Brejon de Lavergnée 1990, no. 24; Brejon de Lavergnée 1997, no. 525.

28. RAPHAEL

Doge Leonardo Loredan in Right Profile

c. 1504–5

Metalpoint on pale green prepared paper, 121 x 104 mm

Representing Leonardo Loredan wearing a dogal tiara, this drawing was apparently made from life; if so, as Gould remarked, it would prove a sojourn by Raphael to Venice. This is not impossible. The contract for the *Monteluce Coronation,* signed in December 1505, specified that Raphael could execute it wherever he wished, including Venice, evidently among the cities in which he considered residing. In principle, Raphael's drawing could have been made after another work, but it is more dense and

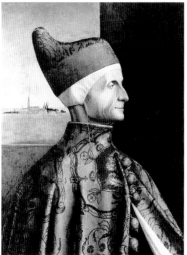

volumetric than one would assume with a Venetian painted model, and while profile portraits of doges were painted well into the 16th century, none of those known possess the informality and immediacy of this image. Carpaccio's profile portrait of Loredan is so different that it cannot be the source (fig. 28a). Nor does it seem likely to have been copied from a drawing. A sculptural model is clearly a possibility, but nothing appropriate is known. Whatever the truth of this matter, there existed some visual relations between Raphael and Venice before his removal to Rome. On the debit side, Raphael knew Carpaccio's drawing of a *Woman in Profile* now in the Ashmolean Museum, for he made a small pen copy of it on a sheet now in the British Museum (Pouncey and Gere no. 6). He knew Bellini's *Madonna* in Boston (Isabella

Fig. 28a
Vittore Carpaccio.
Leonardo Loredan,
c. 1501 or later?, oil on
panel, 71 x 55 cm.
Accademia Carrara,
Bergamo.
Fig. 28b
Giovanni Bellini. *Leonardo Loredan,* c. 1501?,
oil on panel,
61.6 x 45.1 cm.
National Gallery, London.

Stewart Gardner Museum), for he copied the child in it in a drawing in Oxford (Parker no. 539 recto). However, this composition was already known to his father, Giovanni Santi, who employed it in a painting now in the National Gallery, London. As the late Michael Jaffé emphasized to the compiler, the putti standing before the throne in the *Madonna del Baldacchino* were presumably inspired by a Venetian prototype, such as Bellini's destroyed *Saint Catherine Altarpiece* (but a similar formula had been employed in the 1490s by Perugino). Later, in the second decade, Raphael seems to have known some paintings by Titian, but that subject cannot be broached here.

On the credit side, a group of the Virgin and Child by Carpaccio in his *Glory of San Vitale* (San Vitale, Venice) was, as pointed out in 1992 by Cordellier and Py (p. 38), certainly based on a Raphael prototype known from a copy drawing in the Louvre. Giorgione's *Adoration of the Magi* (National Gallery, London) (perhaps a predella panel for Bellini's *San Zaccaria Altarpiece* in Venice) seems in its elaborate paragraphing of figures, to display aware-ness of Raphael's corresponding *Adoration* below the degli Oddi *Coronation.* Titian surely based his *Holy Family* (National Gallery, London) and *Bache Madonna* (Metropolitan, New York) on Raphaelesque models; and the soldier at the left of his *Christ and the Adulteress* (City Art Gallery, Glasgow) is taken from the same rear view of an antique *Hermes* found in a copy of a lost drawing by Raphael, which Titian probably knew.

Nevertheless, despite these links, possibility has not hardened into certainty. Had so absorbent an artist spent much time in Venice before, say, 1505, one would have expected a more profound response to Giovanni Bellini (fig. 28b); after c. 1505, a more profound response to Giorgione. If Raphael visited Venice, it can have been no more than briefly.

References
Benvignat 1856, no. 716; Passavant 1860, no. 408; Pluchart 1889, no. 468; Morelli 1891–92, 377; Fischel 1913–41, no. 76; Joannides 1983, no. 76; Oberhuber 1983, no. 100; Viatte and Goguel 1983, no. 43; Mulazzani 1986, 149–53; Gould 1987, 111–15; Brejon de Lavergnée 1997, no. 526.

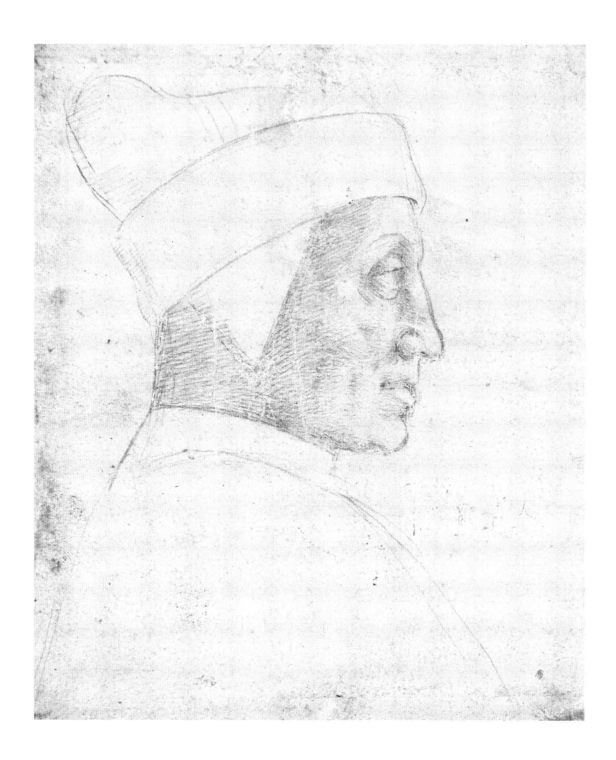

29. RAPHAEL

Head of a Man in Three-quarter View Looking up to the Left

c. 1504–5

Metalpoint on gray-green prepared paper, 121 x 99 mm

Fig. 29a
Raphael. *The Penitent Saint Jerome,* c. 1504, pen and ink over traces of black chalk, 244 x 203 mm. The Ashmolean Museum, Oxford.
Fig. 29b
Raphael. *Landscape and Figure Sketches,* c. 1504, pen and ink, 244 x 203 mm. The Ashmolean Museum, Oxford (verso of fig. 29a).

With a drawing such as this or cat. 28, it is always a delicate judgment whether it was made with a specific purpose, in preparation for a painting, or simply as a *tête d'expression,* an exercise to be kept for reference in the artist's portfolios. However, this drawing was used in, and was no doubt made for, the head of the *Penitent Saint Jerome* known in a fairly finished pen drawing in the Ashmolean Museum (fig. 29a). The Ashmolean drawing, which had been underestimated, was returned to Raphael by Ferino Pagden in 1981, an important re-attribution reinforced by her observation that one of the verso sketches prepares the background of the *Pala Colonna* of c. 1504–5. The mood of the present head, surely studied from life, is sharpened in the pen drawing, in which Saint Jerome's features are more emaciated. The slight awkwardness of the Ashmolean drawing was probably the result of Raphael's having to incorporate into the composition both the head study and the background view, no doubt prepared in a lost drawing: copies of similar studies of Umbrian towns are found in the Venice sketchbook. Setting the head at a three-quarter angle, Raphael emphasized the angularity of the nose, cheekbones, and jaw, pursuing the theme stated by the block-like character of the town.

Jerome was among the most commonly represented saints in the Renaissance, as one among others in altarpieces and, more important, as a single figure, a biblical scholar or a desert penitent. Among the earliest treatments of Saint Jerome in the Wilderness are two paintings made by Piero della Francesca in the 1450s. One represents Jerome as a penitent (Gemäldegalerie, Berlin), the other as a scholar and teacher (Galleria dell'Accademia, Venice). Both types were taken up by painters indebted to Piero, although most treatments of Saint Jerome as a scholar placed him in an interior. Major examples of St. Jerome in the Wilderness exist by Bellini, Perugino, and Pinturicchio—to whom the Ashmolean drawing was long attributed. Raphael's treatment is relatively unusual in setting the saint before a recognizable city view, if somewhat rearranged. It would have been planned for a Perugian client, perhaps one linked with the great church of San Domenico, visible at the right of center in fig. 29b. Whether Raphael produced a painting to this design is not known. A painting of a *Penitent Saint Jerome in the Wilderness* by Raphael is mentioned by the Venetian writer Marcantonio Michiel as in the collection of Marco Mantova Benavides in Padua (Golzio 1936, 171), but it is otherwise unknown and may or may not be related to the Ashmolean design. The artist certainly returned to the subject later. A *Penitent Saint Jerome* based on a design by Raphael was reproduced in an engraving by Marcantonio, and a loosely connected silverpoint drawing by Raphael of c. 1512 was discovered in the Louvre several years ago by Konrad Oberhuber (Cordellier and Py no. 251).

References
Benvignat 1856, no. 689; Passavant 1860, no. 406; Pluchart 1889, no. 435; Morelli 1891–92, 441; Fischel 1913–41, no. 74; Joannides 1983, no. 74; Oberhuber 1983, no. 101; Viatte and Goguel 1983, no. 44; Brejon de Lavergnée 1997, no. 527.

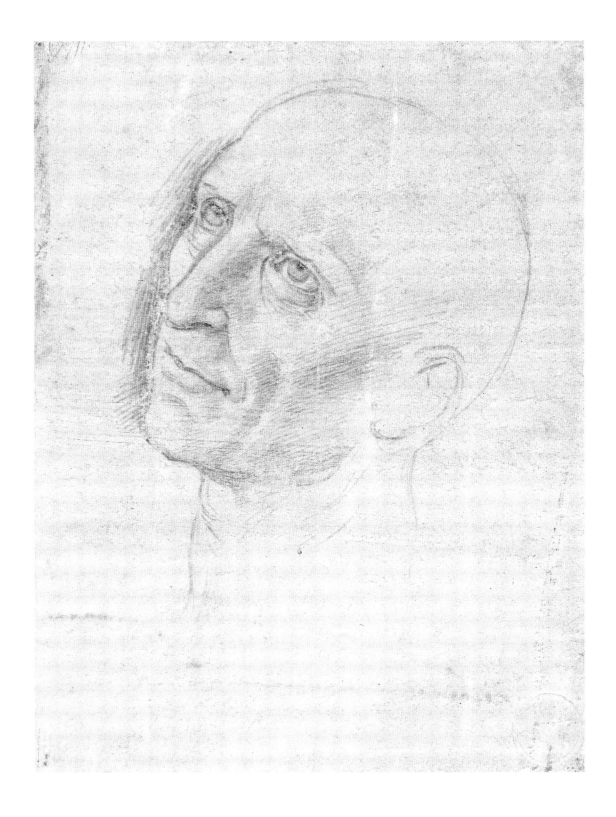

30. RAPHAEL

Head of a Man in Three-quarter View Looking up to the Right

c. 1504–5

Metalpoint heightened with white on green prepared paper, 120 x 104 mm

This drawing and the previous one were probably made from the same model at the same session. Here, however, light falls from the right rather than the left and is much accentuated by the broad but carefully judged application of white body color. This drawing brings out the mass and volume of the head and the breadth of the face rather than their angularity; it is also more detailed. Whereas the profile study fades out behind the ear, directing attention to the tilted face, this one provides a detailed account of the ear and the side of the head. The effect is of concentration rather than penitence, looking upward, possibly for inspiration—like Raphael's later *Portrait of Tommaso Inghirami* (Palazzo Pitti, Florence).

It is tempting to suppose that this drawing was made, like its companion, with a pictorial project in mind. Only its inherent character authorizes one to think so, for no connected compositional drawings are known. But this character is particular. White heightening is not found on any other of the pages of the so-called green sketchbook, and so particular an emphasis implies a context. It suggests an interior setting, with a shaft of light entering from above. Another metalpoint study at Lille, of c. 1507–8 (fig. 30a), for Saint Bernard in the *Madonna del Baldacchino,* a sacra conversazione set in an interior, is similar in treatment. Given that Raphael used the same model as in the previous drawing, it is reasonable to suppose that this drawing was made for a composition representing the same saint, perhaps one illustrating the other main aspect of Jerome's life, his work as a scholar.

Raphael was intently aware of Northern art, more so even than his master Perugino, and considerably more intelligently. No doubt he knew of the Eyckian panel *Saint Jerome in His Study* (fig. 30b), which was in the Medici collection during the fifteenth century. If not, he would certainly have known its most obvious Florentine derivative, Ghirlandaio's fresco of c. 1480, *Saint Jerome in His Study,* in the Florentine church of the Ognissanti.

Paired with Ghirlandaio's painting is Botticelli's *Saint Augustine.* Toward 1500 Botticelli reprised the relation in (perhaps complementary) small-scale panels of *Saint Augustine in His Study* (Uffizi, Florence) and *Saint Jerome's Last Communion* (Metropolitan, New York); a few years later Carpaccio also included a representation of *Saint Augustine in His Study* in a cycle otherwise devoted to Saint Jerome (Scuola di San Giorgio degli Schiavoni, Venice). This is because Augustine was granted a mystical awareness of Saint Jerome's presence at the moment of Jerome's death. It may be that Raphael planned a similar juxtaposition and intended the present head for Saint Augustine. But the similarity of the two heads is such that it is more likely they both represent Saint Jerome. It is pleasant to speculate that the same patron might have ordered from the young painter pendant images of *Saint Jerome in His Study* and *Saint Jerome in the Wilderness* to be set—perhaps within paneling—on facing walls of his study.

References

Benvignat 1856, no. 688; Passavant 1860, no. 405; Pluchart 1889, no. 434; Morelli 1891–92, 441; Fischel 1913–41, no. 77; Joannides 1983, no. 75; Oberhuber 1983, no. 102; Viatte and Goguel 1983, no. 45; Brejon de Lavergnée 1990, no. 25; Brejon de Lavergnée 1997, no. 528.

Fig. 30a
Raphael. *Study for Saint Bernard,* c. 1508, metalpoint on beige prepared paper, 123 x 191 mm. Palais des Beaux-Arts, Lille.

Fig. 30b
Circle of Jan Van Eyck. *Saint Jerome in His Study,* 1442?, oil on panel, 20 x 13 cm. The Detroit Institute of Arts, City of Detroit Purchase.

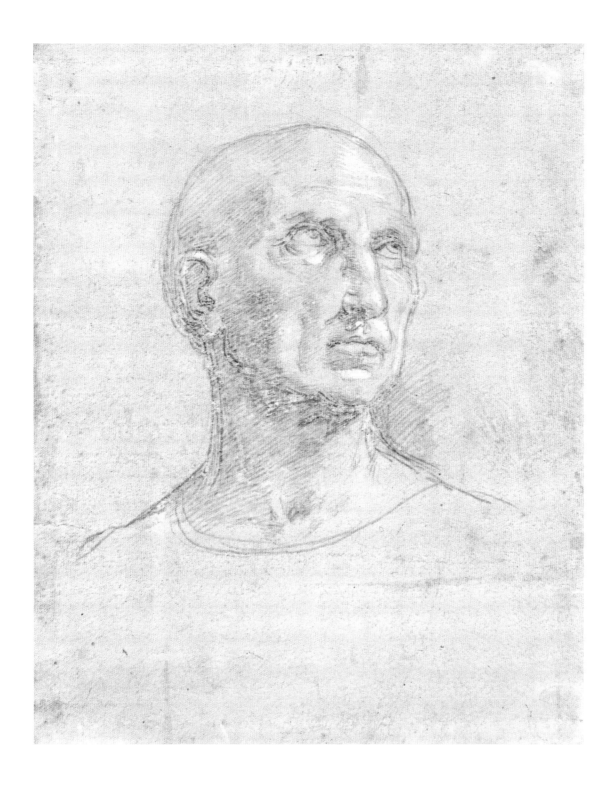

31. RAPHAEL

Head of a Man

1505

Metalpoint with traces of stylus indentation on green-beige prepared paper, pricked for transfer, 204 x 186 mm

This study and another sheet of silverpoint drawings in Oxford (fig. 31a) (probably once owned by Wicar) for the heads of two of the seated saints in the fresco of the *Trinity with Saints* in the Oratorio of the monastery of San Severo in Perugia (fig. 31b), represent a moment of geometrical purism in Raphael's work.

The present study was not employed in the painting. The nearest saint at the right side of the fresco is seen in profile, like his counterpart on the left side, prepared in the Oxford drawing. It is unlikely that Raphael would have placed side-by-side heads as similar to each other in pose as that in the present drawing and in the Saint Stephen on the Oxford sheet. However, since the present head, although foreshortened from below, is not seen from quite so low an angle as the saints on the upper level, it may be that it was intended for a figure in the lower section of the fresco, where Raphael certainly planned to include a number of standing saints (see cat. 18).

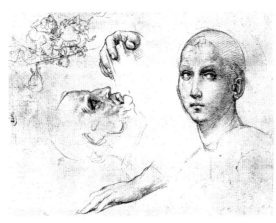

Fig. 31a
Raphael. *Studies for the San Severo Trinity and a Copy after Leonardo,* c. 1505, metalpoint on white prepared paper, 212 x 274 mm. The Ashmolean Museum, Oxford.
Fig. 31b
Nineteenth-century reproduction of Raphael's *The Trinity with Saints* (original c. 1505, San Severo, Perugia).

Yet, the fact that the drawing is pricked counts rather against such a hypothesis, since pricking implies the transfer of an image while maintaining parity of scale. This head is smaller than any head in the fresco would have been, so the pricking would not have been to transfer the design to a cartoon, still less to the wall, and while this would not exclude a connection with the preparatory phases of the fresco, the implication is that it was done for a lost or unexecuted contemporary work on a smaller scale.

Despite the slight blurring of the outlines caused by the pricking, the rigor of the form is exemplary. It shows that Raphael had finally liberated himself from the facial types of Perugino. At first sight the head seems of portrait-like accuracy, and it no doubt was inspired by life study. But when it is compared with the head of Saint Stephen, it is evident that life has been "improved" and that Raphael has developed the same geometrical, egg-shaped, module; indeed, placed side by side the two drawings could represent the same person in youth and age. The geometry here, although less obvious, is as determinant as in the Saint Stephen. The furrows in the center of the brow spread out with the regularity of fan spokes, the creases that run beside the mouth on the right mirror the outline of the jaw on the left, and the sequence of different ridges in the eyebrows and mouth forms a powerful image of subtlety combined with severity. Like the image of the more aged man on the Oxford sheet, this drawing reflects Raphael's experience of Leonardo's head studies for the *Battle of Anghiari*—at least two of Leonardo's drawings for this composition are copied on the Oxford sheet—but Raphael's penchant for geometry reorganizes Leonardo as it reorganizes life.

References
Benvignat 1856, no. 723; Passavant 1860, no. 410; Pluchart 1889, no. 477; Morelli 1891–92, 378; Fischel 1913–41, no. 211; Châtelet 1970, no. 80; Joannides 1983, no. 100; Oberhuber 1983, no. 109; Viatte and Goguel 1983, no. 46; Brejon de Lavergnée 1997, no. 529.

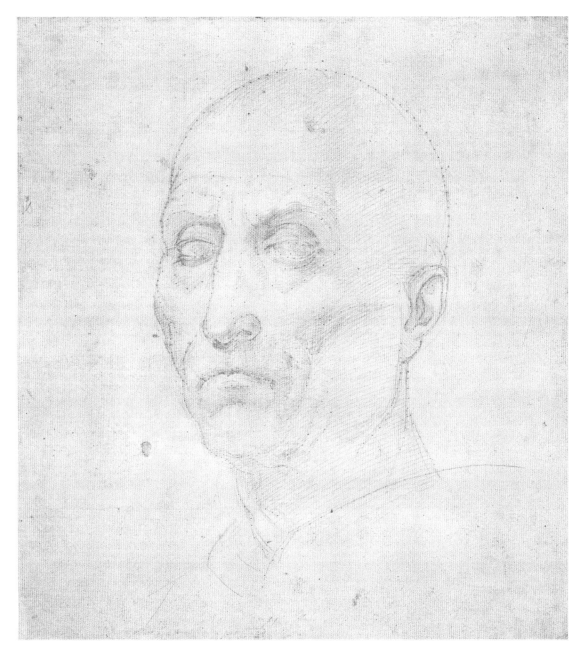

32. RAPHAEL

Half-length Study of a Model Posed as God the Father, for the "Entombment of Christ"
1507

Pen and ink, wash, traces of red chalk, squared in black chalk, 113 x 102 mm

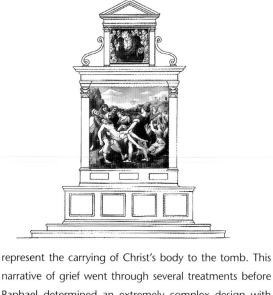

This study was made for the panel of God the Father (fig. 32a) that once crowned the *Entombment* formerly in the church of San Francesco in Perugia and now in the Galleria Borghese in Rome. The ensemble was commissioned by Atalanta Baglione for her family's chapel in commemoration of her son Grifone, assassinated in 1500 during one of the city's internecine conflicts. The main panel is an exceptionally powerful evocation of female grief. Raphael's initial project was a Lamentation over the Body of Christ, based upon the great altarpiece of 1495 by his master Perugino, then in the Florentine church of Santa Chiara and now in the Uffizi. Among Perugino's most influential designs—one, surprisingly, that he did not repeat—it was a source of inspiration for both Fra Bartolommeo and Andrea del Sarto. Two fully worked out drawings by Raphael survive for this stage of the scheme, and it may be that he then planned the upper panel to be somewhat broader, with God the Father spreading out his hands in compassion, a protective umbrella. This arrangement is seen in a silverpoint study, apparently from the same model as the present drawing, in the Ashmolean Museum (Parker no. 534, also from Wicar's collection).

Then, probably inspired by a Roman relief of the funeral of Meleager—accompanied, significantly enough, by Atalanta—which he copied, Raphael decided instead to represent the carrying of Christ's body to the tomb. This narrative of grief went through several treatments before Raphael determined an extremely complex design with two competing areas of action: at the left, the carrying, attended by the distraught Magdalene; on the right, the fainting Virgin supported by the holy woman, an episode that may previously have been planned for the predella. The new dynamism of the main panel naturally affected the upper one—executed, in all probability, by Raphael's friend Domenico Alfani—and Raphael probably then changed its proportions to set up an edgier relation with the main scene: the framing lines within the present drawing indicate a narrower field than that implied by the Oxford drawing. The Father now swivels energetically round to bless his Son, looking down to Christ's face and head. And, perhaps at the last minute, Raphael had the brilliant idea of reciprocating this gaze across the division of the frame. As the dead Christ sightlessly faces his Father, the left-hand bearer raises his head at the same angle to witness God's blessing. In the most advanced drawing to survive for the Entombment group, in the Uffizi (538E), the head of this bearer is the only element to be pricked through, so Raphael could be sure of retaining the correct angle in the (lost) succeeding study.

The seventeenth-century separation of the main and upper panels has removed this reciprocal intensity, but when the altarpiece was complete (fig. 32b) it would have possessed an emotional force hitherto unrealized in Umbria—indeed, it was too forceful for Umbrian tastes and was not influential there.

Fig. 32a
Domenico Alfani? *God the Father*, 1507, oil on panel, 81.5 x 88.5 cm. Galleria Nazionale dell'Umbria, Perugia.
Fig. 32b
Photomontage of main and upper panels of the *Entombment*.

References

Benvignat 1856, no. 697; Passavant 1860, no. 373; Pluchart 1889, no. 465; Morelli 1891–92, 377; Fischel 1913–41, no. 180; Joannides 1983, no. 141; Oberhuber 1983, no. 198; Viatte and Goguel 1983, no. 53; Brejon de Lavergnée 1997, no. 530.

33. RAPHAEL

Two Male Heads and Sketch of a Lion's Head

1507

Pen and ink, 181 x 200 mm

This unusual drawing has been the subject of discussion. The two heads—one well-fleshed, the other emaciated—were obviously planned as a pair, to illustrate the fat and the thin, or Dives and Lazarus, a subject known in the period but treated only occasionally (fig. 33). The satirical tone is unusual in Raphael's work, and that the present drawing was made in preparation for a painting is improbable, even for subsidiary figures in a large fresco. More likely, it is the product of a light-hearted moment, an illustration for a colleague or a lesson for a pupil. Of course, jokes have a point, and in a physiognomic juxtaposition of this sort, Raphael was demonstrating—and perhaps practicing—his powers of characterization. The ancient treatise on

Fig. 33
Bonifazio Veronese.
Dives and Lazarus,
c. 1535, oil on canvas,
205 x 493 cm. Galleria
dell'Accademia, Venice.

physiognomy, wrongly attributed in the Renaissance to Aristotle, gave such exercises intellectual respectability, quite apart from their inherent usefulness in extending an artist's powers of emotional definition. Even Michelangelo, an artist content with a limited range of facial expression and one who generally favored impassivity, made studies of expressions of different types for his pupils to copy, and such a program of study was no doubt also encouraged by Raphael.

The pseudo-Aristotelian account also related human and animal types, a study that interested Leonardo and to which he gave impetus. In the seventeenth century relations of this kind were codified by Charles Le Brun, who prepared an illustrated treatise on the subject of general categories of face and of specific expressions. In the

present drawing the muzzle of a lion, seen in outline at the bottom of the sheet, while not directly related to the two human heads, was presumably made with a physiognomic comparison in mind. Raphael had earlier experimented, particularly for example in cat. 31 and the Ashmolean study for the San Severo *Trinity* (see fig. 31a) with types that might be defined as Leonine. The sheet has clearly been cut down and no doubt once held further studies of animal or human heads.

The pen technique in this drawing, with little use of internal contour and the forms produced by a crosshatching that simultaneously creates plastic form and simplifies it, was employed by Raphael only briefly. A study for the *Entombment* in the Ashmolean Museum, of 1506–7, exhibits a very similar type of hatching, as does a singular drawing—whose purpose, if it had one, is entirely conjectural—of corpses being laid out for burial that is found on the verso of another study for the *Entombment,* now in the British Museum (Pouncey and Gere no. 361). A date of 1507 would also fit the present drawing well.

References
Benvignat 1856, no. 711; Passavant 1860, no. 486; Pluchart 1889, no. 493; Morelli 1891–92, 441; Fischel 1913–41, no. 103; Joannides 1983, no. 193; Oberhuber 1983, no. 194; Viatte and Goguel 1983, 322; Brejon de Lavergnée 1997, no. 551.

34. RAPHAEL

Holy Family with Saint John the Baptist, Zacharias, and Elizabeth in a Landscape

1507–8

Pen and ink over traces of stylus indentation and black chalk, squared in red chalk, 353 x 234 mm

Fig. 34a
Domenico Alfani. *The Holy Family with Saint John the Baptist, Zacharias, and Elizabeth,* signed and dated 1511, oil on panel, 224 x 151 cm. Galleria Nazionale dell'Umbria, Perugia.
Fig. 34b
J.-B. Wicar. Copy of Alfani's *The Holy Family with Saint John the Baptist, Zacharias, and Elizabeth,* c. 1810?, black chalk, 184 x 125 mm. Palais des Beaux-Arts, Lille, Pl.1738/W933.

This drawing was made for Raphael's Perugian-based friend Domenico Alfani, probably in 1507. On the verso is a brief business-like letter in which Raphael requests three things of Domenico: to obtain payment on his behalf from Atalanta Baglione, presumably part of his fee for the *Entombment* (for which Domenico probably executed the superior panel); to ask the goldsmith Caesarino Roscetto to forward a particular sermon; and for Domenico himself to send him some verses from Luigi Pulci's narrative poem *Morgante Maggiore*. The letter implies some intimacy, some degree of intellectual community, and it also indicates that Domenico acted as Raphael's agent in Perugia. Whether providing a modello was simply generosity on Raphael's part, or whether it was part of a business arrangement, is open to question, but Domenico certainly knew and used other drawings by Raphael, even if they were not necessarily specifically solicited from him.

Alfani's altarpiece for the church of San Simone dei Carmine (fig. 34a) is dated 1511. Wicar knew it well and copied it in a drawing also in Lille (fig. 34b). The composition is more complex than anything previously seen in a Perugian church—with the exception of Raphael's

Entombment—and it is closely related to groups of the Holy Family in landscapes that Raphael had been painting in Florence, such as the *Holy Family with the Palm* (Duke of Sutherland Collection, on loan to the National Gallery of Scotland, Edinburgh) and the *Canigiani Holy Family* (Alte Pinakothek, Munich). The complexity of the composition is not a demonstration of virtuosity for its own sake; it presumably responds to a particular demand. The majestic seated Virgin, whose form implies some response to Michelangelo, dominates the center. Her pose explains the action of the Christ child, who has to reach over her lap to take the pomegranate, a symbol of the Passion, offered him by a garlanded Joseph. At the right, the infant Saint John turns outward to the viewer, indicating the significance of the action, witnessed and understood also by his parents, Elizabeth and Zacharias, who stand behind the main group.

In the present drawing, as in the *Entombment*, Raphael experimented with asymmetry: the composition forms a broad X, intersecting in the Christ child's arm and the Virgin's thigh. But below this center, Raphael, while maintaining an approximate balance, plays unlike forms against one another: the child's nude body against the Virgin's legs, the infant Saint John against the cylinder, perhaps a column drum, against which Joseph leans.

The drawing is more simplified than modelli made by Raphael for his own use or for his immediate pupils, and he probably adjusted his technique to accommodate Alfani's limitations as a designer and his restricted powers of execution. The arrangement of the Virgin and Child was re-used by Alfani later in his career, combined with other figures and placed in different settings.

References
Benvignat 1856, nos. 741–42; Passavant 1860, no. 378; Pluchart 1889, no. 458–59; Morelli 1891–92, 378; Fischel 1913–41, no. 161; Joannides 1983, no. 174; Oberhuber 1983, no. 212; Viatte and Goguel 1983, no. 54; Brejon de Lavergnée 1990, no. 26; Brejon de Lavergnée 1997, no. 531.

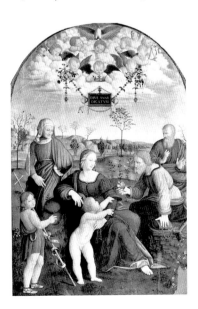

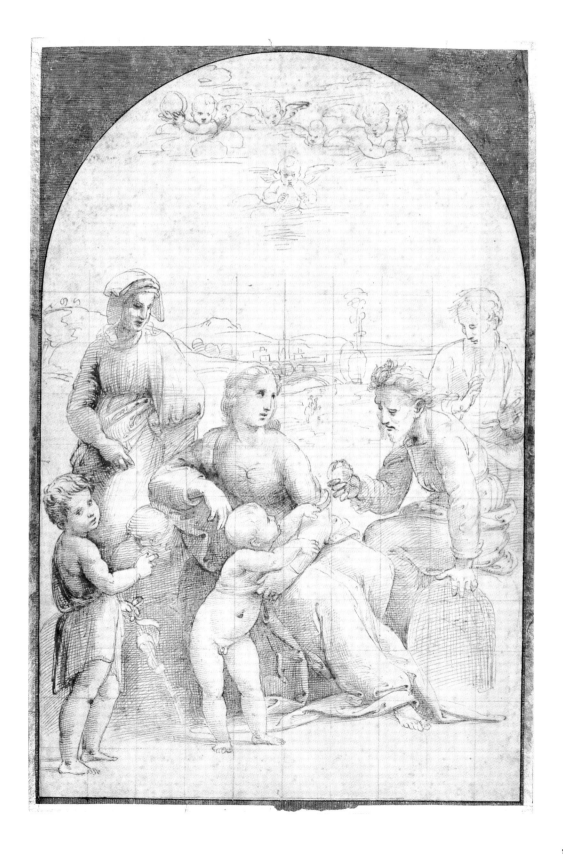

35. RAPHAEL

a. *Two Standing Figures, for the "Disputa" and the "School of Athens"* (recto)

1508–9

b. *Seated and Standing Figures, for the "Disputa" and the "School of Athens"* (verso)

Pen and ink, black chalk, 287 x 203 mm

The free and vital drawings on this sheet would once have extended farther. A bisected watermark of an anchor in a circle at the right edge shows that this sheet must have been half of one the same size as cat. 36, which bears the same watermark. The other half either does not survive or remains unidentified.

As has generally been recognized, this sheet seems to contain studies for two different frescoes in the Stanza della Segnatura, the *School of Athens* (fig. 35a) and the *Disputa* (fig. 35b), but the weight of emphasis is on the latter. It is difficult to interpret in a precise way since Raphael used it for separate figure studies, which, while not exactly scattered, are unclear, or perhaps nonexistent, in their interrelation. The verso was probably drawn first. It shows what appears to be the seated Saint Gregory looking upward, much as in the final fresco, but with his pose tried in different ways. Immediately behind him stands a lissome young man, first sketched nude, then lightly draped, presumably a first idea for one of the acolytes gathered behind the thrones of the doctors of the Church; he seems to be engaged in dialogue with a draped man

holding books immediately to the left, and although these figures were not retained in that form in the fresco, similar roles were redistributed among those in the foreground. The relation is not certain: figures engaged in debate and figures carrying books are also prominent in the *School of Athens*, and these figures could in principle have found a place in an early version of that fresco. But whereas numerous drawings illustrate the early development of the *Disputa*, few survive for the *School of Athens*, whose initial stages remain conjectural. The figure at the bottom of the page, gesturing upward with his left hand and seen slightly from below, may be an early idea for one of the angels in the final composition of the *Disputa* but, alternatively, could have had a role in the upper level of the *School of Athens*.

The purpose of the recto is again uncertain. The standing figure at the left, sagely bearded and heavily draped, could find a place in either fresco. The high angle at which we see him, however, might suggest the latter, but no comparable figure occurs in any of the surviving drawings for the fresco, among which, of course, are very few related to the right-hand side. The young man also presents a puzzle. Whereas the youth on the other side of the sheet was sketched nude before being draped, his nudity was not particularly emphasized. Here the nudity of the frontally posed figure, although light drapery was subsequently thrown across him, seems to be his intended state. It is hard to see such a figure being employed in a religious composition, and he presumably was intended for the *School of Athens*. There is no nudity among the human figures in the final fresco, but Alcibiades is included next to Socrates and might have had a somewhat more compromising role in an earlier version.

There is, however, another possibility. A figure very like that on the recto recurs on a sheet in the Uffizi (496E), which also carries a study for a Venus, similar in elongated proportions to the present male figure. Raphael included a simulated statue of an Apollo, nude, at the upper left of the *School of Athens* and it is generally thought that his first idea for the corresponding simulated female statue on the right was a Venus and Cupid, known from a drawing in the British Museum (Pouncey and Gere no. 27) and an

Fig. 35a
Raphael. *The School of Athens*, 1509–10, fresco. Stanza della Segnatura, Vatican.

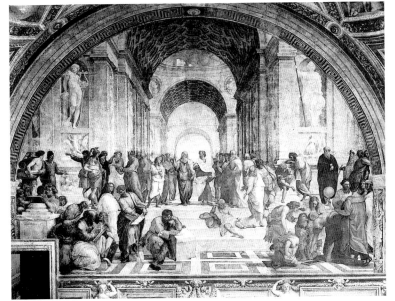

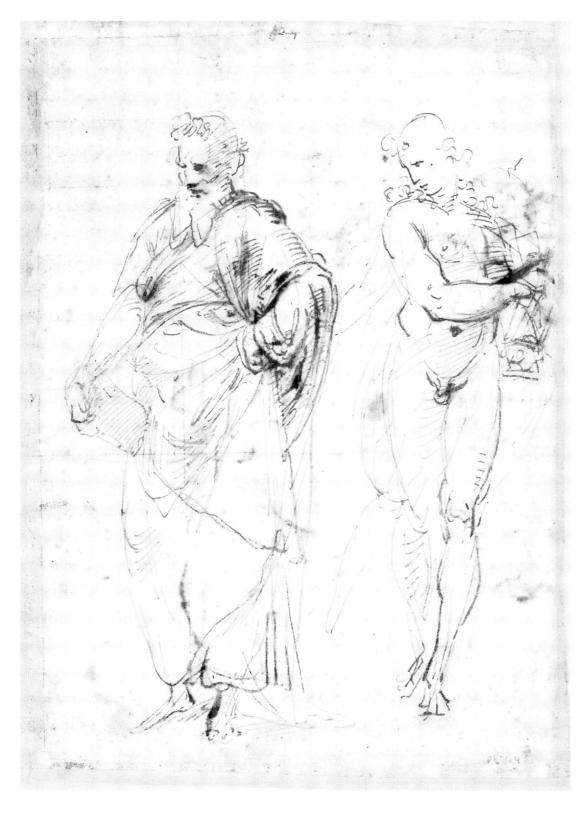

Fig. 35b
Raphael. *The Disputa*
(detail) 1509, fresco.
Stanza della Segnatura,
Vatican.

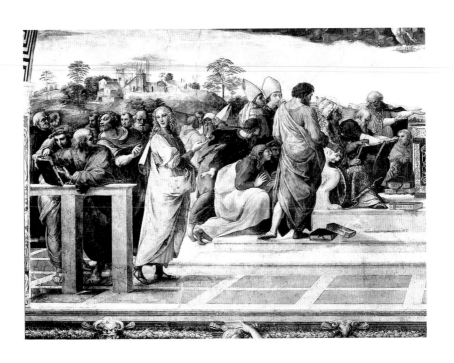

engraving by Marcantonio. In the event, Venus was replaced by Minerva, much more appropriate for an assemblage of philosophers. But since it seems that Raphael initially planned to pair a nude Apollo and a nude Venus in the simulated niches, it may be that the present figure is a first design for Apollo.

Despite the relative uncertainty about its purpose, the sheet has considerable fascination. It represents a freer play of the artist's imagination than generally seen in Raphael's surviving drawings. Of course, without exact knowledge of the context contemplated by the artist it is difficult to be sure, but what we seem to be seeing is Raphael allowing some of his figures to develop their own lives in dialogue with a broader scheme. From his earliest plans for the *Disputa,* a strongly geometrical layout was central to Raphael's conception of the fresco, but he must have been conscious that so majestic a general arrangement could lead to a loss of local vitality. As a complement, Raphael let his pen and imagination wander in individualizing exercises, allowing figures to develop in their own way, at times even eccentrically, to create a lively counterpoint to the general scheme.

Many of the figures in this drawing and some others made at around the same time show a penchant for elongation, not carried through to the fresco or other executed paintings. Also to be found is a particular head type, shaped as a thin oval with a long, sharply pointed nose. Such features, which may derive from renewed study of Filippino Lippi's work, are frequently found in Raphael's pen drawings of the early Roman period, but they drop out of his graphic vocabulary soon thereafter. They were perhaps a way of signaling to himself the need for movement and psychological linking, all the more necessary when designing abstract arrangements. Raphael would, of course, have been deeply conscious of the weaknesses of organization and character definition of the comparably abstract—if infinitely simpler—scheme designed and executed by Perugino in the Cambio in Perugia.

References

Benvignat 1856, nos. 714–15; Passavant 1860, no. 396; Pluchart 1889, no. 447–48; Morelli 1891–92, 378; Fischel 1913–41, no. 266; Joannides 1983, no. 201; Oberhuber 1983, nos. 285–86; Viatte and Goguel 1983, nos. 66–67; Brejon de Lavergnée 1997, no. 533.

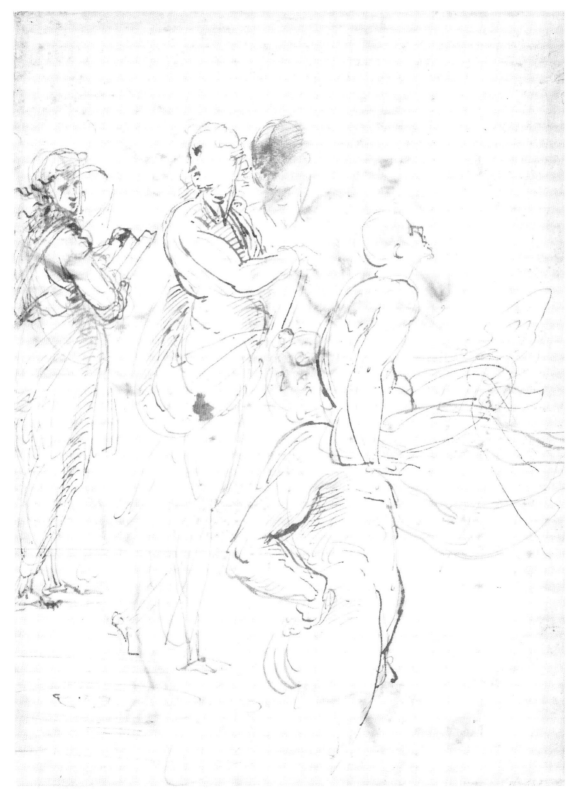

36. RAPHAEL

a. *Drapery Study from the Model, for Christ in the "Disputa"* (recto)

1508–9

Brush and wash heightened with white over traces of graphite, the figure inscribed within a circle made with a compass and stylus indentation, squared in graphite

b. *A Seated Figure and a Standing Figure, for Abraham and Saint Paul in the "Disputa"* (verso)

Pen and ink over traces of graphite, 408 x 269 mm

Fig. 36a
Raphael. *The Disputa* (detail), 1509, fresco. Stanza della Segnatura, Vatican.

The *Disputa* is the painting by Raphael for which the largest number of drawings survives, thirty-odd sheets in all, plus a few others now lost but known in copies. But even this complement leaves considerable areas of the fresco without preparatory studies—only a single drawing is known for the lower right side, for example. Raphael's preparation for the *Disputa* probably involved hundreds of drawings, and while it is unlikely that the other frescoes in the room required as much preparation, it is evident that great numbers of drawings for them have also been lost.

In designing so complex and lavishly populated a composition, Raphael's preparatory process was perforce elaborate. The arrangement had to be geometrically clear, simulate on a flat wall the appearance of an apse, and include a large number of actors whose roles had to be, if not precisely defined, dramatically convincing. Not only was the project an exceptionally difficult one, its success or failure would determine whether he would continue to receive papal patronage. Beginning work in the Vatican as one of several artists, he needed to establish his superiority.

The recto drawing is denser and more resonant than any of the other known individual figure studies for the *Disputa* and, despite its somewhat foxed condition, is one of the richest surviving wash drawings by Raphael. The artist's initial layout drawings for the fresco had been executed in brush and wash, a choice that indicates how concerned he was from the start with the distribution of light and shade to be maintained on the wall. In the most detailed and advanced study for the lower-left quarter of the fresco, wash is also employed as an adjunct. But apart from the present drawing brush and highly contrasted wash is found only in a single drapery study, made at a late moment in the development of the scheme. It is for one of the most prominent figures at the lower left, the long-haired young man who, looking to his agitated companion still vainly attempting to find the solution to his difficulties in a book, points toward the altar and the Eucharist. In both cases the choice of medium was no doubt geared to the enhancement of the modeling. As well as commanding its geometry, Christ has to be the plastic center of the fresco, and Raphael was faced with a hard task in creating this effect since the vanishing point of the perspective construction is, of course, the Eucharist displayed in the elaborate monstrance in the middle of the altar.

But geometry is not ignored. The aureole that surrounds Christ is indicated in stylus on this sheet, in a circle centered in Christ's abdomen. The drawing is squared, for enlargement to the cartoon or, more probably, to some intermediate drawing, and there is also a range of squaring in stylus under the figure, probably to establish aspects of its proportion.

The light sketches on the verso were probably made before the recto, with the sheet employed horizontally. Raphael was trying out the poses of the two figures nearest the viewer seated on the arc of clouds at the upper right of the fresco (fig. 36b); they may already have acquired their identities as Saint Paul and Abraham.

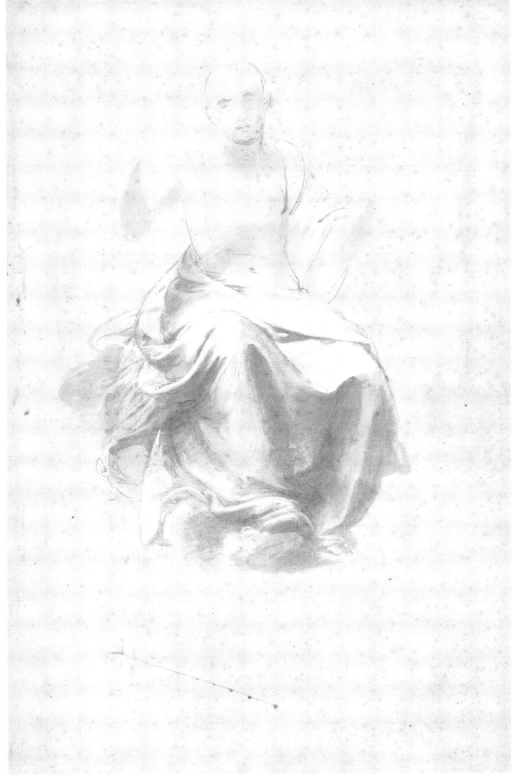

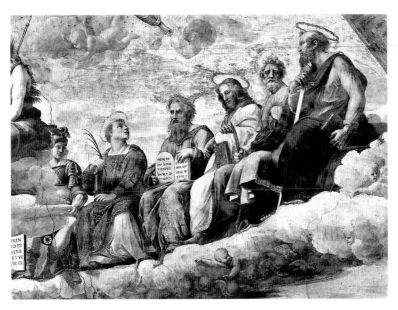

that Christ's commanding presence would not be compromised.

Raphael must have made sketches like this one in very large numbers. Many survive but many more must have been lost. It is likely that it was the magnificence of the recto drawing that ensured the survival of this sheet. Such pen sketches lack superficial attraction and would have been of less interest to collectors than more finished drawings and individual figure studies. But they would have been relished by artists of creative imagination, who would have seen how much Raphael conveyed, and how economically.

Fig. 36b
Raphael. *The Disputa* (detail), 1509, fresco. Stanza della Segnatura, Vatican.
Fig. 36c
Raphael. *Saint Paul, Study for the "Disputa,"* 1509, black chalk with white body color, 387 x 265 mm. The Ashmolean Museum, Oxford.

The basic arrangement of the upper level must have been determined because Raphael reveals no doubts about where the figures should be placed or the angle at which they should be seen. He may indeed have placed seated models on a platform to replicate the planned position of the saints in the fresco. Here establishing the precise relation between the two figures seems to have been his concern. The figures on the upper level are more obviously and tightly controlled by geometry than those below, and Raphael was faced, on a larger scale, with a problem similar to that posed by the San Severo *Trinity*: how to balance local individuality with the arrangement as a whole. If the poses and characterizations were too lively, overall coherence was risked; if the geometric organization was too strong, individual figures would lose their personalities. In the present drawing he placed Saint Paul in fairly strict profile, while Abraham turns outward to speak to him. This arrangement was retained in the succeeding drawing for Saint Paul, a soft black chalk study in the Ashmolean (fig. 36c) (none survives for Abraham) and in the fresco. Of the seven drawings for figures on the upper level, all except that for Christ are in black chalk, and in all the developed ones it is employed broadly and softly. Once again, Raphael wished to obtain breadth of form, but without excessive plasticity, so

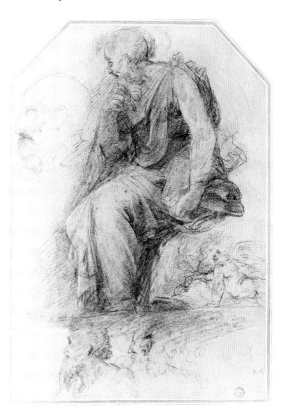

References
Benvignat 1856, nos. 732–33; Passavant 1860, no. 390; Pluchart 1889, nos. 471–72; Morelli 1891–92, 441; Fischel 1913–41, no. 289; Joannides 1983, no. 212; Oberhuber 1983, nos. 308, 314; Viatte and Goguel 1983, nos. 68–69; Brejon de Lavergnée 1990, no. 27; Brejon de Lavergnée 1997, no. 534.

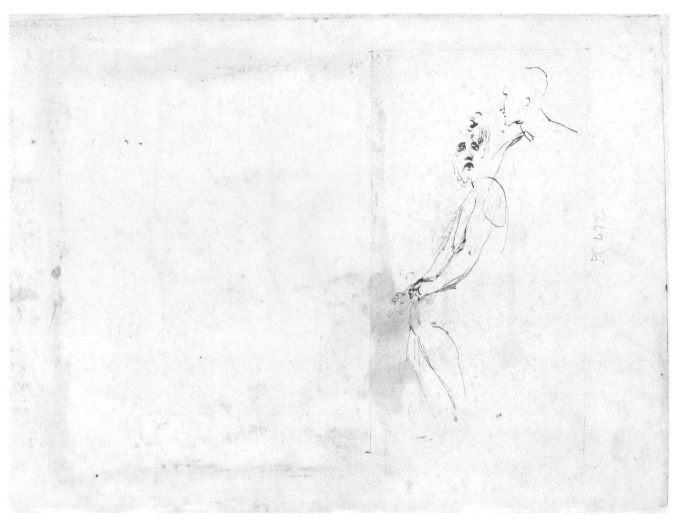

37. RAPHAEL

A Winged Putto

1510

Black chalk, heightened with traces of
white, with an arc made with a
compass and stylus indentation at
the left, 225 x 154 mm

Fig. 37
Raphael. *Theology*,
1510–11, fresco.
Stanza della Segnatura,
Vatican.

This soft drawing was made for one
of the two putti accompanying the
figure of *Theology* (fig. 37) in the
roundel in the segment of the vault
of the Stanza della Segnatura above
the *Disputa*. The initial layout of the
vault differed from the final one,
but the change occurred at an early
stage. Sodoma began the central field as a roundel, but
while he was at work on it, its circumference was changed
to an octagon. The purpose of this transformation was to
replace a directionally neutral circle with the double
directional emphasis of an octagon, which guides the eye
toward the four walls and the four corners. It is evident
that another mind had intervened, but whether this mind
was that of Raphael or that of Bramante, the supervising
architect who was probably responsible for calling Raphael
to Rome, is debatable. In any case the transformation
implies the inclusion of four roundels of female figures
embodying the four faculties—Theology, Philosophy,
Poetry, and Jurisprudence—some of whose main themes
and representative figures are illustrated in the wall frescoes,
and in the four rectangular scenes in the corners of the
vault, whose subjects refer to the wall frescoes to either
side. The change, in short, implies a more tightly unified
scheme for the room, both visually and thematically. It also
entailed extending the corners of the vault into penden-
tives, eliminating the capitals that formerly supported it.

According to Vasari, both the roundels and the rec-
tangles were completed by Sodoma, but they failed to
give satisfaction and were replaced by Raphael. Thus
although they are sometimes treated as though they are
Raphael's earliest work in the Segnatura, it is evident that
they were executed only after he had already undertaken
a considerable amount of work on the walls; they are
probably contemporary with the *School of Athens*.

In the present drawing, the forms of the putto are estab-
lished by a very soft black chalk, which charmingly evokes
slightly pudgy flesh. A compass line in stylus intersects the
figure at the left, its arc perhaps registering the rhythm of
the roundel. The pose is lively and mobile and it may be
that Raphael, here as elsewhere, had it in mind to play

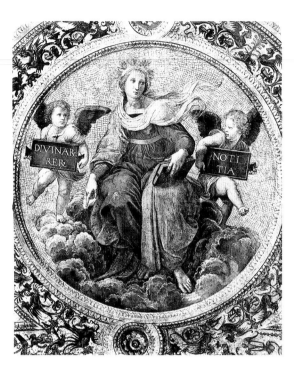

down somewhat the plasticity of the putti so that they
should not detract from the main figure. The figures of
Justice, Philosophy, Poetry, and *Theology* were probably the
first large-scale personifications of abstract concepts that
Raphael had designed, and his approach to them was
tentative: it would be hard to identify which was which
without their labels and accessories. Only once he had
begun to absorb the heroic style of the Prophets and Sibyls
by Michelangelo on the Sistine ceiling did Raphael come
to realize that figures could express concepts by their
physiques and actions. Thus *Prudence, Temperance,*
and *Fortitude* on the Jurisprudence wall, which Raphael
redesigned late in the work in the Segnatura, embody the
concepts that they represent with a force and directness
that marks a new direction in Raphael's art.

References
Benvignat 1856, no. 692; Passavant 1860, no. 39;
Pluchart 1889, no. 433; Fischel 1913–41, no. 266;
Joannides 1983, no. 247; Oberhuber 1983, no. 330;
Viatte and Goguel 1983, no. 76; Brejon de Lavergnée
1997, no. 536.

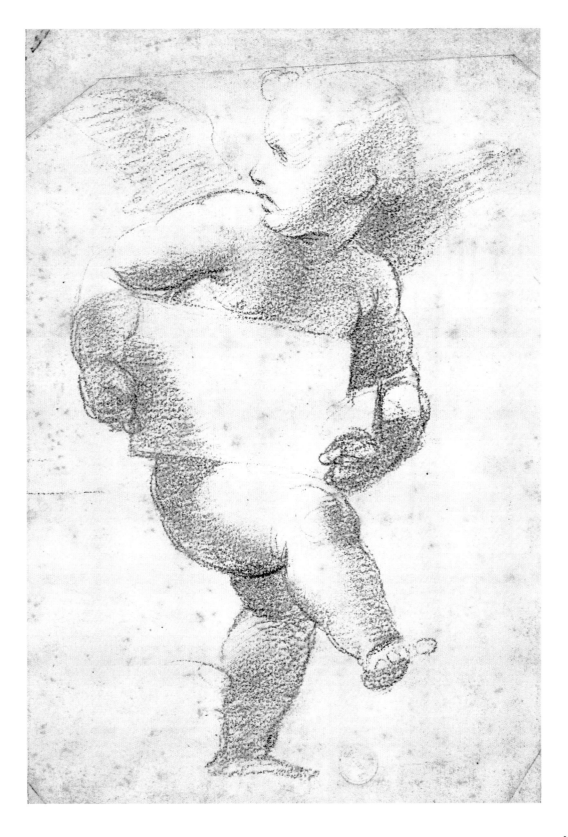

38. RAPHAEL

a. *Seated Male Nude Playing a Lira da Braccio, for Apollo in the "Parnassus"* (recto)

1510

b. *Drapery Studies for Homer in the "Parnassus"* (verso)

Pen and ink over graphite,
349 x 238 mm

Fig. 38a
Raphael. *Parnassus* (detail), 1510, fresco. Stanza della Segnatura, Vatican.
Fig. 38b
Marcantonio Raimondi, after Raphael. *Parnassus* (first project), c. 1512, engraving, 352 x 466 mm. The British Museum, London.

Raphael's study for the seated Apollo in the center of his fresco of *Parnassus* (fig. 38a) in the Stanza della Segnatura is deservedly one of his most famous pen drawings. Clearly studied from the nude model, the forms are placed on the paper with a crispness, precision, and economy that signal a new level of accomplishment in his work. The hardness and severity of the contour, in part executed with a rigorously even pen line, crosses over with silverpoint technique, and it may be significant that one of Raphael's most advanced compositional drawings for the fresco as executed (Pouncey and Gere no. 44, once owned by Wicar) was in fact drawn in a silverpoint so unerringly precise—and technically so exacting—that it had been catalogued as a copy before Oberhuber recognized its authenticity.

The confidence and attack of this pen drawing, like others that survive for the *Parnassus* in the Ashmolean and the Albertina, is in part the result of Raphael's awareness of antique sculpture, which infused many of his studies for this fresco. But the sharpness of contour and the abstract beauty of the forms of, particularly, the thighs and calves, suggest also close study of modern sculpture, that of Michelangelo, of course, but also of Andrea and Jacopo Sansovino. It is the result, too, of a supreme confidence and, perhaps, some impatience. For by the time he made this drawing, Raphael was on his third design for the fresco. The first, recorded in an engraving by Marcantonio Raimondi (fig. 38b), showed an archaeologically classical scene, with the figures dressed in antique robes and small winged genii fluttering in the sky. It was elegant, but static and lacking in energy as a composition, and it emphasized solely the mythically distant past. A second project, known in a copy after a modello of nude figures (Ashmolean Museum, Oxford; see fig. 39a), is more widely spaced with greater interaction among the figures, but they remain on a relatively small scale and there is a strong sense of equality of emphasis. When he came to design the final composition, Raphael broadened his concepts in a number of different ways. Although looking to classical statuary for the muses, he evidently studied them from full-bodied female life. They are the first truly rounded and vital female figures in his work, and they attain—probably coincidentally—a quasi venetian fusion between fleshly amplitude and classical rigor. This project for the fresco also integrated modern poets with classical ones, the modern and ancient worlds, in a way not apparent in the earlier designs. As a consequence, although pseudo-classical costume is

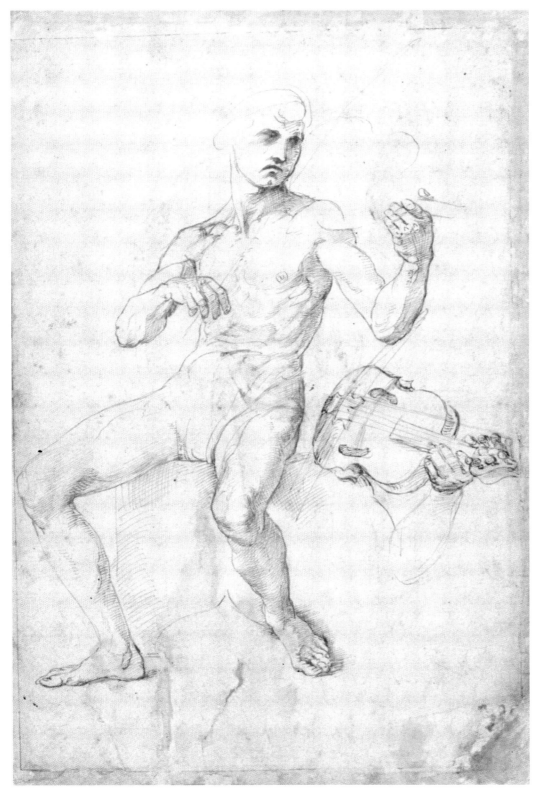

Fig. 38c
Raphael. *Standing Man, Study for the Parnassus,* c. 1509, pen and ink, 343 x 242 mm. The British Museum, London.

maintained throughout, classical and modern figures interact directly. And, moreover, the antique lyre with which Raphael had first equipped Apollo, was replaced with a thoroughly modern lira da braccio. Such conscious anachronism enlivens the fresco and stresses the continuity of ancient and modern in an unexpected way. While the pose of Apollo in the initial version was restrained and based on an antique relief, this figure is obviously studied from life, the action showing that Raphael—and perhaps the model too—knew how the instrument was played. It was bold of Raphael to have risked a potentially ungainly pose, and his success conveys the excitement and intensity of musical creation. Of the eleven surviving sheets of drawings for the *Parnassus,* seven are in pen, two in silverpoint, and two in black chalk. The last two are same-size head studies—one certainly (private collection) and one probably an auxiliary cartoon (Museo Horne, Florence, 5643)—for the heads of the muses. While these ratios may be no more than an accident of survival, it would seem that, unlike the *Disputa*

in which Raphael employed a wide range of media, each for a different task, he simplified his methods in the *Parnassus* and also in the *School of Athens,* for which the surviving drawings are in metalpoint and red chalk. This simplification may have been because in both the *Parnassus* and the *School of Athens* frescoes the placement of figures within pictorial space was a less fundamental requirement than in the *Disputa.* The *School of Athens* is composed essentially in two layers: a line-up in the middle-ground at the top of the stairs, and a foreground articulated with complex groups set at either side. The two layers are connected by transitional figures on the stairs. In the *Parnassus,* set on an opera-stage hill painted around a window that looks out directly onto the Mons Vaticanus (the Janiculum), sacred to Apollo, Raphael knew that recession within the fresco would be contradicted by the real view. He therefore employed a somewhat flattened space and less tightly defined groups of figures, who range quite easily and widely.

The verso drawing, which probably precedes the recto, is a study for the drapery of Homer, situated at the upper left. As the father of epic poetry, he was a major emphasis in the fresco. But he was also an embodiment of poetic inspiration, the blind bard who sings his epic at the dictate of, perhaps, Apollo's music. The complex drapery evoked by Raphael for this figure, more crumpled and less smoothly articulated than that of the majority of the other poets, is surely designed to express the drama of inspiration. Raphael emphasized this drama by basing Homer's head not on busts of the poet but on the head of the recently discovered *Laocoön,* whose expression of struggle and torment was, Raphael saw, appropriate to an evocation of Homer as a vehicle, the involuntary instrument of the gods of whom he sings.

References
Benvignat 1856, nos. 728–29; Passavant 1860, no. 393; Pluchart 1889, nos. 452–53; Morelli 1891–92, 441; Fischel 1913–41, nos. 244–45; Joannides 1983, no. 237; Oberhuber 1983, nos. 365, 368; Viatte and Goguel 1983, nos. 78–79; Brejon de Lavergnée 1990, no. 28; Brejon de Lavergnée 1997, no. 537.

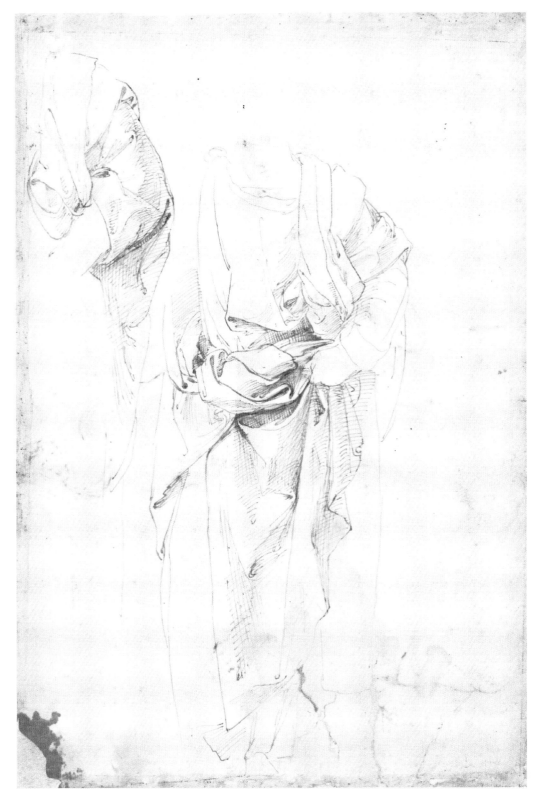

39. RAPHAEL

a. *Studies of Drapery and Hands, for Homer in the "Parnassus"* (recto)

1510

Pen and ink over traces of graphite

b. *Studies of Feet, for the "Parnassus"* (verso)

Pen and ink over graphite and stylus indentation, 334 x 243 mm

This double-sided sheet is a relatively rare survival among Raphael's drawings. Whereas many sheets by the master carry detailed studies of hands and portions of drapery, they are usually subsidiary to more developed figure studies, and even sheets devoted wholly to draperies are not usually as spare as this one. Further, the studies of feet on the verso are unique among Raphael's known drawings.

The drapery and the hands were again made for the figure of Homer and further demonstrate how carefully Raphael prepared this figure. Homer is placed on the same level as the muses. Indeed, he is the only figure of

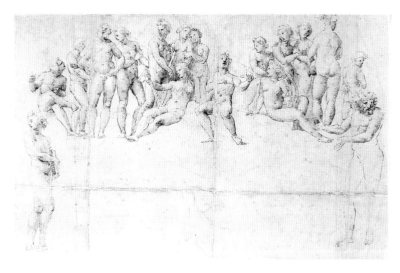

Fig. 39a
Unidentified artist, after Raphael. *Parnassus,* second project (original c. 1509), pen and ink, 292 x 458 mm. The Ashmolean Museum, Oxford.

a poet to be seen at full length on this level, so his draperies were of particular importance. In this drawing Raphael concentrated on the movement of the left hand, as it grasps the drapery, and the fall of the drapery over the outstretched left arm. The hand gestures too are of particular significance, and Raphael realized that he needed to study them with great care. Nevertheless, despite this effort, at a later stage these details were changed. Raphael freed Homer's right arm from the drapery seen here and clad it in a simple sleeve, probably so that it would not cut too abruptly across the body of Dante.

Conversely, the full hang of the drapery from the left hand was curtailed in the fresco, intersected by the drapery of the standing muse of dramatic poetry, just to the right of Homer.

The verso drawings are for a different area of the *Parnassus,* and the fact that they are on the same sheet suggests that Raphael may have worked on similar stages of different parts of his fresco more or less simultaneously, like a writer going over a text that is largely satisfactory, but here and there requires the sharpening of details. They prepare the feet of the two poets who stand at the right edge of the fresco, one of whom, full length and in profile, gestures to the seated figure immediately to the right of the window. They are evidently involved in an aesthetic debate, and Bellori identified them as Horace and Pindar, respectively. The other immediately behind Horace, in depth, identified by Bellori as Ovid, is attentive to their dialogue, his right arm drawn up to his chin in a pose surely suggesting his consideration of the issues involved. That Raphael should have paid particular attention to the bare feet of these figures is difficult to explain, since they do not play an especially expressive role in the painting. But it may be that, in this area as at the edges of the *Disputa,* Raphael felt free to permit a certain marginal roughness. It should be noted that many other identifications for these poets have been suggested by scholars, and that Bellori's are not necessarily correct.

This corner of the fresco seems to have been modified at a fairly late stage in its development. On the right, as can be seen in the Ashmolean drawing (fig. 39a), Raphael originally intended to place two standing figures: one pointing across with both arms, perhaps indicating the view of the Mons Vaticanus; the other close to the pose of the figure as executed, at the right edge. Raphael pursued this idea for a while. Both figures were developed further in a double-sided sheet now in the British Museum (fig. 39b). But at the last moment Raphael—whether at his own volition or at the suggestion of the patron or planner—dropped the pointing figure, whom he may in any case have felt was too similar in pose to the figure at the left of the

altar in the *Disputa*. In his place Raphael inserted the seated Pindar who gestures outward, down into the room, while looking up to the standing figure of Horace. Pindar and Sappho, who displays a scroll bearing her name, at the other side of the window provide splendid framing figures to soften its outline. They are

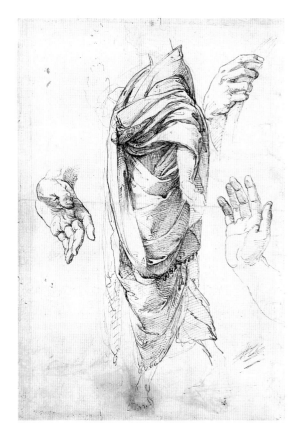

Fig. 39b
Raphael. *Standing Figure and Studies of Hands,* c. 1509, pen and ink over black chalk, 343 x 242 mm. The British Museum, London.

also among the most vigorous figures in the fresco, and in both Raphael makes overt use of his study of Michelangelo: Sappho is virtually a reversal of the elegant ignudo to the right above the Cumaen Sibyl.

A sheet of drawings in the Uffizi (1220E) throws some light on the provenance of the present sheet and related ones. Its recto carries a copy of the muse Melpomene from a drawing in the Ashmolean (developed from figures in the spandrels of classical arches). On its verso are copies after the feet on the verso of the present sheet, the hands from the recto, and two other hands from the British Museum drawing. The Uffizi sheet bears an interesting inscription, perhaps by the great collector Padre Resta: "era questo foglio carissimo à Monsu Possino. l'hebbi dal Sig. Pietro Santi scol di Monsu Lemar suo discepolo 1699." (This sheet was especially dear to Monsieur Poussin. I had it from Signor Pietro Santi, a student of Monsieur [Jean] Lemaire, his [Poussin's] disciple, in 1699.") The inscription indicates that the copy was made, at the latest, before Poussin's death, and that it may even have been owned by him, presumably under the impression that it was by Raphael himself. Quite apart from the interest this copy has for knowledge of Poussin, it demonstrates that the three sheets of drawings by Raphael from which it quotes were together when it was made. They may well have remained together until 1799, only then to be dispersed, for both the Ashmolean and British Museum sheets have a probable provenance from Wicar's first collection.

References
Benvignat 1856, nos. 712–13; Passavant 1860, no. 394; Pluchart 1889, nos. 445–46; Morelli 1891–92, 441; Fischel 1913–41, nos. 242–43; Joannides 1983, no. 236; Oberhuber 1983, nos. 366–67; Viatte and Goguel 1983, nos. 80–81; Brejon de Lavergnée 1997, no. 538.

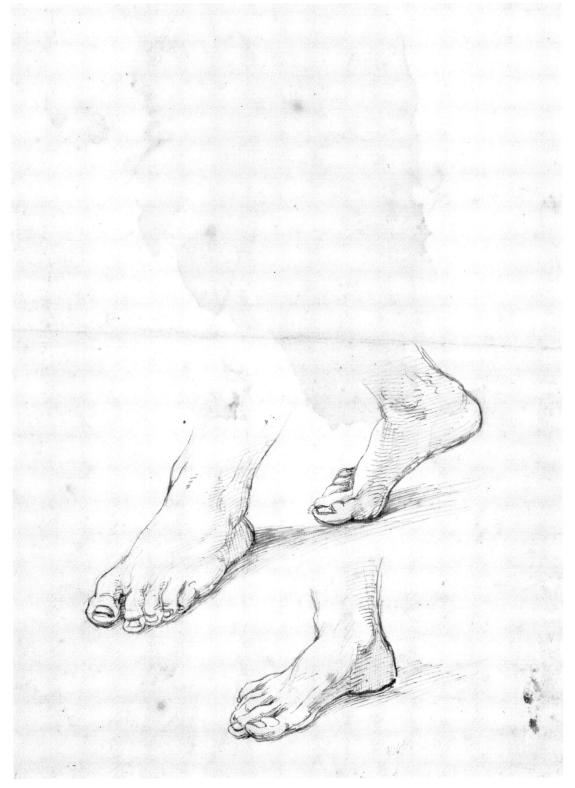

40. Raphael

Studies of a Madonna and Child,
for the "Madonna di Loreto" and
the "Aldobrandini Madonna"

1509–10

Metalpoint on pink prepared paper,
111 x 143 mm

This page contains overlapping studies for three different compositions of the Virgin and Child. It demonstrates that Raphael, in his early years in Rome, as in Florence, conceived such studies not as successive stages in progress toward a single work, but as alternatives, any one of which would make a splendid painting. As it is, two of the drawings on this page, both developed in further drawings in Lille and in the British Museum, resulted in paintings: the *Aldobrandini Madonna* (fig. 40a) and the so-called *Madonna di Loreto* (fig. 40b, a much reproduced image whose original version was identified by Cecil Gould in 1979). The more complete group was not, as far as is known, carried further.

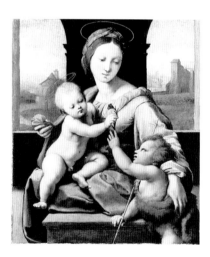 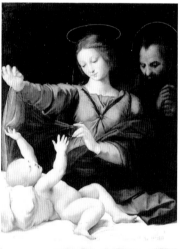

Fig. 40a
Raphael. *The Aldobrandini Madonna,* c. 1509, oil on panel, 387 x 327 cm. National Gallery, London.
Fig. 40b
Raphael. *The Madonna di Loreto,* c. 1510, oil on panel, 121 x 91 cm. Musée Condé, Chantilly.

Raphael made several studies of tightly knit Virgin and Child groups during this period, the majority in the "pink sketchbook" (see cat. 42). They may have been made at intervals of comparative relaxation from his ambitious projects, perhaps in winter, which is less conducive to fresco painting. Toward the end of his Florentine period, Raphael had become attracted by the problems and opportunities posed by Virgin and Child groups set in carefully described interiors. In this he was influenced both by high-finish Northern European Madonnas and by Leonardo's variants of this type in paintings such as the

Benois Madonna in the Hermitage. Indeed, Raphael's exquisite *Madonna of the Carnation* in the Northumberland Collection, rediscovered in 1993 by Nicholas Penny, is virtually a reworking of Leonardo's painting. Raphael seems to have reserved his experiments in this manner for small-scale paintings. Such interiors range from the simple darkened settings of the *Bridgewater Madonna* (see fig. 16a), in which color relations remain close to those of Raphael's open-air Florentine Madonnas, to the *Madonna of the Carnation,* which deploys a scheme based on grays and greens, eliminating saturated reds and blues.

Once in Rome, Raphael developed some of these ideas in other paintings, notably the *Aldobrandini Madonna.* In this work he again employed the interior setting as a laboratory for color combinations he had not previously tried, but simultaneously created a harmonic continuity with the landscape seen through the windows. The *Aldobrandini Madonna* is generally placed in 1509, but the *Madonna di Loreto,* although also conceived on this sheet, was probably not executed until a year or two later. It takes a very different approach to the Holy Family's context, using the darkened setting to thrust the group forward. Another indication that Raphael parceled out, over several years, ideas generated simultaneously is provided by the *Alba Madonna* in the National Gallery of Art, Washington, whose color range, although the setting is entirely exterior, comes close to that of the *Aldobrandini Madonna.* The *Alba Madonna* was prepared in a sheet of drawings that also carries a study for the *Madonna della Sedia* (Palazzo Pitti, Florence), a painting whose colors and textures suggest a date of c. 1512.

The design of the *Aldobrandini Madonna* went through several variants, and in this drawing Raphael finally determined to bring the infant Saint John too into the group, gathered toward the Christ child by the Virgin's tender left hand.

References

Benvignat 1856, no. 695; Passavant 1860, no. 380; Pluchart 1889, no. 437; Fischel 1913–41, no. 352; Châtelet 1970, no. 85; Joannides 1983, no. 274; Oberhuber 1983, no. 418; Viatte and Goguel 1983, no. 95; Brejon de Lavergnée 1997, no. 542.

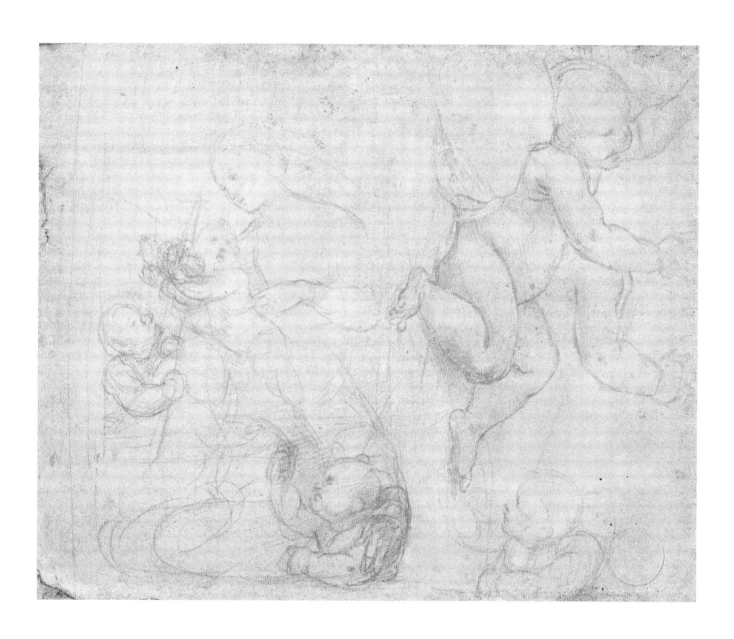

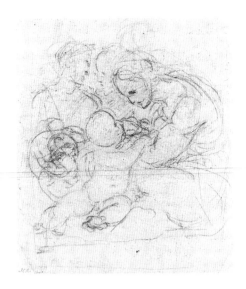

41. RAPHAEL

Studies for the "School of Athens" and for a Virgin and Child with Saint John

1509–10

Metalpoint on pink prepared paper, 156 x 117 mm

The sketch for the pupil of Euclid is a unique survival of a single-figure study for one of the foreground wings of the *School of Athens*. The group of young students that clusters around Euclid's demonstration of geometry at the right side of the fresco (fig. 41a) is one of the most revelatory in Raphael's work. It illustrates with great clarity progressive stages of intellectual enlightenment and different types of intellectual excitement. Few artists have been able to make the processes of rational thought a subject of interest, and whereas Michelangelo could convey with incomparable profundity diverse states of the spirit, even he did not particularly succeed in showing specifically intellectual processes. A geo-

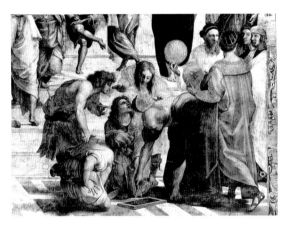

Fig. 41a
Raphael. *The School of Athens* (detail), 1509–10, fresco. Stanza della Segnatura, Vatican.
Fig. 41b
Raphael. *Virgin and Child with Saints*, c. 1509, red chalk, 159 x 129 mm. Fitzwilliam Museum, Cambridge.

metrical demonstration is not in itself an apparently attractive subject for a painter, and it is an indication of Raphael's genius for dramatic invention—and his own excitement at things of the mind—that he makes the subject so compelling.

It seems likely, although it is no more than conjecture, that Raphael transferred to his group of young students the reactions of wonder in a scene of shepherds clustered around the manger of the Christ child, and he may have known drawings by Leonardo made in preparation for some of the early versions of the San Donato a Scopeto *Adoration*. Of course, it was also Leonardo who had further pioneered the representation of the motions

of the mind in the *Last Supper* in Santa Maria delle Grazie in Milan, so even if the specific visual source here is not Leonardo, his is the conceptual inspiration.

Raphael must have made many studies for the different figures. This one is quasi diagrammatic, establishing the relation of head and arm, the hand turned out in an involuntary gesture of surprise. This youth closes the group on the left and is treated relatively flatly, as a kind of parenthesis. He is not the most brilliant of Euclid's pupils, for while the young man kneeling below him has already grasped the logic of Euclid's demonstration, this youth is still trying to follow it.

Gathered within his arm, and certainly a later entry on the page, is the splendidly tight and compressed group of the Virgin and Child with Saint John. The Virgin's head, bent forward, is also tried twisted back in almost pure profile, as though she were looking behind her in alarm. This movement is seen in a more decorative mode in the Ashmolean's study for the muse Melpomene in the *Parnassus*, and it was used precisely to indicate fear in one of the women vainly attempting to flee in Raphael's *Massacre of the Innocents*, designed a year or so after this drawing was made. Perhaps Raphael considered for a moment including a reference to the danger run by the Christ child in this secure composition, before rejecting it. This scheme was taken further in a red chalk drawing in the Fitzwilliam Museum (fig. 41b), in which the group remains tightly unified, but now includes a female saint, probably Catherine, and Saint Joseph.

References
Benvignat 1856, no. 685; Passavant 1860, no. 392; Pluchart 1889, no. 479; Fischel 1913–41, no. 353; Joannides 1983, no. 229; Oberhuber 1983, no. 348; Viatte and Goguel 1983, no. 97; Brejon de Lavergnée 1997, no. 543.

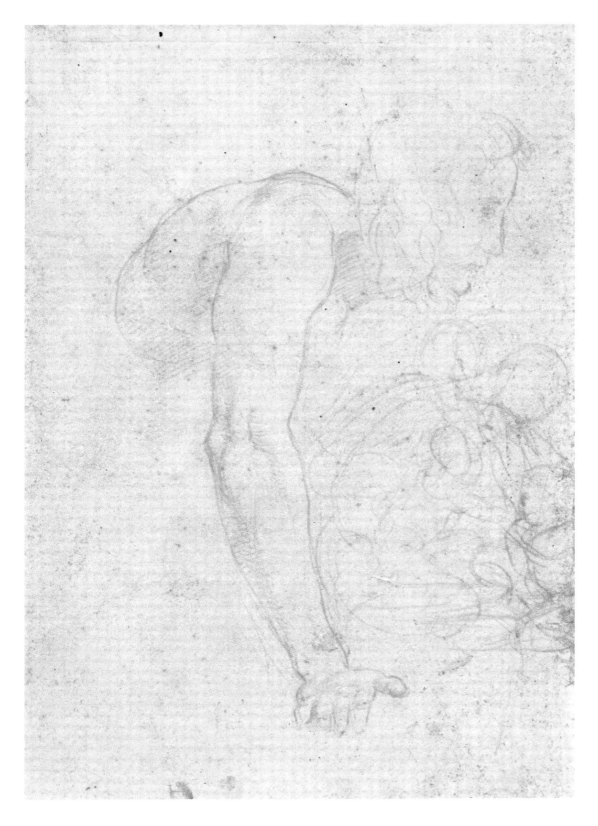

42. RAPHAEL

Two Heads after the Antique and Two Studies of a Reclining Silenus

1509–10

Metalpoint on pink prepared paper, 108 x 168 mm

This page is from Raphael's "pink sketchbook"—ten sheets of roughly equal size, six in Lille (see also cats. 40 and 41), two in the British Museum, one in Cleveland, all with a provenance from Wicar, plus a recently discovered privately owned study (Rubinstein 1987) with a different provenance. An eleventh smaller drawing in Rotterdam for Saint John in the *Alba Madonna* may also be related. This group is connected with three other drawings, identical in technique, ground, and their Wicar provenance—two in the Ashmolean and one in the British Museum. They are about twice the size of the sheets of the pink sketchbook, which were no doubt formed by bisecting the larger ones. The three larger drawings—and one of the smaller ones (cat. 41)—were made in preparation for the *School of Athens* or the *Parnassus.* Most of the smaller sheets, however, prepare a series of Madonnas and Holy Family: the *Madonna di Loreto,* the *Alba Madonna,* the *Aldobrandini Madonna,* and the *Madonna della Sedia,* as well as further similar compositions probably not realized in paint. The purpose of the others, among them the present page, which has been cut apart and rejoined, is uncertain.

Although the panel paintings prepared in these sheets were probably executed over two or three years, the drawings seem stylistically homogeneous and were presumably made over a relatively short time, perhaps in the winter of 1509–10. Although Raphael continued to make silverpoint drawings until around the middle of the second decade—but not, apparently, thereafter—he then generally drew on gray or dark brown grounds, and most of these later drawings are achieved studies rather than inventive sketches.

The heads are copied from an antique bust, known in many examples and once thought to be a captive Gaul but in fact that of Homer. Whether it had been identified as such in the Renaissance is unclear; if so, the heads might have been made for Homer in the *Parnassus,* before Raphael decided to transplant the more dramatic head of the *Laocoön.* As for the reclining Silenus, Alfonso d'Este commissioned Raphael, perhaps as early as 1511, to paint an *Indian Triumph of Bacchus,* which included Silenus, for his *camerino d'alabastri* (chamber of alabasters) (fig. 42a). If so, this drawing might be part of Raphael's research. A *Triumph of Silenus* is known both from an engraving by Agostino Veneziano and from a drawing in the British Museum generally given to the "Calligraphic Forger," who had access to the Viti-Antaldi collection (fig. 42b). This attribution is not secure—the drawing is made on the page of a ledger dated 1535, while the forger seems to have been active in the early seventeenth century—but there is no reason to doubt that it reproduces, perhaps via a copy by Timoteo Viti, a lost drawing by Raphael of c. 1510, either an alternative design for Alfonso or for an unrelated scheme.

Fig. 42a
After Gian Francesco Penni?, after Raphael. *Modello for the Triumph of Bacchus for Alfonso d'Este,* engraving, 346 x 380 mm. The British Museum, London.
Fig. 42b
Unidentified artist, after Raphael. *Study for a Triumph of Silenus,* c. 1535? or later?, pen and ink with traces of squaring in black chalk, 280 x 429 mm. The British Museum, London.

References

Benvignat 1856, no. 735; Passavant 1860, no. 404; Pluchart 1889, no. 484; Fischel 1913–41, no. 345; Joannides 1983, no. 268; Oberhuber 1983, no. 410; Viatte and Goguel 1983, no. 98; Brejon de Lavergnée 1997, no. 544.

43. RAPHAEL

Standing Man Turned to the Left, for Christ in a Descent into Limbo

1511–12

Pen and ink over stylus indentation, 400 x 259 mm

Fig. 43a
Raphael. *The Descent into Limbo*, 1510–11, pen and ink over metalpoint, 208 x 204 mm. Uffizi, Florence.
Fig. 43b
Disputed sculptor, after Raphael. *The Descent into Limbo*, bronze roundel. Monastery of Chiaravalle.

This study was made for Christ in a Descent into Limbo for which a modello, also in pen, is in the Uffizi (fig. 43a). That one, and another modello of *Doubting Thomas* in silverpoint on pink ground in Frankfurt (Städelsches Kunstinstitut 4302), a preparatory pen sketch for which is in the Fitzwilliam Museum (PD125-1961), were made in preparation for two roundels to be executed in bronze. The present drawing indisputably precedes the Uffizi modello, and demonstrates that Raphael made figure drawings larger in scale than the modelli that they prepare. The roundels, now in the Abbey of Chiaravalle (fig. 43b), were executed for Agostino Chigi. They are usually attributed either to Caradosso or Lorenzetto. However, on 10 November 1510, Raphael's Umbrian friend, the goldsmith Caesarino Roscetto, was commissioned to create, within six months, two roundels in bronze, each four *palmi* (about 88 cm) in diameter, to Raphael's design. Both in the published version of the contract, now lost, and in another cited by Shearman, the forms to be sculpted are called "pluribus floribus," but, as Bartalini argued, this improbable reading is probably a mistranscription of "fi(g)uris." That these roundels (same number, same material, same size, same patron, similar date) were entirely unrelated to the pair in Chiaravalle stretches credulity. Late 1510 is a feasible date for Raphael's various drawings, but because Caesarino had not completed his task by November 1511, the compositions might have been

redesigned then. In principle, therefore, there is good reason to attribute the bronzes to Caesarino. Alternatively, one would have to assume either that Raphael designed two pairs of same-size bronze roundels for Chigi, executed by different sculptors, or that Caesarino proved a failure and lost the commission.

The roundels were probably to be placed on either side of the altar niche of Agostino Chigi's chapel in Santa Maria della Pace. Their forms are conceived in sharp-edged flattened planes—hence Raphael's stern penwork here—developed from the marble relief style of Desiderio da Settignano. Their function was established in Fischel's posthumously published monograph of 1948. Fischel's reconstruction was taken further by Hirst (1961), who argued that the planned altarpiece was the *Resurrection* prepared in Raphael's compositional drawing in Bayonne and several associated figure studies (see cat. 47).

Shearman has recently insisted on the present drawing's dependence from Michelangelo's *Dying Slave* (Louvre, Paris), notably in the position of the legs, and he is surely correct. Assuming Michelangelo's figure was begun only in 1513, Shearman redated the drawing—and the scheme—to c. 1514. This shift is unnecessary. Michelangelo had experimented with comparable poses since at least 1505, and it is probable that he devised the pose of the *Dying Slave* well before the 1513 contracts, taken by Shearman as the earliest possible date for the sculpture. The chronology of Michelangelo's Julius Tomb (San Pietro in Vincoli, Rome) is too complex to examine here, but it is evident that when Raphael frescoed the lunette of the Justice wall in the Stanza della Segnatura, before mid 1511, he knew the pose of another of Michelangelo's figures for the tomb, the *Moses,* more or less in its executed form, for Raphael based his representation of *Fortitude* upon it.

References
Benvignat 1856, no. 698; Passavant 1860, no. 402; Pluchart 1889, no. 439; Morelli 1891–92, 441; Châtelet 1970, no. 88; Joannides 1983, no. 314; Oberhuber 1983, no. 402; Viatte and Goguel 1983, no. 105; Brejon de Lavergnée 1990, no. 31; Cordellier and Py 1992, 209; Brejon de Lavergnée 1997, no. 546; Shearman 2000, 287–92.

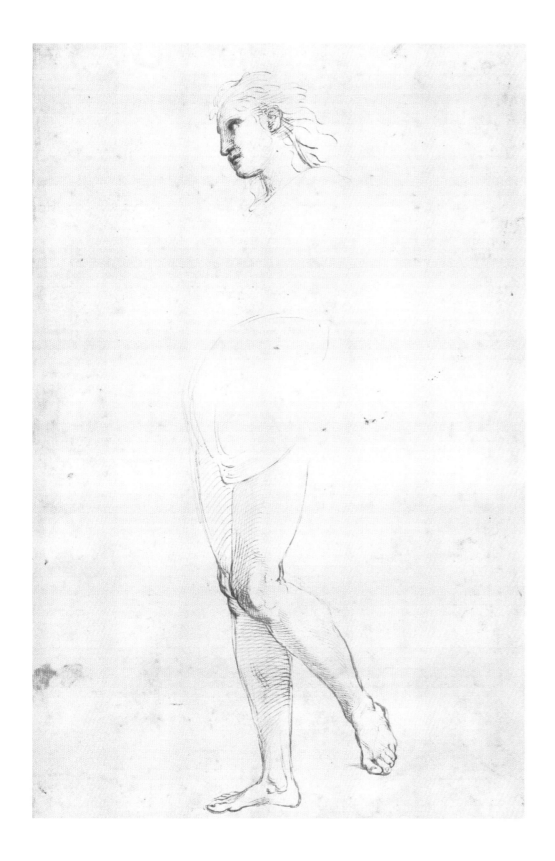

44. RAPHAEL

A Flying Putto Holding Flowers

1512–13

Black chalk heightened with white on light gray prepared paper, squared in black chalk and stylus indentation, with arcs made with compass and stylus indentation, 236 x 172 mm

This marvelously lively flying putto shows Raphael's response to the soft chalk style of Fra Bartolommeo, to whom it was, for a period, attributed. It was probably drawn in preparation for the *Sistine Madonna* (fig. 44a), a visionary subject conceived, in part, in the tradition of work by the Frate, such as his *God the Father Appearing to Saints Mary Magdalene and Catherine of Siena* of 1508–9, in Lucca (Pinacoteca).

An autograph sketch for the *Sistine Madonna* in Frankfurt (fig. 44b), which carries on its verso a copy after a lost study by Raphael for the *School of Athens,* shows the Virgin advancing on a float of clouds. She is escorted at lower right by a fluttering angel, posed very like that in the present drawing, scattering flowers. There would have been a corresponding figure to the lower left alluding to one of the Virgin's titles, Santa Maria dei Fiori. Flower-scattering angels are frequent in Fra Bartolommeo's altarpieces.

This drawing clarifies and develops Raphael's thought processes. Although far from aggressively plastic, this angel has clear aerodynamic lines: he is nothing like the soft putto in cat. 37. At this stage Raphael probably intended the energy and strong foreshortening of the flying angels to contrast with the flatter, more iconic figure of the Virgin, but in the canvas as painted, he revised his ideas while retaining the effect of contrast. The flying angels were removed to make way for two saints not indicated in the drawing, Sixtus and Barbara, who hover to the left and right of the Virgin. They were probably inserted at the request of the patron. The angels were not, however, discarded. They were grounded, transformed into contemplative spirits leaning on a ledge at the bottom of the canvas. Airborne cherubim are retained, but treated as vaporous heads fusing with the clouds that accompany the Virgin. She advances rapidly, but less vigorously than in the Frankfurt sketch: her volition reduced, she is wafted toward the worshipper as though by divine breath, the Christ child's hair lifting from his forehead.

Fig. 44a
Raphael. *The Sistine Madonna,* c. 1512–13, oil on canvas, 265 x 196 cm. Gemäldegalerie Alte Meister, Dresden.

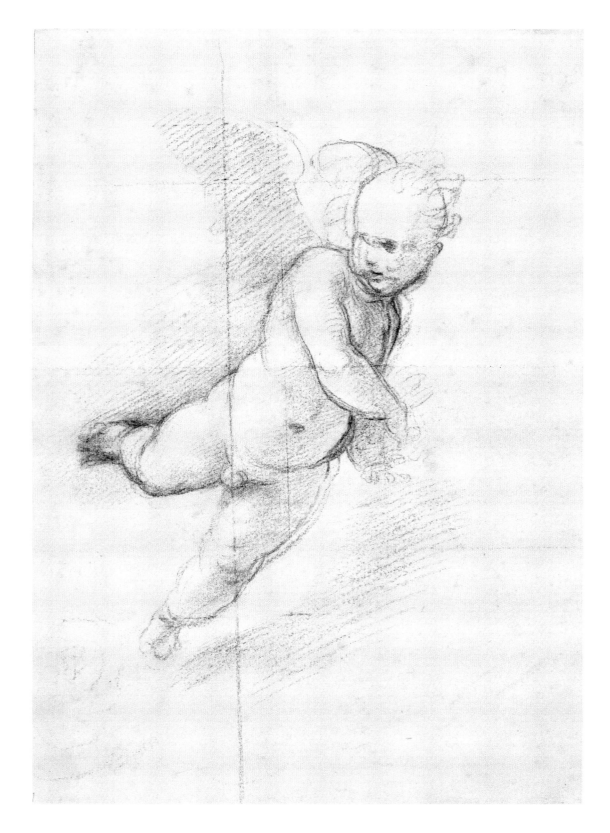

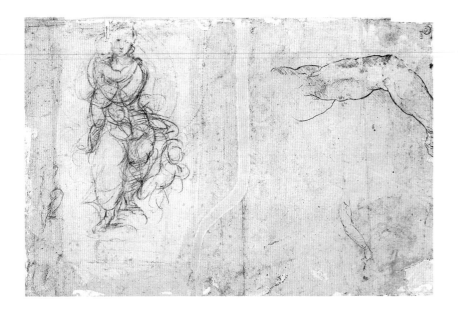

Fig. 44b
Raphael. *Sketch for the Sistine Madonna and Other Studies,* c. 1512, black chalk and pen and ink over leadpoint, 248 x 375 mm. Städelsches Kunstinstitut, Frankfurt.

The painting, for the monks of the convent of San Sisto in Piacenza, was probably executed quickly. Its date is undocumented, but it was no doubt commissioned by Julius II, whose features and cope are employed for those of Saint Sixtus, in commemoration of Julius's uncle and patron, Pope Sixtus IV. Thus Raphael certainly began the painting, and probably completed it, before Julius died in February 1513. The composition as a whole bears a notable resemblance to the Virgin and Child in the *cappelletta* of Michelangelo's Julius Tomb as defined by the contract of April 1513, and as illustrated in a drawing in Berlin (Kupferstichkabinett 15305). But this resemblance does not entail a post-April 1513 date for Raphael's painting since the Berlin drawing probably precedes this contract by some years. In any case, a very similar figure of the Virgin had appeared in Michelangelo's modello for Julius's tomb in the Metropolitan Museum of Art, New York (62.931), now universally accepted as an alternative project of 1505.

References
Benvignat 1856, no. 690; Passavant 1860, no. 485; Pluchart 1889, no. 432; Morelli 1891–92, 441; Fischel 1913–41, no. 227; Châtelet 1970, no. 90; Joannides 1983, no. 283; Oberhuber 1983, no. 329; Viatte and Goguel 1983, no. 74; Brejon de Lavergnée 1997, no. 535.

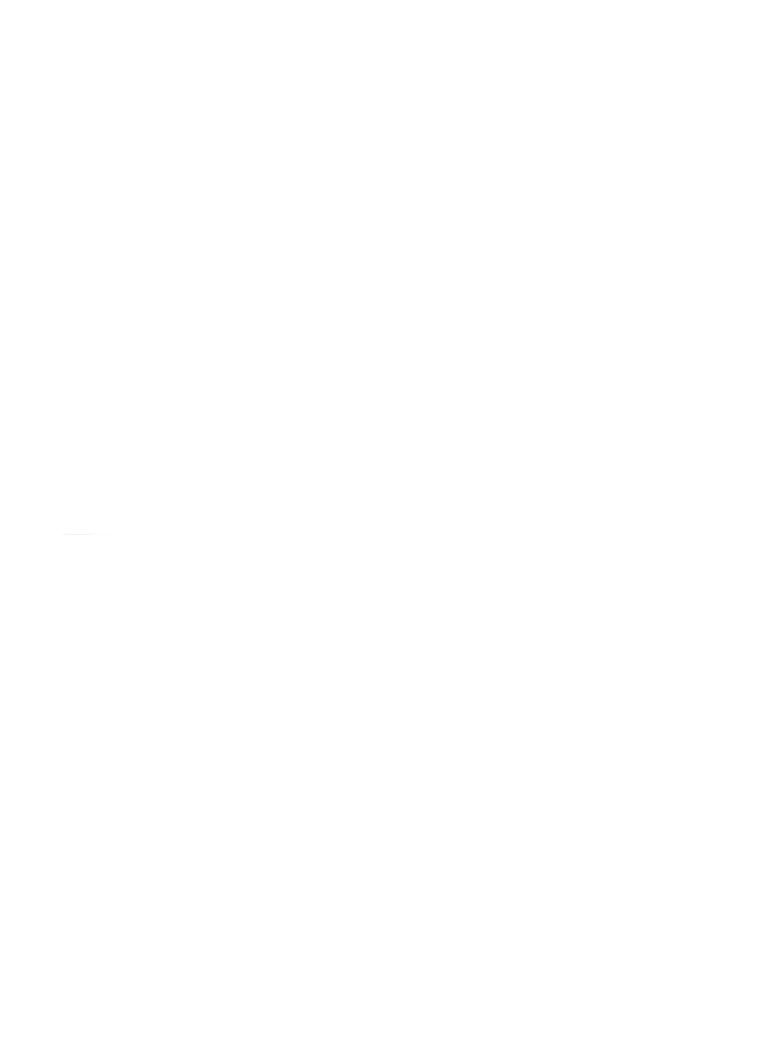

Drawings
by Raphael's
Followers

45. Sebastiano Del Piombo

Polyphemus

1511

Pen and ink, 122 x 128 mm

This Polyphemus is very close to that in Sebastiano's fresco of c. 1511–12 in the Villa Farnesina (fig. 45). Common are the heavy profile, shaggy thatch of hair, and powerful forearm drawn up and across the body. This motif had already been employed by Sebastiano in Venice, but here, like the pose of Polyphemus as a whole (which is indebted to the earliest ignudi on the Sistine ceiling), it also displays the influence of Michelangelo. Sebastiano was the Venetian artist of his generation most devoted to magniloquent form. This propensity alerted him to Michelangelo's work and, no doubt, encouraged Michelangelo's reciprocation.

The present drawing is unique in Sebastiano's identified graphic oeuvre in its medium: all his other drawings are in black chalk, sometimes with the addition of white body color and/or wash. Its areas of ultra-refined penmanship are surprising, since Sebastiano might have been expected to handle pen throughout with the vigorous strokes seen in Polyphemus's hair. Although doubtless made in Rome, the drawing is retrospective evidence for an uninvestigated facet of Sebastiano's Venetian work. Like Giorgione and Titian, both of whom made designs for prints, and Giulio Campagnola, who was active as both a designer and an engraver of others' designs, Sebastiano executed finished pen drawings for engraving. Many scholars have attributed to him the invention of *Christ and the Woman of Samaria,* engraved by Campagnola, which is closely comparable in its dramatic staging to Sebastiano's *Judgment of Solomon* (The Bankes Collection of the National Trust, Kingston Lacy). Further, as Pouncey pointed out in 1948, Sebastiano also designed Campagnola's famous *Reclining Nude,* whose forms are inseparable from those of the women in the *Judgment of Solomon,* and from Sebastiano's *Ceres* in Berlin (Gemäldegalerie). It is tempting therefore to ask whether the present drawing could have been made for an engraving rather than the fresco. No such print is known, however, and it is probably safer to assume that, newly arrived in Rome, Sebastiano was attempting to conform to the Raphaelesque practice of elaborate graphic preparation by making a sharply focused study of a particular part of his figure in a technique with which he was familiar.

The drawing communicates greater poignancy than the fresco. Polyphemus' dreamy and sympathetic contemplation of the unattainable nymph, a quintessentially Venetian evocation of the *après-midi d'un faun,* is coarsened in the fresco, where his desire is expressed in incipient movement. But together with his great canvas *Venus and the Graces Informed by Cupid of the Death of Adonis* (Uffizi, Florence), the fresco demonstrates Sebastiano's agency in introducing to Rome Ovidian myth as a vehicle for the most profound treatments of human emotion, and it highlights Agostino Chigi's role in giving him the opportunity to do so. Nothing is known in detail of the relations between the two men, but it seems that Sebastiano ceased working for Chigi after 1512–13. His supplanting by Raphael must have been one of the reasons for their enmity.

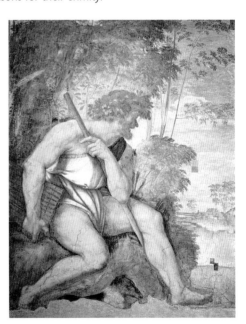

References

Benvignat 1856, no. 862; Pluchart 1889, no. 556; Morelli 1891–92, 442–43; Berenson 1938, no. 2481; Dussler 1942, no. 155; Pallucchini 1944, 35, 80, 177; Tietze and Tietze-Conrat 1944, no. 1926; Châtelet 1970, no. 108; Oberhuber 1976, 106–7; Hirst 1981, 36–37; Oberhuber 1993, no. 104; Brejon de Lavergnée 1997, no. 611; Rearick 2001, 44.

46. GIULIO ROMANO,
after Raphael

Standing Saint Holding a Standard and the Model of a Town (Saint Valerian?)

c. 1517?

Pen and brown ink, some stylus indentation at bottom of sheet, a vertical line in black chalk, 305 x 210 mm

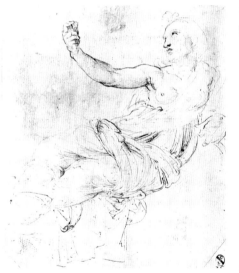

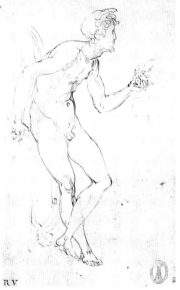

Fig. 46a
Raphael. *Seated Muse Euterpe for the "Parnassus,"* 1510?, pen and ink, 243 x 218 mm. Graphische Sammlung Albertina, Vienna.
Fig. 46b
Giulio Romano, after Raphael. *Adam,* c. 1515? (original c. 1507–8?), pen and ink, 314 x 192 mm. Graphische Sammlung, Weimar.

This controversial drawing, traditionally classed at Lille as by Raphael, was transferred to Giulio Romano by Hartt who dated it c. 1537. His view was rejected by Viatte and Goguel, who astutely recognized its close links with Raphael's drawings of c. 1509 and tentatively re-assigned it to the master. It is immediately comparable in its open linear handling with pen drawings made by Raphael for the *Parnassus* in 1509–10, such as the study for the Muse Euterpe in the Albertina (fig. 46a) in which long lines with relatively little internal hatching are similarly employed. At this phase of work in the Stanza della Segnatura, Raphael was aiming to enlarge his figures and find a grander, more sculptural style. In the Albertina drawing a head and arm adapted from those of the Adam in Michelangelo's *Creation of Adam* for the Sistine ceiling are joined to a body whose drapery is taken directly from the Vatican *Ariadne.* This extraordinarily skilful composite establishes a conceptual as well as stylistic link with the present drawing, for this figure too is based in part on an antique statue of a *Genius,* as Bober

and Rubinstein noted. Their observation substantiates Viatte and Goguel's alertness in placing it around the same time as the Albertina drawing.

Nevertheless, although several scholars have accepted Raphael's authorship, in the compiler's view this drawing does not possess the energy or plasticity of Raphael's studies for *Parnassus.* It is oddly empty and lacking in energy for an autograph drawing of c. 1510. Lines lie flatly on the page and fail to evoke three-dimensional form; the head aligns inorganically with the shoulders, disrupting both gravity and gravitas; and the facial expression is less focused and intense than one would expect from Raphael. To the compiler, the most likely explanation is that the author is indeed Giulio Romano, copying a lost drawing by Raphael. Other instances of Giulio copying Raphael's drawings are known, among them the same-size copy in Weimar (fig. 46b, drawn on the verso of an autograph sketch by Raphael of the Colosseum) after Raphael's Adam in the Ashmolean Museum. It was common educational practice for pupils to replicate their master's drawings, and these copies were probably made early in Giulio's career. Certain traits recur in slightly later pen drawings: the formulation of the fingers and hand in the present drawing and in the Weimar copy are seen in his sketch for the Psyche Loggia (Art Gallery of Ontario, Toronto, 86/246). Giulio continued to make copies of drawings by Raphael for some time. In Düsseldorf (Kunstmuseum FP 13 verso) is a red chalk drawing of a child by Giulio of around 1517, which must reproduce a lost sketch by Raphael of c. 1507 made in preparation for a modello now in the Musée Condé, Chantilly (Peronnet no. 5).

References
Benvignat 1856, no. 724; Passavant 1860, no. 398; Pluchart 1889, no. 485; Morelli 1891–92, 378; Hartt 1958, no. 275; Joannides 1983, 259; Oberhuber 1983, no. 402; Viatte and Goguel 1983, no. 82; Bober and Rubinstein 1986, 221–22; Cordellier and Py 1992, 209; Brejon de Lavergnée 1997, no. 549.

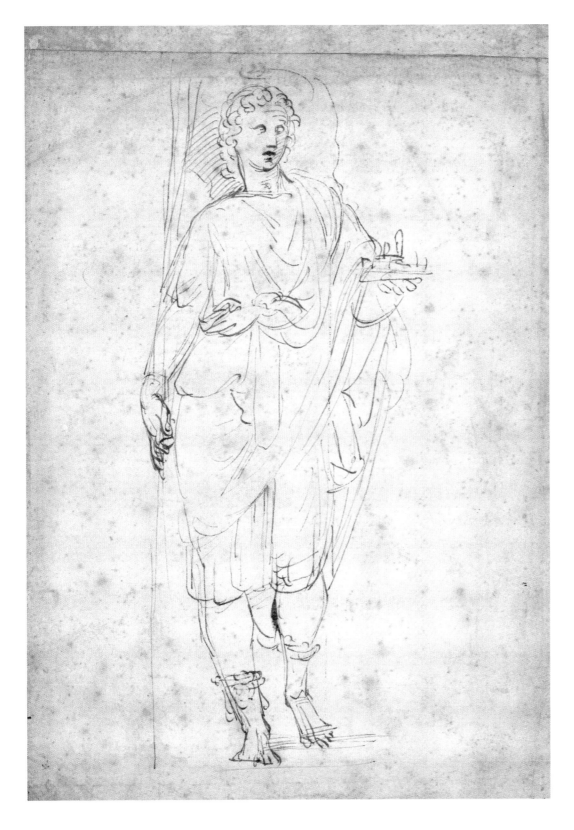

47. Giulio Romano

**a. *The Resurrection of Christ;
a Coat of Arms* (recto)**

1503

Pen and ink over traces of black chalk

b. *Drapery Study* (verso)

Black chalk, 343 x 239 mm

Fig. 47a
Raphael. *Resurrection of Christ*, c. 1512–13, pen and ink, touches of red chalk, 406 x 275 mm. Musée Bonnat, Bayonne.

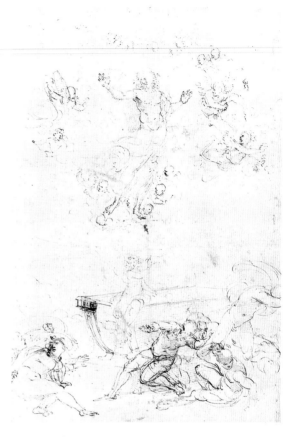

The present drawing prepares the top section of a dramatic altarpiece of the Resurrection. The lower section presumably contained frightened guards. The composition is adapted from Raphael's drawing of a multi-figure *Resurrection,* now in the Musée Bonnat (fig. 47a). Its date would be just after Raphael's death, when Giulio, although still operating within Raphael's schema, was altering their balance; such modification is characteristic of Giulio's treatment of his master's conceptions at a moment when he was discovering his own artistic personality.

For what project was Giulio's drawing intended? Agostino Chigi had commissioned from Raphael the decoration of two chapels, one in Santa Maria della Pace (discussed in cat. 43), the other in Santa Maria del Popolo. The latter chapel, of which Raphael was also the architect, is a small but exceptionally lavish centrally planned structure opening off the north aisle. It now contains pyramidal monuments to Agostino and his brother Sigismondo; four seated statues, of which only two, of the prophets Jonah and Elijah, were executed to Raphael's designs; a mosaic dome; and a large altarpiece. The chapel is dedicated to the Madonna of Loreto.

Neither chapel was complete at the deaths of Chigi and Raphael. In the 1530s the Popolo chapel was provided with an altarpiece, painted in oil on the wall, of the *Birth of the Virgin* by Sebastiano del Piombo. The Pace chapel remained incomplete; in 1531 Sebastiano was commissioned to supply it with a *Resurrection,* but failed to do so. It was generally accepted, following paired articles of 1961 by Hirst and Shearman, that the Popolo altarpiece was to be an Assumption of the Virgin and that the Resurrection for the Pace was laid out in the Bayonne drawing, followed up in several detailed figure studies. Two drawings by Raphael for an *Assumption* exist: one in Stockholm (Nationalmuseum 291), the other at the Ashmolean (Parker no. 554). Gould (1992) then argued that the Bayonne *Resurrection* drawing implies an altarpiece larger than Chigi's Pace chapel could have accommodated. This argument is not watertight because a small altarpiece can be complicated. Nevertheless, it would be surprising to find so dramatic and lavishly studied a composition as the Bayonne *Resurrection* executed on a small scale, and Gould's suggestion that it was intended instead for the Popolo chapel has had considerable resonance. Clayton (1999), developing Gould's thesis, introduced the idea that altarpieces representing the Resurrection were planned for both of Chigi's chapels, with a less populated treatment in the Pace. The ambient iconographies of both chapels support Clayton's analysis, which entails accepting that Raphael's *Assumption* drawings were made for some other project, perhaps that carried out by Fra Bartolommeo for Santa Maria in Castello at Prato in 1516.

Adapting Clayton's argument, the sequence of altarpieces projected for the Popolo chapel might be reconstructed as follows. A *Resurrection* was designed by Raphael c. 1512–13 but never begun. The project was

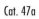

taken up by Giulio Romano in the immediate aftermath of the deaths of Raphael and Chigi (separated by only a week), but his design, prepared in the present drawing, was either rejected or shelved by Chigi's heirs and executors. An altarpiece of the *Resurrection,* appropriate in size to the Popolo chapel, was executed by Girolamo Genga between approximately 1523 and 1525, but for unknown reasons it was not installed. It was presented by Sigismondo Chigi to the Roman church of Santa Caterina da Siena, where it has remained. Finally the project was allocated to Sebastiano, probably in 1526, at which point the Virgin was substituted for Christ. Sebastiano first made a study of her Assumption, then her birth, the subject finally painted. Such radical changes of iconography, however, remain to be explained. An alternative would be to assume that the Santa Caterina *Resurrection* was an entirely separate Chigi project, in which case the designs of Raphael and Giulio could have been made for that before it was allocated to Genga.

The coat of arms at lower center was identified by Fischel as that of the Prince of Wales, and he suggested that the drawing was made for an otherwise unknown English commission. However, as established by Wolk-Simon and Bambach, not only are the arms not those of the heir to the English throne, it was—as every British schoolchild knows—precisely lack of male issue that was then Henry VIII's central political concern. It was, indeed, the main cause of the English Reformation. The coat of arms remains to be identified: it may be no more than an invention by Giulio.

The verso has attracted no attention, surprisingly, for a securely attributable black chalk study by Giulio datable c. 1520 is a rarity. It seems to represent a sleeve over a shoulder, or, if inverted, a sleeve over an arm. Giulio creates a sense of shiny fabric in a darkened room. The chalk is applied in thin lines, carefully stumped to create a continuous sheen. It was no doubt made in preparation for a female costume and is immediately comparable in texture with ones painted by Giulio in the last years of Raphael's life and immediately after his death. Giulio, following Raphael's lead and perhaps exerting some reflex influence upon his master, showed great liking for the luster of rich garments in shadowy settings in paintings such as the *Madonna della Gatta* (Capodimonte, Naples), the *Wellington Madonna* (Apsley House, London), or the *Fugger Altarpiece* (Santa Maria dell'Anima, Rome), but the present study can be connected with none of those paintings, nor with any other attributed to Raphael, Giulio, or Penni. While probably made for a panel painting, a connection with a fresco scheme cannot be excluded. In this case the most likely candidates would be the female allegories in the Sala di Costantino at the Vatican. They were initially planned for execution in oil with surfaces comparable to those of panel painting, and indeed two of them were so completed. However, the present drawing cannot be connected with those works, nor with the remainder of the allegories, executed in fresco. For now, its purpose must remain a matter for speculation.

Fig. 47b
Giulio Romano. *Study for the "Madonna della Gatta,"* c. 1519?, black chalk, 318 x 388 mm. The British Museum, London.

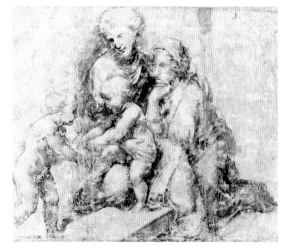

References
Benvignat 1856, no. 687; Pluchart 1889, no. 462; Fischel 1913–41, no. 387; Hirst 1961, no. 71; Oberhuber 1972, 34–35; Oberhuber 1983, no. 402; Joannides 1983, 259; Viatte and Goguel 1983, 322; Westfehling 1990, no. 47; Cordellier and Py 1992, 209; Griswold 1992, no. 62; Masari 1993, 93; Brejon de Lavergnée 1997, no. 587; Wolk-Simon and Bambach 1999, 166, 178.

48. GIULIO ROMANO

The Holy Lamb

c. 1540

Pen and ink, 166 x 195 mm

Fig. 48
Giulio Romano. *Study for the Tomb of a Dog,* c. 1531–34, pen and ink with wash, 124 x 160 mm. Cooper-Hewitt Museum, National Design Museum, Smithsonian Institution, New York, 1958-143-14.

Characteristic of Giulio's work in Mantua is that whereas his treatment of human beings tends toward the formulaic and the animalic, his approach to animals is penetrating and profound. His portraits of Gonzaga horses in the Sala dei Cavalli in Palazzo del Te anticipate Stubbs in their empathy and objectivity, and the animals in his designs for paintings are generally characterized more subtly than his human actors. The mobility and elasticity of animal bodies pleased Giulio, allowing him to create active and expressive forms. They—together with fishes, crustaceans, and insects—appear frequently in his metalwork designs.

Giulio was the most brilliant designer of metalwork of his generation and many drawings for objects survive in the original or in copies. His wit and invention—generally intended to charm, sometimes to create shock, no doubt to be followed by laughter—were massively influential. Sadly, virtually no Giulian metalwork survives, and it is unclear how much was actually executed to his designs; but, as Holman (2000) has shown, at least some objects were made and even as early as 1525 Giulio's ideas could test the skills of an expert silversmith.

The majority of Giulio's metalwork designs are for tableware—dishes, platters, bowls, knives—or associated domestic utensils such as bucket handles and the like. But he also designed other objects: a swaddled baby, no doubt for a bronze tomb effigy, and figures of dogs: a charming drawing survives in the Cooper-Hewitt Museum (fig. 48), for a stucco memorial to one of Federico Gonzaga's favorite dogs in the Giardino Segreto of the Palazzo del Te (for which see Belluzzi 1998, pl. 1230). Giulio also designed a quantity of ecclesiastical metalwork. At first sight this *Agnus Dei,* whose style suggests a date approaching 1540, might seem to find a place among altar vessels, perhaps as a container for consecrated wafers.

The Holy Lamb, however, is a design not for metalwork but for a fresco, which the angled lines at the upper left and right make clear. They indicate the ribs of a vault, and the figure must therefore have been intended to be frescoed in one vane of a quadripartite vault spanning a small chapel. Perhaps the Instruments of the Passion were planned for the others. This lamb, like the one that stands on the altar in Hubert and Jan Van Eyck's *Ghent Altarpiece* (Saint Bavon Cathedral) is the Lamb of God, the embodiment of the Savior. Nevertheless, although the aim is of high seriousness, whether that is achieved is questionable. If the cross is excluded, the numinous quality is absent and symbolic resonance lacking. Giulio is not a spiritually sensitive artist—his most effective religious scenes tend to be of violent subjects such as the Crucifixion, martyrdoms, and the like. And here one might well feel that, although the purpose is religious, the emotion, the charm, is entirely secular. By the end of Giulio's career, his devotion to fanciful and decorative objects had come to assume the determining role in his imaginative life and his pictorial creations.

References
Benvignat 1856, no. 710; Gonse 1877, 64; Pluchart 1889, no. 496; Fischel 1898, no. 632; Hartt 1958, no. 274; Brejon de Lavergnée 1989, no. 38; Brejon de Lavergnée 1990, no. 46; Brejon de Lavergnée 1997, no. 588.

49. GIULIO ROMANO

Seated Male Nude, for King Lothair

1515–16

Red chalk over stylus indentation,
405 x 263 mm

Fig. 49
Giulio Romano.
King Lothair (detail),
1515–16?, dado
fresco. Stanza
dell'Incendio, Vatican.

The present study from the nude, one of the largest of Giulio's red chalk drawings to survive, was made in preparation for the figure of King Lothair (fig. 49), situated below the *Battle of Ostia*, in the dado of the Stanza dell'Incendio, the third room to be decorated by Raphael and his shop. This scheme was executed between 1514 and 1517, but its internal chronology is still debated. It is not yet clear whether the dado was painted as a whole, in a single campaign following the completion of the four histories occupying the wall surfaces above door level, or whether the dado on each wall was executed immediately following the history that surmounts it. Until the succession of the *giornate* (daily work areas) becomes known, any hypothesis is open to demolition, but to the present writer the second option seems marginally more likely.

The order of execution of the histories is also debated. The *Coronation of Charlemagne* must postdate December 1515, when Leo X met Francis I, king of France (portrayed in the fresco) in Bologna; the *Oath of Leo* must refer to, and postdate, a political crisis of mid 1516, when Leo had to defend himself against charges of corruption. A drawing by Raphael made in preparation for the *Ostia* was sent to Dürer, who inscribed it with the date 1515 (Albertina, Vienna, 17575). So the design of that fresco, and probably its execution—perhaps to be credited to the little-known Pellegrino da Modena—must have been under way by that year. The *Fire in the Borgo*, which gives the room its name, is generally believed to have been the first fresco to be painted, but it seems to the compiler to have been the last: its figure style and color range are more congruent with Raphael's work of 1517 than that of 1514.

Vasari says that Giulio's first major intervention in Raphael's work came, precisely, in the dado of this room. If the section beneath the *Ostia* followed immediately upon the completion of that fresco, then this drawing would have been made no later than 1516 and possibly in 1515. The drawing is in many ways awkward, imperfectly foreshortened, perfunctory in modeling and stiff in contour. Although Giulio made quite adequate studies of the nude in the later 1510s, life study was never among his great strengths, and he seems virtually to have abandoned it after Raphael's death. Here, laying out a figure to be painted fully armored, he probably felt that what he had done was sufficient.

The seated kings in the dado are represented not as living forms but as gilded bronzes, set against a simulated ashlar wall and flanked by paired herms in simulated marble. This work provided a pattern for the rest of Giulio's life. His dominant textural interests were always in metal and stone, and in Mantua he became the most inventive Italian master of his generation in the employment of rustication in architecture and in designing objects in metal.

References
Benvignat 1856, no. 734; Pluchart 1889, no. 481; Fischel 1898, no. 204; Hartt 1958, no. 10; Châtelet 1970, no. 39; Oberhuber 1972, no. 437; Joannides 1983, no. 379; Oberhuber 1983, 136; Viatte and Goguel 1983, no. 91; Griswold 1992, no. 63; Brejon de Lavergnée 1997, no. 589.

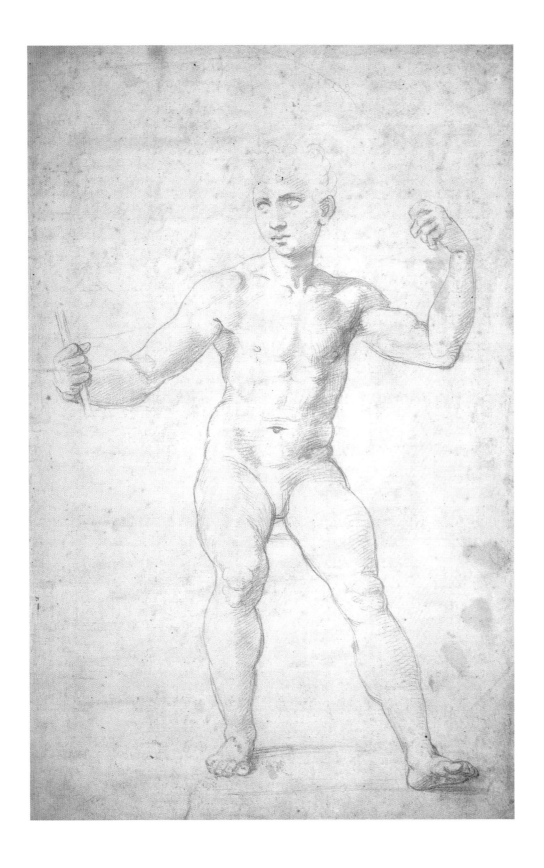

50. PERINO DEL VAGA

Saint Michael Defeating Satan

c. 1545

Pen and ink over black chalk,
223 x 158 mm

This *Saint Michael,* given to the Palais des Beaux-Arts de Lille in 1865, is a lively reinterpretation of Raphael's great altarpiece painted for Francis I in 1518 (Louvre, Paris), which Perino no doubt saw under way in Raphael's studio. He made a refined pen study of the saint's arms on a page now in San Francisco (fig. 50a), which, as noted by Wolk-Simon, he employed to prepare the background of the Basadone *Nativity,* signed and dated 1534 (National Gallery, Washington). By 1534, Perino's wife, Caterina, had no doubt inherited the estate—including many drawings—of Raphael's assistant and her brother, Gian Francesco Penni, who probably died around 1530. Another drawing by Perino for the Basadone *Nativity,* a nude study for *Saint Sebastian* (Rijksmuseum, Amsterdam, RP-T-1948-525), is so close in style to Raphael's red chalk studies of c. 1512 to confirm that Perino was (re)studying Raphael's work of that phase. The resemblance is the more telling in that Perino's earlier red chalk figure studies show little trace of the direct influence of Raphael's drawings in that medium. Perino is probably also responsible for a pen copy in Frankfurt (Städelsches Kunstinstitut 381) of a lost chalk study by Raphael for a guard in the *Resurrection* (see cat. 47), drawn on the verso of a drawing by

Raphael himself, and two red chalk replicas, in the Ashmolean (Parker no. 646) and the Musée Condé, Chantilly (Perronet no. 14), of studies by Raphael, now in the Albertina (17573 and 17574), for the frescoes in Santa Maria della Pace.

Ironically, when Perino painted a Saint Michael in the central panel of the triptych executed for San Michele in Colle Liguria c. 1535, conservative Genoese religious patronage no doubt compelled him to adopt a more conventional design where the archangel stands atop his vanquished enemy. However, in the last decade of his life, back in the artistically sophisticated climate of Rome, freer to exercise his imagination upon Raphael's legacy, Perino's figurative work developed a new force. It is another, bulkier and more energetic version of Raphael's *Saint Michael* that commands the end wall of the Sala Paolina in the Castel Sant'Angelo, named after the archangel (fig. 50b). A similar force and movement are seen in the present drawing, no doubt of the early 1540s: the penwork is closely comparable with that of another study for the Sala Paolina, *Alexander Cutting the Gordian Knot* (Metropolitan, New York, 1984-413).

This drawing is remarkable for its graphic exuberance. Repeated lines dissolve contours and the energy of the figure radiates around it. The oval, to which the pose responds, suggests a design for a plaque or a pendant, perhaps for a member of the French order of Saint Michael, a French client, or a client honored by the French king, an additional reason for recalling Raphael's example. Although less prolific in this field than Giulio Romano, Perino made many designs for metalwork, and this is among his liveliest. Like many of his drawings, it contains accounts on the verso.

Fig. 50a
Perino del Vaga. *Part copy of Raphael's "Saint Michael,"* c. 1534, pen and ink, 191 x 162 mm. Fine Arts Museums of San Francisco, Achenbach Foundation for Graphic Arts Purchase, 1984.2.38.
Fig. 50b
Perino del Vaga and others. *Saint Michael,* c. 1546, fresco. Sala Paolina, Castel Sant'Angelo, Rome.

References
Pluchart 1889, no. 67; Davidson 1985, 748; Brejon de Lavergnée 1997, no. 475; Parma 2001, 22.

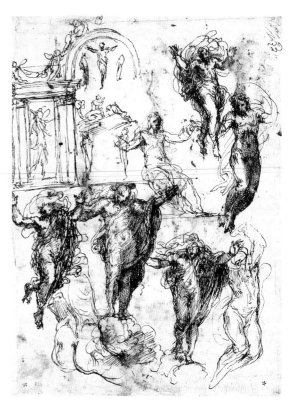

51. POLIDORO DA CARAVAGGIO

The Transfiguration of Christ

c. 1535

Pen and ink, wash, red chalk wash, heightened with white, 380 x 265 mm

The arrangement of this drawing of the *Transfiguration,* acquired by the Palais des Beaux-Arts de Lille in 1989, was obviously developed from Raphael's final masterpiece, placed from c. 1524 in San Pietro in Montorio and universally admired. But Polidoro's response may have been prompted by the same-size copy by Raphael's pupil Gian Francesco Penni, then in Naples.

The present drawing is the end product of a series of studies, including two fine sheets of pen sketches in the British Museum (Pouncey and Gere nos. 217 and 218 [fig. 51]); it comes closest to a study in Berlin (Kupferstichkabinett 21501), accepted by some scholars but rejected by others. They are connected with the destroyed central panel of a triptych by Polidoro, once in the church of Santa Maria del Carmine in Messina, which was painted c. 1535. Two panels, one fragmentary, of flanking saints, survive; the final appearance of the *Transfiguration* is probably recorded in a painting now in the Brera. The composition is deeply indebted to the upper part of Raphael's panel, but the broad and bulky figures, their proportions, and the jagged gestures of Christ indicate that Polidoro's approach to his former master—although he was rather a member of the Raphael shop than a close pupil—was far from subservient. Nevertheless, the poses of individual figures retain the rhythm and compactness associated with the art of the High Renaissance. The disciple seen obliquely from the rear in the center of the lower section recalls the appealing woman in the center of the *Incendio;* the figure at the left echoes some of Michelangelo's designs for the double tomb of the Magnifici (Lorenzo the Magnificent and his brother, Giuliano) in the New Sacristy of San Lorenzo, Florence; and the slumped but powerfully compact figure on the right recalls the sleeping guard just to the right of the window in Raphael's *Release of Peter* (Stanza di Eliodoro, Vatican). Polidoro's painting was influential and inspired numerous variants among his followers.

This persistent Raphaelism of design raises the question of their relation to a panel of the *Transfiguration* in the Prince's Gate Collection of the Courtauld Institute, which is generally attributed to Polidoro. Its upper section is close to that of Polidoro's lost altarpiece, but the disciples below are posed differently from those in either the painting or any known preparatory drawing. The execution of the Courtauld panel—in thin layers of brown oil paint handled like wash drawing, with only some areas of drapery defined in color—suggests that it is among the earliest oil *bozzetti* (sketch) in Italian art. Several others survive in various collections, which are also closely related to works by Polidoro. However, not one directly follows a preparatory drawing; furthermore, they are clearly closely related to an extraordinary group of very loosely executed, primarily monochrome paintings, some on a large scale, which cannot possibly be bozzetti. These works, which suggest the mind of a major creative artist, are blatantly unfinished by sixteenth-century standards and would appear so even set beside the late paintings of Titian. If they are by Polidoro, as is now widely believed (see the discussion in Leone de Castris 2001), they imply a seismic aesthetic shift in his final years.

References
Brejon de Lavergnée 1997, no. 499; Leone de Castris 2001, D.118 and pp. 557ff.

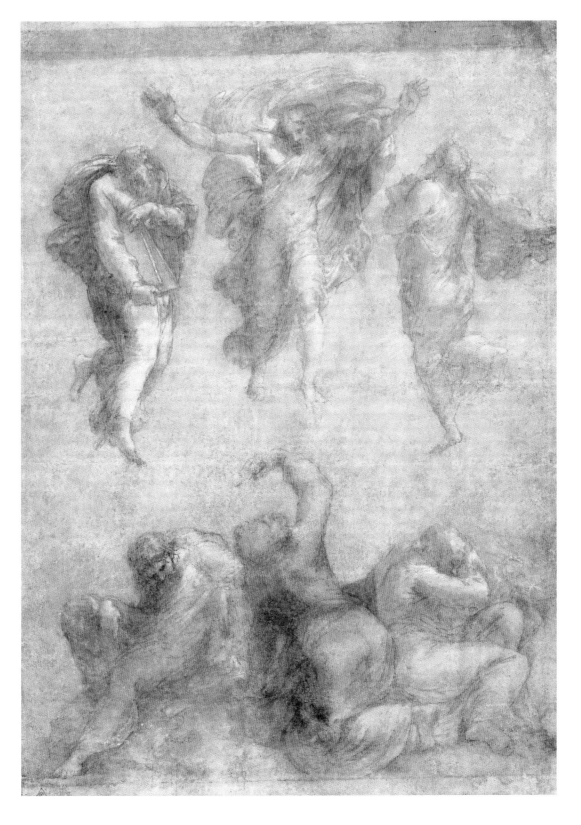

Drawing in
Florence

around 1520

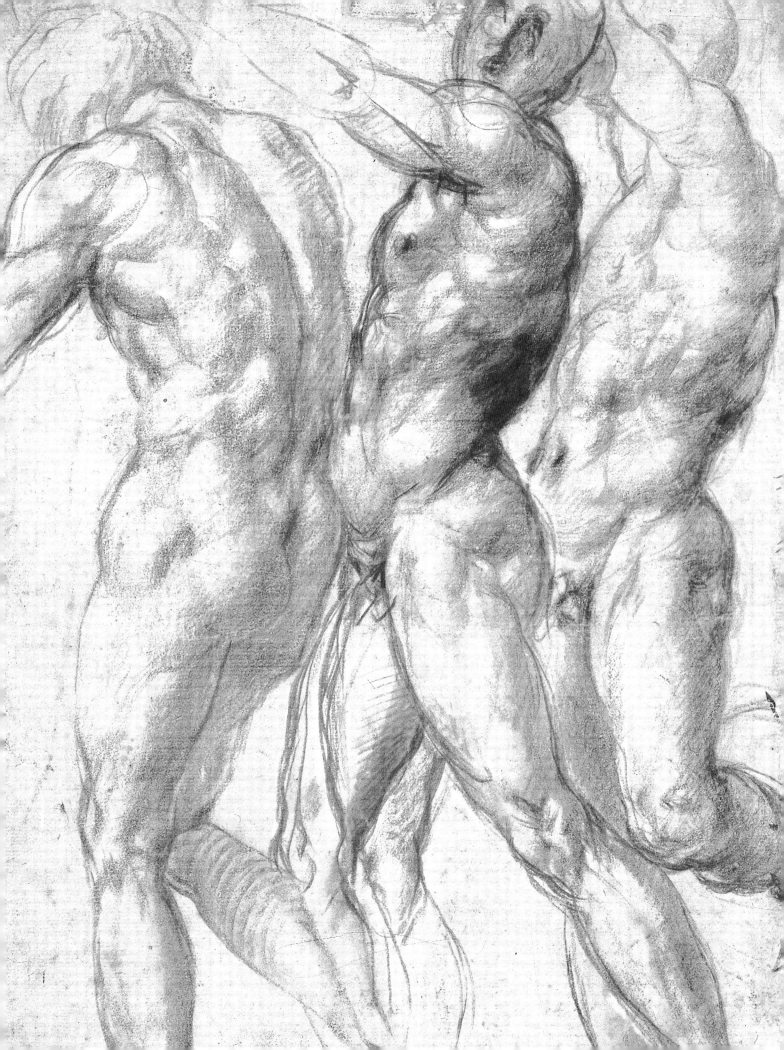

52. ANDREA DEL SARTO

Saint Mark

c. 1525

Pen and ink, wash, heightened with
white, pricked for transfer,
Diam. 152 mm

This circular composition of Saint Mark was drawn in preparation for one of the embroideries of the altar cloth commissioned by Silvio di Rosada Passerini, made a cardinal by Leo X in 1517, for the high altar of the cathedral of Cortona and presented in 1526 (fig. 52). The attribution to Sarto was published by Pouncey in 1964; previously the drawing had been given to Raffaellino del Garbo (Berenson's Raffaellino dei Carli), the author of numerous drawings for embroideries (see cat. 8) and who, as Shearman has argued, may have been for a time Andrea's master. Perhaps before 1515, Raffaellino had already made designs for embroideries to decorate one of Cortona cathedral's copes, and Andrea may have inherited the project from him. Of the seven roundels on the altar cloth, only five are Andrea's responsibility, whereas the two Franciscan saints at the ends were designed by Raffaellino. Such a junction speaks of an interrupted project as, more faintly, do certain emphases in the present drawing, such as the evangelist's spiky hair, which is reminiscent of Raffaellino's tastes. The date of the commission—or of Andrea's participation in it—is variously placed between 1522 and 1526; a later rather than earlier date within this span is suggested by the resemblance of the Virgin and Child in the middle of the field with that

of Andrea's famous and much replicated *Porta Pinti Madonna* of c. 1524 (destroyed) and his *Madonna del Sacco* in Santissima Annunziata in Florence, signed and dated 1525.

Although pricked for transfer, severely damaged, and not universally accepted, the present drawing still displays a vitality and energy that argue strongly in favor of Andrea's authorship. While Andrea has carefully adjusted the figure to be compatible with the roundel format, the evangelist is not dominated by the form of the field, and there remains a tension between his upright stance and the circular perimeter. The figure shows something of Raphael's influence in the clear organization of the drapery, wound more tightly round the figure than is customary with Andrea, and something also of the contained force that he would have seen in Michelangelo's designs for the *Apostles* planned for the cathedral of Florence. Less expected is the lion, which, although miniaturized, is more active and less docile than the lions that habitually accompany Saint Mark, and which, although not entirely deprived of his customary wings, has concealed them behind the evangelist's halo. As Cordellier suggested, the vitality of the lion suggests that it was based on life-sketches.

A companion drawing for *Saint Luke,* of the same size and technique as the *Saint Mark,* also pricked, and in comparable condition, is in Rome (Istituto Nazionale per la Grafica); it is generally accepted as autograph. Two other drawings of *Saint John* and *Saint Matthew,* again identical in size, technique, and condition but not pricked, are in the Uffizi (14421F and 14422F, see Petrioli Tofani 1986). These last two are more disputed, but despite the lack of pricking there seems no good reason to reject them.

Fig. 52
After Andrea del Sarto.
Detail of Saint Mark for the Passerini Altar Vestment, c. 1526,
Museo Diocesano,
Cortona.

References
Benvignat 1856, no. 1111; Gonse 1877, 397; Pluchart 1889, no. 253; Morelli 1891–92, 442; Berenson 1903, no. 639; Berenson 1938, no. 639; Berenson 1961, no. 639; Pouncey 1964, 282; Monti 1965, 168–69; Shearman 1965, 1: 152, 2: 349, 359, 383; Cordellier 1986, no. 34; Petrioli Tofani 1986, 246–47; Cordellier 1989, no. 34; Cordellier 1990, no. 40; Brejon de Lavergnée 1997, no. 608.

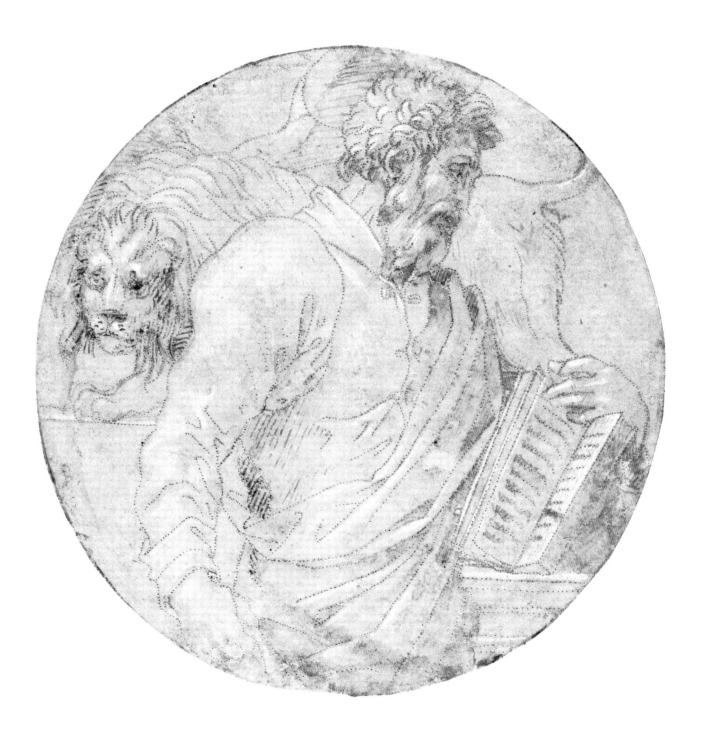

185

53. ANDREA DEL SARTO

Virgin and Child with Saint John the Baptist and Saints Elizabeth and Anne?

c. 1519

Red chalk, 194 x 156 mm

Although traditionally ascribed to Andrea, this drawing has also been given to Pontormo, Giovanni Sogliani, and Domenico Puligo. But further studies of those artists have not substantiated such reattributions, and there is now a widespread tendency to return it to Andrea.

All scholars have noted a close link with Andrea's painting in the Wallace Collection (fig. 53). The aspect ratio matches and the arrangement of Virgin and Child is very similar. But the saints differ, as does the action of the young Saint John, and the painting is lit from the right rather than the left. Indeed, despite their core similarity, the two

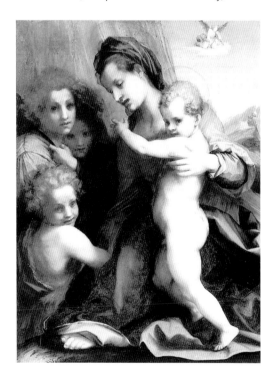

Fig. 53
Andrea del Sarto. *The Virgin and Child with Saints*, c. 1519, oil on panel, 107 x 81 cm. The Wallace Collection, London.

compositions create a very different effect. In the painting the viewer accesses the heads of the Virgin and Christ child immediately, and is only then engaged by the outward gazes of the child and the youth (or angel) above John: it is a self-conscious work and makes the viewer self-conscious. The drawing is detached and quiet, the actions more simply readable. The fall of light accentuates the left calf of the Virgin, and thus structures the lower-left corner,

ignored in the painting; it is matched lower right by the correspondingly angled fall of the Virgin's drapery. The composition is compact and fills the available space. As Cordellier has remarked there are echoes of Donatello's reliefs, particularly his *Madonna of the Clouds* (Museum of Fine Arts, Boston). Andrea includes framing lines, clouds above the figures, and a relatively low-lying landscape between the Virgin and Saint Elizabeth. The figures occupy the field horizontally, leaving space above. In the Wallace painting the field is occupied vertically: a rising bluff closes off depth at the left, a plunging view opens to the right. It is inherently unstable in a way in which the drawing is not, and suggests a more adventurous client.

There is no reason to believe that the drawing was made specifically for the painting. Andrea exploited his visual inventions in a variety of ways, and versions could take many forms: direct repetitions, modified repetitions, variants, and truncated variants. Given its more orthodox composition, the drawing probably came first. The presence of Saint Elizabeth at the left and Saint Anne at the right suggests a commission either by or for a woman and the fact that the sister and mother of Francis I were named, respectively, Elizabeth and Anne supports Cordellier's suggestion that it was drawn during Andrea's sojourn in France in 1518, a design for an unexecuted or lost painting. Its formal qualities also fit with Leonardo's admiration for Donatello and his presence in France. The Wallace painting, whose known history is entirely Italian (Italy is also the source of the many copies), would be a variant of that design produced soon after Andrea's return to Florence. The drawing has much in common structurally with the *Charity* (Louvre, Paris) painted for the court of France, whereas the oblique setting, spotlighting, asymmetry, and plunging view in the Wallace painting imply an up-to-date response to the work of the younger generation of painters in Florence.

References
Benvignat 1856, no. 13; Gonse 1877, 401; Pluchart 1889, no. 502; Freedberg 1963, 2: 254–55; Viatte 1963, no. 96; McKillop 1974, 229; Petrioli Tofani 1986, 194; Cordellier 1986, no. 12; Shearman 1987, 500; Cordellier 1989, no. 33; Cordellier 1990, no. 38; Brejon de Lavergnée 1997, no. 609.

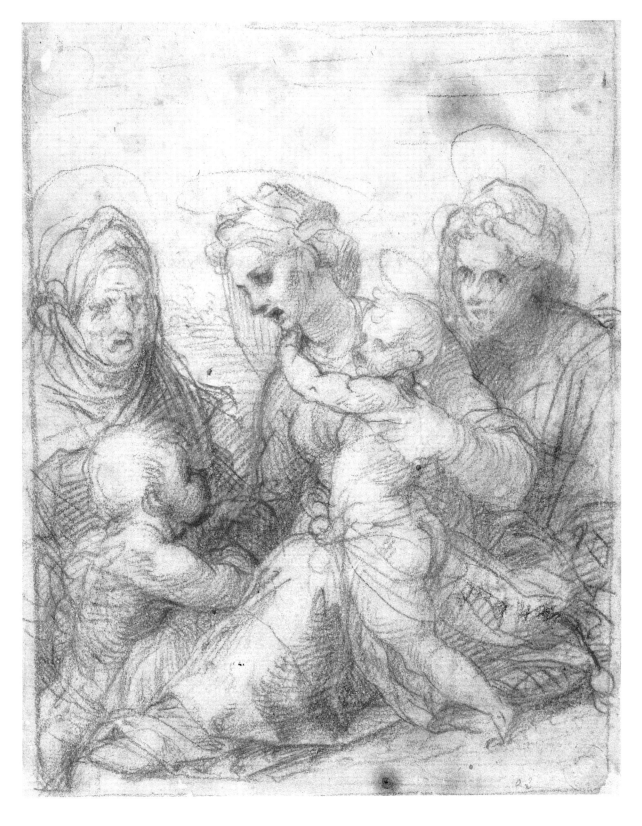

54. ANDREA DEL SARTO

a. *Two Putti, after Michelangelo, from the Throne Arm to the Right of the Libyan Sibyl in the Sistine Chapel Ceiling* (recto)

c. 1513

b. *A Water Carrier, after Antonio Pollaiuolo?* (verso)

Red chalk, 179 x 113 mm

The drawings on the recto and the verso of this sheet are both lively in themselves and provide an unexpected insight into their author. Andrea del Sarto was so distinctive and powerful as a painter and draftsman that there has been a tendency in scholarship to treat his work in relative isolation. His paintings are in general not closely related to works by his contemporaries, and his visual sources have not been subject to as close analysis as they deserve. This is in part because, in comparison with Raphael, for example, little is known of Sarto's activities as a copyist, and in this context the identification by Petrioli Tofani (1986) of a group of drawings by Sarto in the Uffizi after Marcantonio Raimondi's engraving, made to Baccio Bandinelli's design, of the *Massacre of the Innocents* of 1525, has been most valuable in alerting scholars to Andrea's response to current developments. Furthermore,

while it was always obvious that Sarto's earliest Virgin and Child compositions responded to the Florentine Madonnas of Raphael, it has now become clear that his awareness of Raphael was more extensive. Cordellier's acute observation that Sarto's design for a miniature of *Pentecost* in Paris (Louvre 1670) is indebted for its central figures to an early modello by Raphael for the *Disputa* opens the possibility that Sarto knew not only public works by other artists, but, in some cases, their drawings too.

The same is true of Michelangelo. Shearman (1965) pointed to echoes of the Sistine frescoes in Sarto's work in Santissima Annunziata, and Sarto's chalk technique often resembles Michelangelo's handling of pen. As the compiler has suggested, Sarto's Saint John for the Scalzo *Baptism of the Multitude* (National Gallery of Victoria, Melbourne, 351/4r) surely reveals knowledge of a drawing such as Michelangelo's Louvre study for the *Battle of Cascina* (712), and Sarto's *Dragon,* also in the Louvre (1724), probably copies a lost drawing by Michelangelo (Cordellier 1986, no. 63 recto).

Fig. 54a
Michelangelo. *Libyan Sibyl with Accompanying Figures,* 1512, fresco. Sistine Chapel, Vatican.

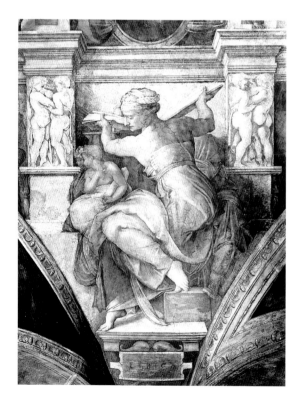

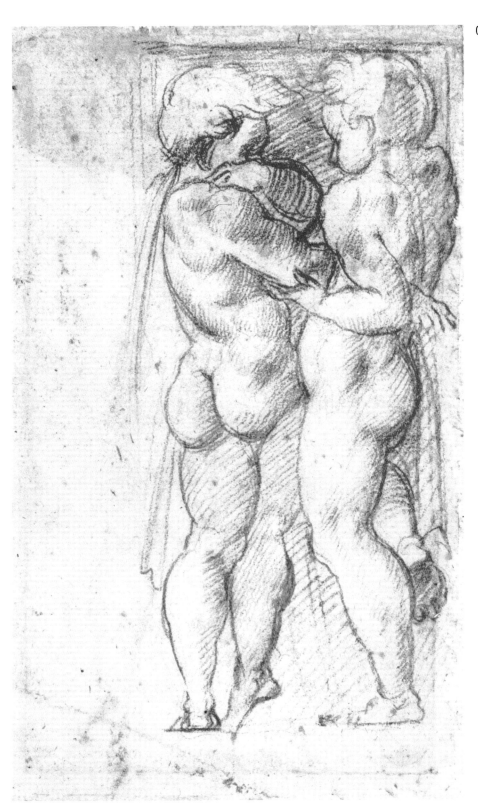

Fig. 54b
Antonio Pollaiuolo?
Figure Study, pen and
ink, 135 x 52 mm.
Uffizi, Florence.

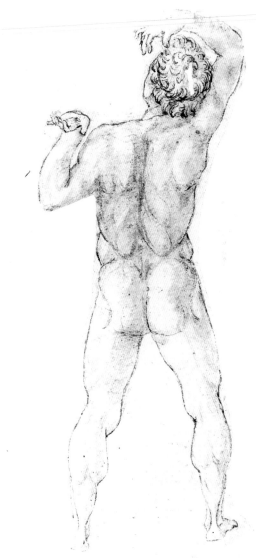

Michelangelo in his *Corsini Madonna* (Egremont Collection, Petworth), generally dated around 1513.

Sarto also studied his forebears. In 1977 Byam Shaw identified a drawing, previously thought to be a life study of a horse and rider, as a copy after a detail in Antonio and Piero Pollaiuolo's great *Martyrdom of Saint Sebastian* (National Gallery, London) of c. 1475. Byam Shaw's observation is specifically relevant in the present instance since the source of the verso figure on this sheet also lies in the Pollaiuolo circle, specifically a drawing of disputed authorship in the Uffizi, the water-carrier, itself no doubt made from a wax or clay derivative of a familiar antique type (fig. 54b). The two figures are so close that it seems likely that Sarto knew this very drawing.

Cordellier (oral communication to Barbara Brejon de Lavergnée, 1996) has suggested that the authorship of Sarto's friend Jacopo Sansovino should be considered for the present sheet. The two men were certainly close. Jacopo provided Andrea with plastic models for some of his paintings, and the very few drawings plausibly attributed to Jacopo (see Boucher 1991) are similar in technique to those of Sarto. But Sansovino, so far as we know, showed no interest in painting or in this particular aspect of Michelangelo nor can he be shown to have responded to work by the Pollaiuoli. To the compiler, the attribution to Sarto seems more plausible.

In the present drawing Sarto copied two putti flanking the Libyan Sibyl (fig. 54a). These figures would have been hard to see from the floor of the Sistine chapel, and the drawing suggests that he either had access to the scaffolding in the last phase of the ceiling's execution or knew a drawing for the putti by Michelangelo himself— the handling of chalk is closely reminiscent of the latter's fast pen drawing. It is appropriate that Andrea should have chosen to copy putti, since he was a great master of them; he included a pair particularly indebted to

References
Benvignat 1856, no. 726–27; Pluchart 1889, nos. 494–95; Viatte and Goguel 1983, 322; Brejon de Lavergnée 1997, no. 832.

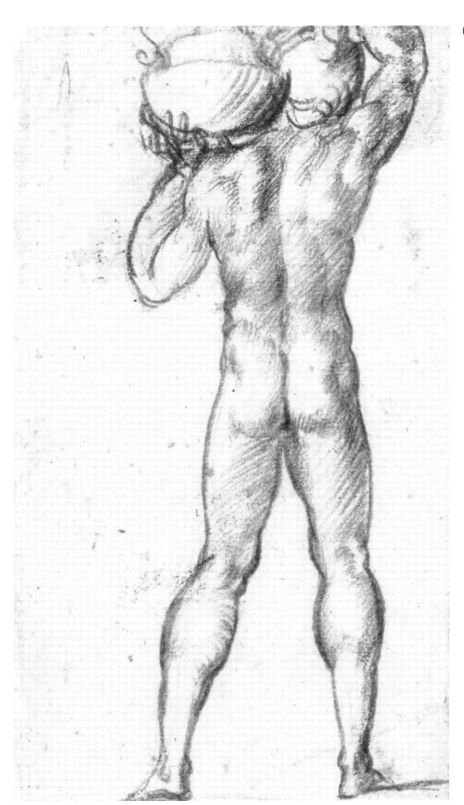

Cat. 54b

55. Jacopo Carucci, called Il Pontormo

a. Three Male Nudes (recto)

1517–18

Red chalk

b. Drapery Studies for Saint John the Evangelist in the Pucci Altarpiece (verso)

Black chalk, 397 x 265 mm

Fig. 55a
Jacopo Carucci, called Il Pontormo. *The Restoration to Office of the Butler and the Execution of the Baker,* c. 1516, oil on panel, 610 x 517 cm. The National Gallery, London.

The recto is among Pontormo's most famous drawings. It is known in two copies, one in the Uffizi (Cox-Rearick 1964 no. A33, probably by Naldini), the other privately owned. The three figures move in a sequence that, to modern eyes, is irresistibly reminiscent of Eadweard Muybridge's photographs and their pictorial development by Marcel Duchamp. There are, of course, links with Michelangelo's *Battle of Cascina,* but the mystical elongation of Pontormo's figures and his indifference to individual psychology are very different from Michelangelo's moral vision. The superimposition of one form upon another subverts functionality in favor of paradox, blurring, and unclarity.

The technique varies from sharp hatching to a broad stumping in which modeling is achieved by films of chalk, wonderfully evoking the surface of flesh. Pontormo learned this technique from Sarto but exploited it more fully. Pontormo developed the simultaneous, dialectical production of the wiry and the smooth: sharply hatched linear drawings confront drawings stumped or executed with red-chalk wash—a technique he pioneered—in which individual lines can scarcely be descried.

The recto drawing was identified in 1964 by Cox-Rearick as a study for the *Restoration to Office of the Butler and Execution of the Baker* (fig. 55a), one of the Joseph cycle painted by Pontormo and others c. 1516 for Pierfrancesco Borgherini. As Cox-Rearick noted, the pose tried in the left-hand figure resembles that of a man descending the flight of stairs in the painting, for whom another red chalk drawing—like this larger than the figure in the painting—in the Uffizi (6690F, Cox-Rearick no. 26) was certainly made. But, while acknowledging similarities of pose, one might wonder why Pontormo should have placed so much stress on the skin texture and musculature of figures that, in the painting, were always intended to be clothed? No other drawing by Pontormo for the Joseph cycle displays this intensity of surface realization. Furthermore, the central figure in the

drawing seems to be moving on the flat rather than descending and the right-hand figure looks and stretches upward in a way that finds no justification in the painting. A different possibility is suggested by a large drawing in the British Museum (fig. 55b). It prepares the decoration of one wall of a chamber. In its central section, below a lunette depicting *Leda and the Swan,* stands a bathing figure attended by others; further figures enter at each side. Once dated around 1520 and connected with Pontormo's work at Poggio a Caiano, this drawing is now generally placed c. 1517–18. It was certainly made for a Medici client—perhaps, as suggested by Costamagna, Lorenzo, duke of Urbino. The emphasis on nudity and the presence of Leda, unlikely in a public room, would be appropriate for a bathroom. If so, the main figure could be Mars, with perhaps, Venus facing him on the opposite wall. There would, no doubt, have been frescoes on the side walls. A number of nude studies (for example, Uffizi 675E [in which one figure is apparently pulling on his hose in direct emulation of a famous figure in *Cascina*], 6543F, and 8976S; Cox-Rearick nos. 74, 78, and 84) are generally dated around this time, and these works and the present drawing could well have been made for this scheme. They would find a comfortable place in a design making considerable play with figures moving from level to level, and others descending laterally from simulated stairways.

The verso drawing is entirely different in technique and approach. The emphasis is on breadth of form and the faceting of light over the drapery, here the center of

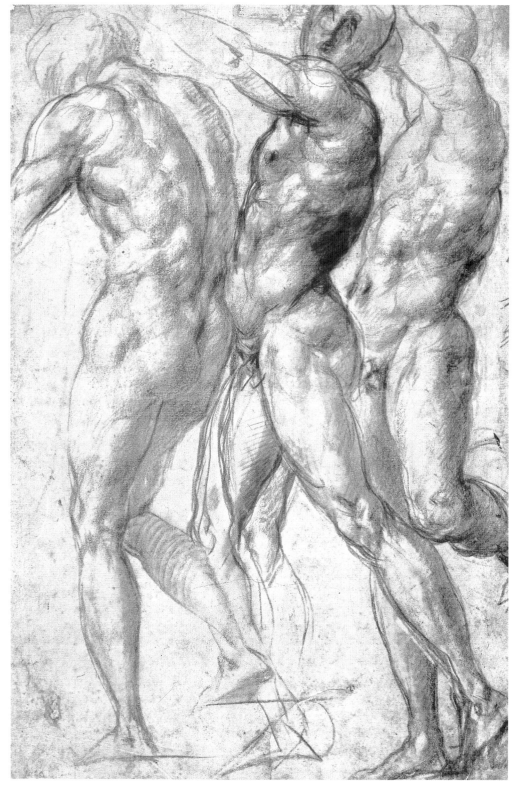

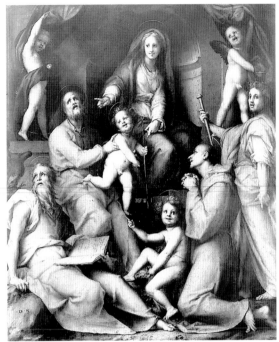

Fig. 55b
Jacopo Carucci, called Il
Pontormo. *The Bath of
Mars?*, c. 1517, red
chalk, 475 x 500 mm.
The British Museum,
London.
Fig. 55c
Jacopo Carucci, called Il
Pontormo. *The Virgin and
Child with Saints Joseph
and Other Saints* (the
Pucci altarpiece), dated
1518, oil on panel, 214
x 185 cm. San Michele
Visdomini, Florence.

Pontormo's attention. It was identified by Cox-Rearick as a study for Saint John the Evangelist in the Pucci altarpiece in the Florentine church of San Michele Visdomini (fig. 55c); the drawing must, as she recognized, follow on from the composition sketch in Rome (Gabinetto Nazionale Disegni e Stampe F.C. 147 r, Cox-Rearick no. 29). The head is tried in different positions, in profile as in the compositional sketch and turned outward as in the final painting; the hands and head were not finalized here but left for development in successive studies.

The figure is clearly identified as Saint John by the rectangle of spared paper that indicates his gospel, but his pose was in the event taken over with relatively little change for Saint Joseph, to whom the altar is dedicated. Joseph sits holding the infant Christ immediately above Saint John, whose legs are now arranged at a much shallower angle and sheathed in less vigorously modeled drapery. John holds his—less prominent—gospel in his left hand, and rests on his right. The outstretched right arm in the drawing now supports the Christ child. Finding his way to the final design, Pontormo did not hesitate to adapt this figure to a new and more suitable role.

Although the Pucci altarpiece has a tight surface structure, the upright and inverted "As" (like the monogram of Andrea del Sarto) that organize it produce a central diamond shape of inherent instability. This is compounded by the asymmetry of left and right, which becomes more pronounced as the eye moves down the painting, an asymmetry pushed into eccentricity by the heads of the

evangelist, Joseph, the Christ child and the Virgin, all of whom gaze outward to the viewer's left, a direction in which the Virgin and the infant Saint John the Baptist actually gesture. Pontormo presumably planned his painting to stand in some specific relation, now lost, with the church's high altar.

Something of this instability, surprisingly, together with the airless setting, the complex movement of the child and the relation to him of Saint John, reflects the influence of the *Madonna del Impannata* (Palazzo Pitti, Florence) by Raphael and his studio, commissioned for Bindo Altoviti's Florentine palace. Although designed in 1513–14, the painting seems to have languished for several years in Raphael's workshop to be finished by his assistants and transported to Florence only around 1517. No doubt the presence in the city of this smooth and rather leaden painting contributed to Pontormo's darkening of manner in the Pucci altarpiece, dated 1518.

References
Benvignat 1856, nos. 1429–30; Gonse 1877, 555; Pluchart 1889, nos. 162–63; Berenson 1938, no. 2252b; Bacou 1957, 62; Berenson 1961, no. 2252b; Viatte 1963, no. 89; Cox-Rearick 1964, nos. 25, 45; Châtelet 1970, no. 73; Cox-Rearick 1981, nos. 25, 45; Turner 1986, no. 102; Cordellier 1986, no. 83; Brejon de Lavergnée 1989, no. 36; Brejon de Lavergnée 1990, no. 42; Griswold 1992, no. 60; Costamagna 1994, 29, 38, 128, 137; Brejon de Lavergnée 1997, no. 127.

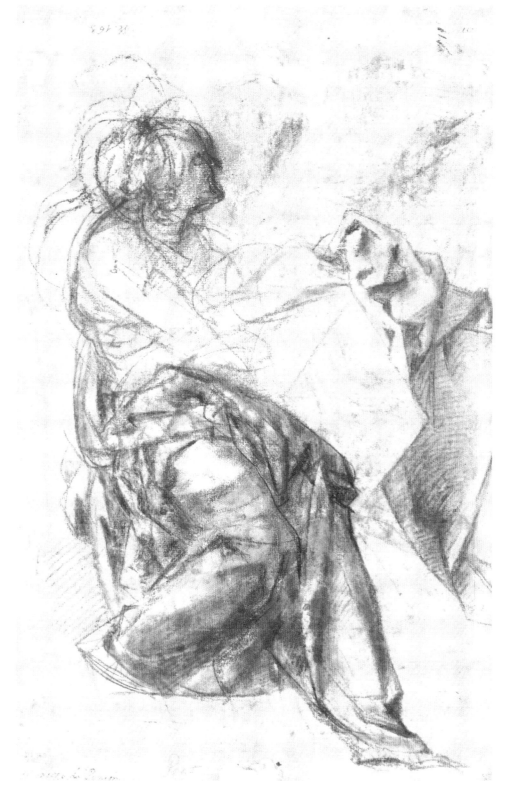

Cat. 55b

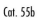

56. JACOPO CARUCCI, called IL PONTORMO

a. *Saint Michael* (recto)

c. 1519

Black chalk

b. *Two Seated Male Nudes* (verso)

Red chalk, 384 x 157 mm

Fig. 56a
Jacopo Carucci, called Il Pontormo. *Saint Michael and Saint John the Evangelist,* c. 1519, oil on panel, 173 x 193 cm (overall). San Michele, Pontormo.

Pontormo's drawing is, as all recent scholars have recognized, a study for the Saint Michael in a large arch-shaped panel of Saint Michael and Saint John the Evangelist (fig. 56a), painted for the chapel of the Madonna in the church of San Michele in Pontormo, the artist's birthplace. The panel's open center frames a niche, which no doubt once housed a revered sculpture: a Virgin and Child is the most likely possibility. The employment of soft black chalk, with stumping and white lead, is clearly designed to establish the tonal foci of the right-hand side of the painting, with the main accents on the face of Michael, his bent leg, and the drapery. The evangelist on the left is prepared in a drawing in the Uffizi (fig. 56b). The two sheets were probably once the same size and slightly taller than they are now, but unlike the Uffizi sheet the present one has been reduced in width by some 10 cm. Vasari's account implies that the painting was executed shortly after Pontormo completed the Pucci altarpiece in San Michele Visdomini, a panel, incidentally, in which

the church's name saint is not included. Scholars of Pontormo agree to a date of c. 1519–20, and by this time he would no doubt have learned of Raphael's majestic *Saint Michael* sent to the French court in late 1518. Pontormo's Michael bears no relation to that of Raphael's painting, but it may register a reaction to the probable first design, recorded by both Marco Dente da Ravenna and Agostino Veneziano in engravings whose dates are uncertain but that were probably in circulation in 1519. Pontormo could be seen to have produced a critique of this design, adopting a Michelangelesque idiom to do so. The allusion to Raphael's great rival is seen clearly in a further drawing in the Uffizi (6506F, Cox-Rearick no. 101) which studies the pose of Saint Michael's legs. In red chalk, it is executed with a sharp point and quite open hatching to create a bright marmoreal surface. Cox-Rearick pointed out the close relation between this drawing and the legs of Michelangelo's *Dying Slave,* and even had Pontormo not yet seen this figure (see cat. 43), which was then in Michelangelo's Roman workshop, he would have known comparable ones, for Michelangelo had employed similar leg positions in drawings made for other contexts. The nature of the movement and the raised arm also link, for example, with Michelangelo's Louvre study for *Cascina,* a drawing probably known to Pontormo's master, Andrea del Sarto. But whatever its specific source, of a Michelangelesque echo there is no doubt and it may extend to the basic scheme of placing a lightly poised figure above another. Michelangelo's first idea for the Victory groups of the Julius Tomb, in which winged female figures stand atop immobilized vices, might have fed into Pontormo's form.

The iconography of Pontormo's Saint Michael is characteristically individual—even eccentric—but given its location, it must have had clerical approval. The angelic warrior stands atop not an adult devil but a putto. To represent Satan as an impish child is unusual and one can only speculate upon Pontormo's reasons for doing so. But whatever the ostensible purpose, his treatment surely contains an element of humor. Pinioned but not crushed under the saint's foot, the evil child still succeeds

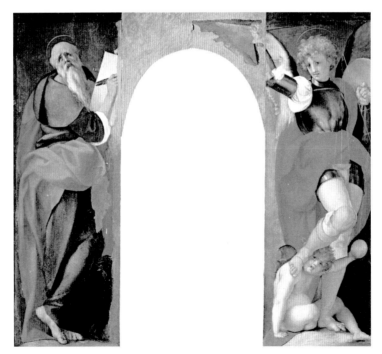

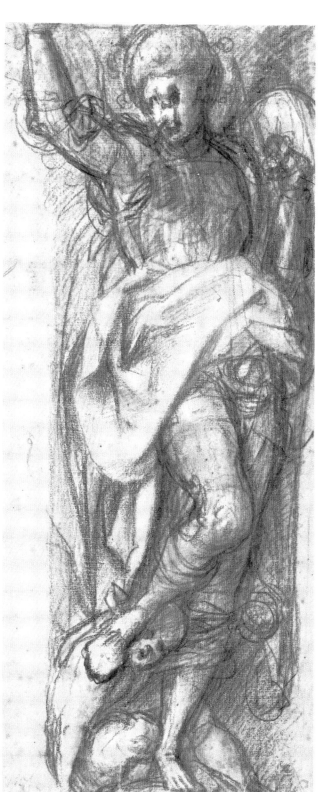

Cat. 56a

in grasping one of the pans of Michael's scale, claiming a soul as his own. The other pan, of course, rises, although this can now be seen more clearly in the drawing than in the damaged painting.

The losses to the verso drawing are the product of the truncation designed to frame the recto image. Pontormo

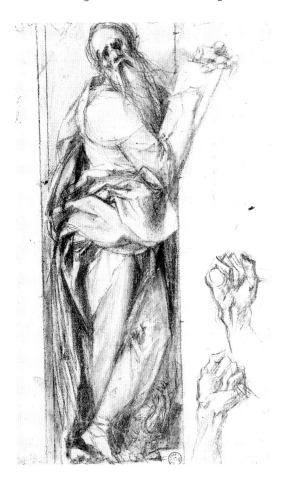

Fig. 56b
Jacopo Carucci, called Il Pontormo. *Study for Saint John the Evangelist,* c. 1519, red and black chalk, 406 x 251 mm. Uffizi, Florence.

has sketched on the left a seated boy, on the right a reclining youth. The drawing is characteristic of his rapid figure sketches, handled in long contour lines of an inimitable flexibility and elasticity, contrasted with areas of sleek stumping and others executed in bracelet hatching. Some of this effect came from Andrea del Sarto's drawings, but Pontormo took it to a new level of achievement.

The left-hand figure was seen by Cox-Rearick as preparatory for the satanic putto on the recto, but, as Shearman noted, this connection is questionable. The poses are not identical and this figure does not seem to register a weight. It may be rather, as Brejon de Lavergnée has suggested, that both figures were drawn in connection with the composition of *Vertumnus and Pomona,* frescoed by Pontormo in the Medici Villa at Poggio a Caiano in 1521. The fresco contains numerous reclining and partially nude figures, and represents a high point of joie de vivre in the work of an artist whose attitude to life was anything but cheerful.

Such drawings once again take inspiration from Michelangelo—indeed a relation could be argued between, particularly, the left-hand figure and the seated figure in the *Battle of Cascina.* But Michelangelism is here attenuated and relaxed. Pontormo had to drain Michelangelesque meaning from Michelangelesque forms before they could be refilled. And a relation with Michelangelo must be set beside—and within—a continuing relation with Andrea del Sarto: the youth at the right is quoted fairly exactly, but in reverse, from the reclining beggar in Andrea's *Miracle of the Relics of San Filippo Benizzi,* frescoed in the atrium of Santissima Annunziata in Florence in 1510.

References
Benvignat 1856, nos. 1427–28; Pluchart 1889, nos. 568–69; Bacou 1957, 62; Viatte 1963, no. 88; Cox-Rearick 1964, nos. 99–100; Pouncey 1964, 290; Châtelet 1970, no. 74; Shearman 1972, 212; Cox-Rearick 1981, nos. 99–100; Brejon de Lavergnée 1989, no. 37; Brejon de Lavergnée 1990, no. 44; Griswold 1992, no. 61; Costamagna 1994, 144–45; Brejon de Lavergnée 1997, no. 128.

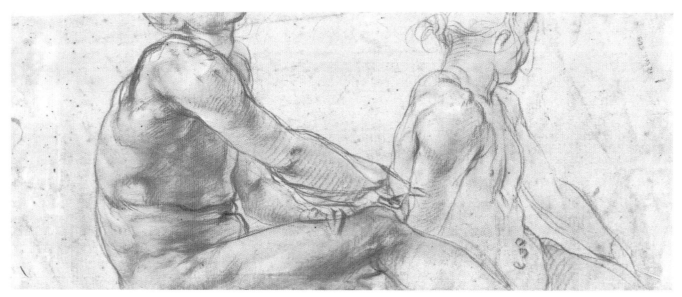

57. Francesco Salviati

Standing Female Nude

c. 1530

Red chalk, 347 x 167 mm

Fig. 57a
Francesco Salviati.
A Fragmentary Nude Torso Seen from the Back, c. 1527?, red chalk, 228 x 151 mm. Biblioteca Reale, Turin, 15649b, D.C.
Fig. 57b
Baccio Bandinelli.
A Female Nude, c. 1525?, red chalk, 410 x 242 mm. Private collection.

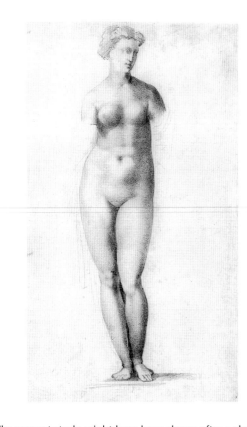

The technique of this drawing, attributed to Francesco Salviati both by Catherine Monbeig Goguel (in a letter to Barbara Brejon de Lavergnée of 1995) and by the compiler, is inspired by Baccio Bandinelli, one of the most distinctive and assured draftsmen active in Florence during the second and third decades of the cinquecento. Salviati worked with Bandinelli for a while as a teenager and clearly relished his red-chalk style, in which suppression of individual strokes created "touchless," subtly modulated surfaces (fig. 57b). But the approach here is more nervous and emphatic than Bandinelli's, with distinct strokes of sharp chalk worked into a mesh in the shoulders. The contour is also drawn more distinctly, with more constant pressure, than is habitual in Bandinelli; indeed its wire-like tension is close to the contours of the chalk drawings of Rosso Fiorentino, another artist who profoundly influenced Salviati, and to whom many of the latter's drawings have, in the past, been attributed. Such blending is characteristic of Salviati who, capable of tense and elongated forms like Rosso, retained a contrasting penchant for the inflated and the swollen, which Bandinelli's work encouraged.

The present study might have been drawn after a clay or plaster model by Bandinelli himself. It has the cylindrical smoothness characteristic of the sculptor's female types, although the implied sense of movement is greater than usual with Bandinelli, whose forms tend to stasis. But while it was probably made after Salviati had left Bandinelli's workshop, it no doubt reprises exercises practiced there, in which the master set his students the task of copying sculptural models by candlelight.

Salviati was one of the most versatile, inventive and playful draftsmen working in Italy during the middle decades of the sixteenth century. An inveterate copyist of the work of his great elders and contemporaries, he was deeply interested also in the painting of the quattrocento and even the trecento. An unpredictable artist, at times capable of sober objectivity, at others brimming over with ludic individuality, he is hard to pin down, and even though serious research on his life and work has now been under way for some four decades, his paintings and drawings continue to hold many surprises.

References
Benvignat 1856, no. 21; Gonse 1877, 552; Pluchart 1889, no. 19; Delacre 1938, 502; Viatte 1963, no. 24; Brejon de Lavergnée 1997, no. 28.

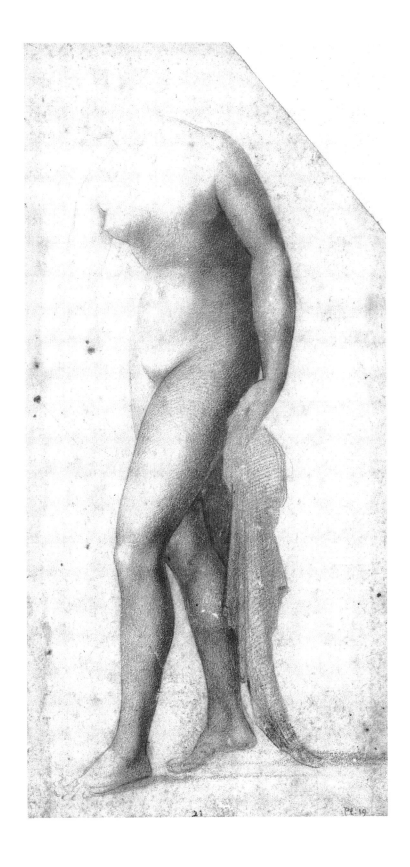

Selective Bibliography

Ames-Lewis 1981a
Francis Ames-Lewis. *Drawing in Early Renaissance Italy.* New Haven/London, 1981.

Ames-Lewis 1981b
Francis Ames-Lewis. "Drapery Pattern Drawings in Ghirlandaio's Workshop and Ghirlandaio's Early Apprenticeship." *Art Bulletin* 63 (1981), 49–62.

Ames-Lewis and Wright 1983
Francis Ames-Lewis and Joanne Wright. *Drawing in the Italian Renaissance Workshop.* Exh. cat. University Art Gallery, Nottingham; Victoria and Albert Museum, London, 1983.

Bacou 1957
Roseline Bacou. "Ils existent, le saviez-vous." *L'Oeil* (April 1957), 22–29, 62.

Bambach Cappel 1990
Carmen Bambach Cappel. "Review of M. Hirst, 'Michelangelo and His Drawings.'" *Art Bulletin* 72 (1990), 493–98.

Bartalini 1992
Roberto Bartalini. "Due episodi del mecenatismo di Agostino Chigi e le antichità della Farnesina." *Prospettiva* 67 (1992), 17–38.

Bartalini 1996
Roberto Bartalini. *Le occasioni di Sodoma* Rome, 1996.

Beaucamp 1939
Fernard Beaucamp. *Le peintre Lillois J.-B. Wicar (1762–1834). Son œuvre et son temps.* 2 vols. Lille, 1939.

Beck 1986
James Beck, ed. *Raphael Before Rome.* Studies in the History of Art 17. Washington, 1986.

Belluzzi 1998
Amadeo Belluzzi. *Palazzo Te a Mantova.* 2 vols. Modena, 1998.

Benvignat 1856
Charles Benvignat. *Musée Wicar. Catalogue des dessins et objets d'art légués par J.-B. Wicar.* Lille, 1856.

Berenson 1903
Bernard Berenson. *The Drawings of the Florentine Painters.* 2 vols. London, 1903.

Berenson 1938
Bernard Berenson. *The Drawings of the Florentine Painters.* 3 vols. 2d ed. Chicago, 1938.

Berenson 1961
Bernard Berenson. *I Desegni di pittori Fiorentini.* 3 vols. 3rd ed. Milan, 1961.

Berti 1965
Luciano Berti. "I Disegni," 2:389–507. In Salmi 1965.

Birke and Kertesz 1992–96
Veronika Birke and Janine Kertesz. *Die Italienischen Zeichnungen der Albertina.* 4 vols. Vienna/Cologne/Weimar, 1992–96.

Bober and Rubinstein 1986
Phyllis Bober and Ruth Rubinstein. *Renaissance Artists and Antique Sculpture.* London/Oxford, 1986.

Borgo 1976
Ludovico Borgo. *The Works of Mariotto Albertinelli.* New York/London, 1976.

Boucher 1991
Bruce Boucher. *The Sculpture of Jacopo Sansovino.* New Haven/London, 1991.

Brejon de Lavergnée 1989
Barbara Brejon de Lavergnée. *Renaissance et Baroque. Dessins Italiens du musée de Lille.* Exh. cat. Palais des Beaux-Arts, Lille, 1989.

Brejon de Lavergnée 1990
Barbara Brejon de Lavergnée. Catalogue entries in Westfehling 1990.

Brejon de Lavergnée 1997
Barbara Brejon de Lavergnée. *Catalogue des Dessins Italiens. Collections du Palais des Beaux-Arts de Lille.* Paris/Lille, 1997.

Burns, Collareta, Gasparotto 2000
Howard Burns, Marco Collareta, Davide Gasparotto, et al. *Valerio Belli, Vicentino.* Exh. cat. Centro Internazionale di Architettura Andrea Palladio. Vicenza, 2000.

Byam Shaw 1977
James Byam Shaw. "The Study of a horse by Andrea del Sarto and its origins." *Burlington Magazine* 119 (1977), 848–49.

Cadogan 1983
Jean Cadogan. "Reconsidering Some Aspects of Ghirlandaio's Drawings." *Art Bulletin* 65 (1983), 274–90.

Cadogan 2001
Jean Cadogan. *Domenico Ghirlandaio.* New Haven/London, 2001.

Carli 1979
Enzo Carli. *Il Sodoma.* Milan, 1979.

Châtelet 1967
Albert Châtelet. *Dessins Italiens du musée de Lille.* Exh. cat. Rijksmuseum, Amsterdam, and tour, 1967.

Châtelet 1970
Albert Châtelet. *Disegni di Raffaello e di altri italiani del museo de Lille.* Exh. cat. Galleria degli Uffizi, Florence, 1970.

Clayton 1999
Martin Clayton. *Raphael and His Circle, Drawings from Windsor Castle.* Exh. cat. Queen's Gallery, London, and tour, 1999.

Cordellier 1986
Dominique Cordellier. *Hommage à Andrea del Sarto.* Exh. cat. Musée du Louvre, Paris, 1986.

Cordellier 1989
Dominique Cordellier. Catalogue entries in Brejon de Lavergnée 1989.

Cordellier 1990
Dominique Cordellier. Catalogue entries in Westfehling 1990.

Cordellier and Py 1992
Dominique Cordellier and Bernadette Py. *Musée du Louvre, Département des Arts Graphiques, Inventaire général des dessins italiens. Raphael, Son atelier, ses copistes.* Paris, 1992.

Costamagna 1994

Philippe Costamagna. *Pontormo.*
Paris/Milan, 1994.

Cox-Rearick 1964

Janet Cox-Rearick. *The Drawings of
Pontormo.* Cambridge, Massachusetts, 1964.

Cox-Rearick 1981

Janet Cox-Rearick. *The Drawings of
Pontormo.* 2d ed. New York, 1981.

Crowe and Cavalcaselle 1882–83

J. A. Crowe and G. B. Cavalcaselle. *Raphael.
His Life and Works.* 2 vols. London,
1882–83.

Cruttwell 1904

Maud Cruttwell. *Verrocchio.* London, 1904.

Dalli Regoli 1966

Gigetta dalli Regoli. *Lorenzo di Credi.* Pisa,
1966.

Davidson 1985

Bernice Davidson. *Raphael's Bible. A Study
of the Vatican Logge.* University Park,
Pennsylvania, 1985.

Delacre 1938

Maurice Delacre. *Le dessin de Michel-Ange.*
Brussels, 1938.

Delacre and Lavallée 1927

Maurice Delacre and Pierre Lavallée.
Dessins de maîtres anciens. Brussels, 1927.

Denon 1999

Dominique-Vivant Denon, l'oeil de Napoléon.
Pierre Rosenberg et al. Exh cat. Musée du
Louvre, Paris, 1999.

De Tolnay 1975–80

Charles De Tolnay. *Corpus dei disegni de
Michelangelo.* 4 vols. Novara, 1975–80.

Dussler 1942

Luitpold Dussler. *Sebastiano del Piombo.*
Basel, 1942.

Dussler 1959

Luitpold Dussler. *Die Zeichnungen des
Michelangelo, Kritischer Katalog.* Berlin,
1959.

Fahy 1966

Everett Fahy. "The Beginnings of
Fra Bartolommeo." *Burlington Magazine*
108 (1966), 456–63.

Fahy 1969

Everett Fahy. "The Earliest Work of Fra
Bartolommeo." *Art Bulletin* 51 (1969),
142–54.

Fahy 1977

Everett Fahy. "Michelangelo and Domenico
Ghirlandaio," 152–57. In *Studies in Late
Medieval and Renaissance Painting in Honor
of Millard Meiss.* New York, 1977.

Ferino Pagden 1981

Sylvia Ferino Pagden. "Raphael's Activity in
Perugia as Reflected in a Drawing in the
Ashmolean Museum, Oxford." *Mitteilungen
des Kunsthistorischen Instituts in Florenz* 25,
no. 2 (1981), 231–52.

Ferino Pagden 1982

Sylvia Ferino Pagden. *Disegni umbri del
Rinascimento da Perugino a Raffaello.*
Exh. cat. Galleria degli Uffizi, Florence,
1982.

Ferino Pagden 1984

Sylvia Ferino Pagden. *Gallerie
dell'Accademia di Venezia. Catalogo
dei disegni antichi, Disegni umbri.* Milan,
1984.

Ferino Pagden 1986

Sylvia Ferino Pagden. "The Early Raphael
and his Umbrian Contemporaries,"
93–107. In Beck 1986.

Fischel 1898

Oskar Fischel. *Raphaels Zeichnungen.*
Strasbourg, 1898.

Fischel 1913–41

Oskar Fischel. *Raphaels Zeichnungen.*
8 vols. Berlin, 1913–41.

Fischel 1917

Oskar Fischel. *Die Zeichnungen der Umbrer.*
Berlin, 1917.

Fischel 1948

Oskar Fischel. *Raphael.* Translated by
Bernard Rackham. London, 1948.

Fischer 1982

Chris Fischer. "Remarques sur 'Le Marriage
mystique de sainte Cathereine de Sienne'
par Fra Bartolommeo." *La Revue du
Louvre et des musées de France* 31 (1982),
167–80.

Fischer 1986

Chris Fischer. *Disegni di Fra Bartolommeo
e della sua cerchia.* Exh. cat. Galleria degli
Uffizi, 1986.

Fischer 1990a

Chris Fischer. *Fra Bartolommeo, Master
Draughtsman of the High Renaissance.*
Exh. cat. Museum Boymans-van
Beuningen, Rotterdam, 1990.

Fischer 1990b

Chris Fischer. "Fra Bartolommeo e il suo
tempo," 59–75. In *La chiesa e il convento di
San Marco a Firenze.* Florence, 1990.

Fischer 1994

Chris Fischer. *Fra Bartolommeo et son
atelier. Dessins et peintures des collections
françaises.* Exh. cat. Musée du Louvre,
Paris, 1994.

Forlani Tempesti 2001

Anna Forlani Tempesti et al. *Da Raffaello a
Rossini. La Collezione Antaldi. I disegni ritrovati.*
Exh. cat. Palazzo Antaldi, Pesaro, 2001.

Freedberg 1963

Sydney J. Freedberg. *Andrea del Sarto.*
2 vols. Cambridge, Massachusetts, 1963.

Gabelentz 1922

Hans von der Gabelentz. *Fra Bartolommeo
und die Florentiner Renaissance.* 2 vols.
Leipzig, 1922.

Gere 1953

John Gere. "William Young Ottley as a
Collector of Drawings." *British Museum
Quarterly* (1953), 44–53.

Gere and Pouncey 1982
John A. Gere and Philip Pouncey. *Italian Drawings in the Department of Prints and Drawings in the British Museum. Artists Working in Rome, c. 1550 to c. 1640.* London, 1982.

Gnoli 1923
Umberto Gnoli. *Pittori e miniatori nell'Umbria.* Spoleto, 1923.

Goguel 1987
Catherine Goguel. "Le tracé invisible des dessins de Raphael." In Hamoud and Strocchi 1987, 377–89.

Goldner 1997
George Goldner et al. *The Drawings of Filippino Lippi and His Circle.* Exh. cat. Metropolitan Museum of Art, New York, 1997.

Golzio 1936
Vincenzo Golzio. *Raffaello nei documenti.* Vatican City, 1936. Rev. ed., Farnborough, 1971.

Gonse 1877
Louis Gonse. "Le musée Wicar." *Gazette des Beaux-Arts* (January 1877), 80–95; (April 1877), 386–401; (November 1877), 393–401; (December 1877), 551–60.

Gould 1987
Cecil Gould. "Raffaello a Venezia," 111–15. In Hamoud and Strocchi 1987.

Gould 1992
Cecil Gould. "Raphael at S. Maria della Pace." *Gazette des Beaux-Arts* 120 (September 1992), 78–88.

Griswold 1987
William Griswold. "A Drawing by Cosimo Rosselli." *Burlington Magazine* 129 (1987), 514–16.

Griswold 1992
William Griswold. *Masterworks from the Musée des Beaux Arts, Lille.* Exh. cat. Metropolitan Museum of Art, New York, 1992.

Gronau 1896
Georg Gronau. "Das sogennante Skizzenbuch des Verrocchio." *Jahrbuch des Königlich Pressischen Kunstsammlungen* 17 (1896), 65–72.

Gruyer 1886
Gustave Gruyer. *Fra Bartolommeo della Porta et Mariotto Albertinelli.* Paris, 1886.

Gualdi Sabatini 1983
Fausta Gualdi Sabatini. *Giovanni di Pietro, detto Lo Spagna.* 2 vols. Pesaro, 1984.

Hamoud and Strocchi 1987
Micaela Sambucco Hamoud and Maria Letizia Strocchi, eds. *Studi su Raffaello. Atti del Congresso internazionale di studi.* Urbino, 1987.

Hartt 1958
Frederick Hartt. *Giulio Romano.* 2 vols. New Haven, 1958.

Hirst 1961
Michael Hirst. "The Chigi Chapel in S. Maria della Pace." *Journal of the Warburg and Courtauld Institutes* 24 (1961), 161–85.

Hirst 1981
Michael Hirst. *Sebastiano del Piombo.* Oxford, 1981.

Holman 2000
Beth Holman. "A 'Subtle Artifice': Giulio Romano's *Salt Cellar with Satyrs* for Federico II Gonzaga." *Quaderni di Palazzo Te* 8 (2000), 57–68.

Holst 1971
Christian von Holst. "Florentiner Gemälde und Zeichnungen aus der Zeit von 1480 bis 1580: kleine Beobachtungen und Ergänzungen." *Mitteilungen de Kunsthistorischen Instituts in Florenz* 15 (1971), 1–64.

Jaffé 1994
Michael Jaffé. *The Devonshire Collection of Old Master Drawings.* 4 vols. London, 1994.

Joannides 1983
Paul Joannides. *The Drawings of Raphael.* Oxford, 1983.

Joannides 1987
Paul Joannides. "Raphael and Giovanni Santi," 55–61. In Hamoud and Strocchi 1987.

Knapp 1903
Frtiz Knapp. *Fra Bartolommeo della Porta und die Schule von San Marco.* Halle, 1903.

Laclotte 1956
Michel Laclotte. *De Giotto à Bellini. Les primitifs italiens dans les musées de France.* Exh. cat. Orangerie des Tuileries, Paris, 1956.

Laclotte 1993
Michel Laclotte et al. *Le siècle de Titien.* Exh. cat. Grand Palais, Paris, 1993.

Lanfranc de Panthou 1995
Caroline Lanfranc de Panthou. *Dessins italiens du musée Condé à Chantilly.* Vol. 1, *Autour de Pérugin, Filippino Lippi et Michel-Ange.* Exh. cat. Musée Condé, Chantilly, 1995.

Leone de Castris 2001
Pierluigi Leone de Castris. *Polidoro da Caravaggio.* Milan, 2001.

Lightbown 1978
Ronald Lightbown. *Sandro Botticelli.* 2 vols. London, 1978.

Magnusson 1992
Borje Magnusson. *Rafael Teckningar.* Exh. cat. Nationalmuseum, Stockholm, 1992.

Mancinelli 1986
Fabrizio Mancinelli. "The Coronation of the Virgin by Raphael," 127–36. In Beck 1986.

Masari 1993
Stefanie Massari. *Giulio Romano pinxit et delineavit. Opere grafiche autografe di collaborazione e bottega.* Exh. cat. Palazzo del Te, Mantua, 1993.

McKillop 1974
Susan McKillop. *Franciabigio.* Los Angeles, 1974.

Merson 1862

Olivier Merson. "Les dessins du musée de Lille." *L'Artiste* (October 1862), 166–88.

Monti 1965

Raffaele Monti. *Andrea del Sarto*. Milan, 1965.

Morelli 1890

Giovanni Morelli. *Kunstkritischer Studien über italienische Malerei. Die Galerein Borghese und Doria Panfili in Rom*. Leipzig, 1890.

Morelli 1891–92

Giovanni Morelli. "Handzeichnungen italienischer Meister in photographischen Aufnahmen von Braun & Co, in Dornach, kritischer gesichtet von Giovanni Morelli (Lermolieff)." Transcribed by E. Habish. In *Kunstchronik* 3, no. 17 (1891–92), 376–78, 441–43.

Mulazzani 1986

Germano Mulazzani. "Raphael and Venice: Giovanni Bellini, Dürer and Bosch," 149–53. In Beck 1986.

Nesselrath 1986

Arnold Nesselrath. "I libri di disegni di antichità. Tentativo di una tipologia," 89–147. In *Memoria dell'antico nell'arte italiana*. Turin, 1986.

Oberhuber 1972

Konrad Oberhuber, ed. *Raphaels Zeichnungen*. Vol. 9. Berlin, 1972.

Oberhuber 1976

Konrad Oberhuber. *Disegni di Tiziano e della sua cerchia*. Exh. cat. Fondazione Giorgio Cini, Venice, 1976.

Oberhuber 1983

Konrad Oberhuber et al. *Raphael. Die Zeichnungen*. Berlin, 1983.

Oberhuber 1993

Konrad Oberhuber. Catalogue entries in Laclotte 1993.

Oursel 1983

Hervé Oursel. *Dessins de Raphael du musée des Beaux-Arts de Lille*. Exh. cat. Musée des Beaux-Arts, Lille, 1983.

Pallucchini 1944

Rodolfo Pallucchini. *Sebastiano Viniziano*. Milan, 1944.

Parker 1956

Karl Parker. *Catalogue of the Drawings in the Ashmolean Museum, Oxford*. Vol. 2, *The Italian Schools*. Oxford, 1956.

Parma 2001

Elena Parma. *Perino del Vaga*. Exh. cat. Palazzo del Te, Mantua, 2001.

Parma Armani 1986

Elena Parma Armani. *Perin del Vaga. L'anello mancante*. Genoa, 1986.

Passavant 1860

Johan David Passavant. *Raphael d'Urbin et son père Giovanni Santi*. 2 vols. Paris, 1860.

Penny 1992

Nicholas Penny. "Raphael's 'Madonna dei Garofani' rediscovered." *Burlington Magazine* 134 (1992), 67–81.

Peronnet 1997

Benjamin Peronnet. *Dessins italiens du musée Condé à Chantilly*. Vol. 2, *Raphaël et son cercle*. Exh. cat. Musée Condé, Chantilly, 1997.

Petrioli Tofani 1986

Annamaria Petrioli Tofani. "I disegni." In *Andrea del Sarto*. Exh. cat. Palazzo Pitti, Florence, 1986.

Piot 1861–62

Eugène Piot. *Le Cabinet de l'Amateur*. Paris, 1861–62.

Pluchart 1889

Henry Pluchart. *Musée Wicar. Notice des Dessins, Cartons, Pastels, Miniatures et Grisailles Exposés*. Lille, 1889.

Popham and Wilde 1949

Arthur Ewart Popham and Johannes Wilde. *The Italian Drawings of the 15th and 16th Centuries in the Collection of His Majesty the King at Windsor Castle*. London, 1949.

Popham and Wilde 1952

Arthur Ewart Popham and Philip Pouncey. *Italian Drawings in the Department of Prints and Drawings in the British Museum. The 14th and 15th Centuries*. London, 1952.

Pouncey 1964

Philip Pouncey. "Bernard Berenson: I disegni dei pittori Fiorentini." *Master Drawings* 2 (1964), 278–93.

Pouncey and Gere 1962

Philip Pouncey and John A. Gere. *Italian Drawings in the Department of Prints and Drawings in the British Museum. Raphael and His Circle*. London, 1962.

Ragghianti and dalli Regoli 1975

Carlo Ludovico Ragghianti and Gigetta dalli Regoli. *Firenze 1470–1480. Disegni dal modello*. Pisa, 1975.

Rearick 2001

William R. Rearick. *Il disegno Veneziano del Cinquecento*. Milan, 2001.

Robinson 1870

John Charles Robinson. *A Critical Account of the Drawings by Michel Angelo and Raffaello in the University Art Galleries, Oxford*. Oxford, 1870.

Rubinstein 1987

Ruth Rubinstein. "Ajax and Cassandra: An Antique Cameo and a Drawing by Raphael." *Journal of the Warburg and Courtauld Institutes* 50 (1987), 204–5.

Salmi 1965

Mario Salmi et al. *Michelangelo—Artista—Pensatore—Scrittore*. 2 vols. Novara, 1965.

Scheller 1973
R. W. Scheller. "The Case of the Stolen Raphael Drawings." *Master Drawings* 11 (1973), 119–37.

Schulze Altcappenberg 1995
Hein-Theodore Schulze Altcappenberg. *Die Italienischen Zeichnungen des 14 und 15 Jahrhunderts im Berliner Kupferstichkabinett. Kritischer Katalog.* Berlin, 1995.

Scottez de Wambrechies 1989
Annie Scottez de Wambrechies. "J. B. Wicar et sa Collection de Dessins," 13–14. In Brejon de Lavergnée 1989.

Shearman 1961
John Shearman. "The Chigi Chapel in S. Maria del Popolo." *Journal of the Warburg and Courtauld Institutes* 24 (1961), 129–60.

Shearman 1965
John Shearman. *Andrea del Sarto.* 2 vols. Oxford, 1965.

Shearman 1972
John Shearman. "Review of Janet Cox-Rearick, *The Drawings of Pontormo.*" *Art Bulletin* 54 (1972), 209–12.

Shearman 1987
John Shearman. "The Exhibitions for Andrea del Sarto's fifth Centenary." *Burlington Magazine* 129 (1987), 498–502.

Shearman 2000
John Shearman. "Per Raffaello e Valeri Belli. Tredici schede," 287–301. In Burns, Collareta, Gasparotto 2000.

Shoemaker 1975
Innis Shoemaker. *Filippino Lippi as a Draughtsman.* Ph.D. thesis, Columbia University, 1975.

Tietze and Tietze-Conrat 1944
Hans Tietze and Erica Tietze-Conrat. *The Drawings of the Venetian Painters in the 15th and 16th Centuries.* New York, 1944.

Turner 1986
Nicholas Turner. *Florentine Drawings of the 16th Century.* Exh. cat. British Museum, London, 1986.

Vasari 1879
Giorgio Vasari. *The Lives of the Artists.* 1879.

Venturi 1925
Adolfo Venturi. *Storia dell'arte italiana.* Vol. 9, *La pittura del Cinquecento,* part 1. Milan, 1925.

Viatte 1963
Françoise Viatte. *Catalogue raisonné des dessins florentins et siennois des XVe et XVIe siècles au musée de Lille.* Ph.D. thesis, École du Louvre, 1963.

Viatte and Goguel 1983
Françoise Viatte and Catherine Goguel. *Raphael dans les Collections Françaises, Dessins.* Exh. cat. Grand Palais, Paris, 1983.

Westfehling 1990
Uwe Westfehling. *Raffael und die Zeichenkunst der italienischen Renaissance.* Exh. cat. Wallraf-Richarts-Museum, Cologne, 1990.

Weston-Lewis 1994
Aidan Weston-Lewis. *Raphael: The Pursuit of Perfection.* Exh. cat. National Gallery of Scotland, Edinburgh, 1994.

Wolk-Simon and Bambach 1999
Linda Wolk-Simon and Carmen C. Bambach. "Towards a Framework and Chronology for Giulio Romano's Early Pen Drawings." *Master Drawings* 37 (1999), 165–80.

Photography Credits

Permission to reproduce illustrations is provided by the owners as listed in the captions. Additional photography and source credits are listed here. Numbers in brackets refer to catalogue entries; "fig." numbers refer to comparative illustrations in the essays and catalogue entries.

Copyright Alinari/Art Resource, New York: [5] fig. 5, [7] fig. 7a, [9] fig. 9, [10] fig. 10, [13] fig. 13, [35] fig. 35a, [35] fig. 35b, [36] fig. 36a, [36] fig. 36b, [37] fig. 37, [38] fig. 38a, [41] fig. 41a, [49] fig. 49, [50] fig. 50b, [54] fig. 54a, [55] fig. 55c; copyright Ashmolean Museum: figs. 4, 5, 9, 10; Michele Bellot, copyright Réunion des Musées Nationaux/Art Resource, New York: fig. 8, fig. 13, [6] fig. 6, [49] fig. 49b; Gérard Blot, copyright Réunion des Musées Nationaux/Art Resource, New York: [12] fig. 12; copyright The British Museum: fig. 15, [18] fig. 18a, fig. 18b; [22] fig. 22a, [23] fig. 23a, [24] fig. 24, [27] fig. 27, [38] fig. 38b, [38] fig. 38c, [39] fig. 39b, [42] fig. 42a, [42] fig. 42b, [47] fig. 47b, [51] fig. 51, [55] fig. 55b; copyright The Detroit Institute of Arts: [30] fig. 30b; copyright Ursula Edelmann, courtesy Städelsches Kunstinstituts: [4] fig. 4, [44] fig. 44b; copyright Fitzwilliam Museum, University of Cambridge: [41] fig. 41b; Andrew Garn, copyright Cooper-Hewitt, National Design Museum, Smithsonian Institution/Art Resource, New York: [48] fig. 48; Louis Held, courtesy Kunstsammlungen zu Weimar: [46] fig. 46b; Paolo Mannoni Fotografo: [43] fig. 43a, [54] fig. 54b, [56] fig. 56b; R. G. Ojeda, copyright Réunion des Musées Nationaux: [47] fig. 47a; copyright Réunion des Musées Nationaux/Art Resource, New York: fig. 6, fig. 12, [22] fig. 22b, [23] fig. 23b, [30] fig. 30a, [34] fig. 34b, [40] fig. 40b; the Royal Collection, copyright Her Majesty Queen Elizabeth II: fig. 3; copyright Scala/Art Resource, New York: fig. 3, [45] fig. 45; courtesy Yvonne Tan Bunzl: [57] fig. 57b; copyright the Trustees of the Wallace Collection, London: [53] fig. 53.

Produced by the Publications Department of the Réunion des Musées Nationaux,
under the direction of Béatrice Foulon

Editor: Geneviève Rudolf

Picture research: Patrick Shaw Cable, The Cleveland Museum of Art, and Agnès
Reboul, Agence photographique de la Réunion des Musées Nationaux, Paris

Design and layout: Évelyne Simonin

Cover design after an original idea of Frédéric Célestin

Fabrication: Isabelle Loric

Printed and bound by Imprimerie Kapp Lahure Jombart, Évreux (France)

Dépôt légal : juillet 2002
ISBN: 2-7118-4552-4
RMN: EK 38 0048